This book is dedicated to my longtime
Publisher and friend at Peachpit Press,
Nancy Aldrich-Ruenzel.

It was an honor to get to work with you, and your
wisdom, advice, direction, and insights will
never be forgotten, by me or our readers.

While we'll miss you terribly in your retirement,
know that we'll honor your legacy of
always "doing right by the reader," and we'll
continue to work hard to create the kind of
books that would make you proud.

ACKNOWLEDGMENTS

I start the acknowledgments for every book I've ever written the same way—by thanking my amazing wife, Kalebra. If you knew what an incredible woman she is, you'd totally understand why.

This is going to sound silly, but if we go grocery shopping together, and she sends me off to a different aisle to get milk, when I return with the milk and she sees me coming back down the aisle, she gives me the warmest, most wonderful smile. It's not because she's happy that I found the milk; I get that same smile every time I see her, even if we've only been apart for 60 seconds. It's a smile that says, "There's the man I love."

If you got that smile, dozens of times a day, for nearly 26 years of marriage, you'd feel like the luckiest guy in the world, and believe me—I do. To this day, just seeing her puts a song in my heart and makes it skip a beat. When you go through life like this, it makes you one incredibly happy and grateful guy, and I truly am.

So, thank you, my love. Thanks for your kindness, your hugs, your understanding, your advice, your patience, your generosity, and for being such a caring and compassionate mother and wife. I love you.

Secondly, a big thanks to my son, Jordan. I wrote my first book when my wife was pregnant with him (20 years ago), and he has literally grown up around my writing. It has been a blast watching him grow up into such a wonderful young man, with his mother's tender and loving heart and compassion way beyond his years. I can't believe he's already off to college (out-of-state no less—sniff, sniff), but I know he knows that his dad just could not be prouder or more excited for him (though he may not realize just how much I miss seeing his big smile every morning before school and at the dinner table every night). Throughout his life, he has touched so many people, in so many different ways, and even though he's so young, he has already inspired so many, and I just cannot wait to see the amazing adventure, and the love and laughter this life has in store for him. Hey, little buddy, this world needs more "yous!"

Thanks to our wonderful daughter, Kira, for being the answer to our prayers, for being such a blessing to your older brother, and for proving once again that miracles happen every day. You are a little clone of your mother, and believe me, there is no greater compliment I could give you. It is such a blessing to get to see such a happy, hilarious, clever, creative, and just awesome little force of nature running around the house each day—she just has no idea how happy and proud she makes us. She is awesomeness wrapped in a layer of chocolate with sprinkles. It doesn't get much better than that.

A special thanks to my big brother, Jeff. I have so much to be thankful for in my life, and having you as such a positive role model while I was growing up is one thing I'm particularly thankful for. You're the best brother any guy could ever have, and I've said it a million times before, but one more surely wouldn't hurt—I love you, man!

My heartfelt thanks go to my entire team at Kelby Media Group. I know everybody thinks their team is really special, but this one time—I'm right. I'm so proud to get to work with you all, and I'm still amazed at what you're able to accomplish day in, day out, and I'm constantly impressed with how much passion and pride you put into everything you do.

A warm word of thanks goes to my in-house Editors Kim Doty and Cindy Snyder. This update to the book—the first I've done without my old friend and co-author Matt Kloskowski—wouldn't have happened without their hard work, dedication, and push to get this all done, and I can't thank you two enough. This was a *lot* of work, and you both did it with a great deal of grace and smiles, and it really made my part incredibly easy and fun. I'm indebted to you both.

the photoshop elements 14 book
for digital photographers

Scott Kelby

The Photoshop Elements 14 Book for Digital Photographers Team

MANAGING EDITOR
Kim Doty

TECHNICAL EDITOR
Cindy Snyder

ART DIRECTOR
Jessica Maldonado

PHOTOGRAPHY BY
Scott Kelby

Published by
New Riders

Composed in Avenir, Myriad Pro, and Helvetica by Kelby Media Group, Inc.

Trademarks

All terms mentioned in this book that are known to be trademarks or service marks have been appropriately capitalized. New Riders cannot attest to the accuracy of this information. Use of a term in the book should not be regarded as affecting the validity of any trademark or service mark.

Photoshop Elements is a registered trademark of Adobe Systems, Inc.
Windows is a registered trademark of Microsoft Corporation.
Macintosh is a registered trademark of Apple Inc.

Warning and Disclaimer

This book is designed to provide information about Photoshop Elements for digital photographers. Every effort has been made to make this book as complete and as accurate as possible, but no warranty of fitness is implied.

The information is provided on an as-is basis. The authors and New Riders shall have neither the liability nor responsibility to any person or entity with respect to any loss or damages arising from the information contained in this book or from the use of the discs, electronic files, or programs that may accompany it.

THIS PRODUCT IS NOT ENDORSED OR SPONSORED BY ADOBE SYSTEMS INCORPORATED, PUBLISHER OF ADOBE PHOTOSHOP ELEMENTS 14.

ISBN 13: 978-0-134-29089-8
ISBN 10: 0-134-29089-5

9 8 7 6 5 4 3 2 1

www.kelbyone.com
www.newriders.com

I'm equally as lucky to have the immensely talented Jessica Maldonado working on the design of my books. I just love the way Jessica designs, and all the clever little things she adds to her layouts and cover designs. She's not just incredibly talented and a joy to work with, she's a very smart designer and thinks five steps ahead in every layout she builds. I feel very, very fortunate to have her on my team.

To my best buddy and book-publishing powerhouse, Dave Moser (also known as "the guiding light, force of nature, miracle birth, etc."), for always insisting that we raise the bar and make everything we do better than anything we've done before.

Thanks to my friend and business partner, Jean A. Kendra, for her support and friendship all these years. You mean a lot to me, to Kalebra, and to our company.

My heartfelt thanks to Kleber Stephenson, for helping us get over a mountain we haven't been able to get over for years, and for putting together a team to get us there.

A big thanks to my Executive Assistant, Lynn Miller, for wrangling a "kitten that's always trying to jump out of the box" each day, and for keeping me focused, organized, and on track, which has to be just an insanely challenging job, but she seems to do it pretty effortlessly, which is a testament to how good she is at it. Thank you, Lynn.

A big high-five to Nikki McDonald, my "Editor of Awesomeness" at Peachpit Press, to Nancy Davis, our "Mistress of Midnight Publishing," and to Sara Jane "SJ" Todd, and all the wonderful folks at Peachpit. Thanks for all your hard work and dedication to making the kind of books that make a difference.

Thanks to my former co-author, Matt Kloskowski, who co-authored many of the previous editions of this book with me. His words and influence are still felt throughout, and the book is better for it.

Thanks to my friends at Adobe Systems: Brian Hughes, Terry White, Sharad Mangalick, Scott Morris, Jim Heiser, Tom Hogarty, Stephen Nielsen, Bryan Lamkin, Julieanne Kost, and Russell Preston Brown. Gone but not forgotten: Barbara Rice, Rye Livingston, John Loiacono, Kevin Connor, Deb Whitman, Addy Roff, Cari Gushiken, and Karen Gauthier.

I want to thank all the talented and gifted photographers who've taught me so much over the years, including: Moose Peterson, Joe McNally, Bill Fortney, George Lepp, Anne Cahill, Vincent Versace, David Ziser, Jim DiVitale, Cliff Mautner, Dave Black, Helene Glassman, and Monte Zucker.

Thanks to my mentors, whose wisdom and whip-cracking have helped me immeasurably, including John Graden, Jack Lee, Dave Gales, Judy Farmer, and Douglas Poole.

Most importantly, I want to thank God, and His Son Jesus Christ, for leading me to the woman of my dreams, for blessing us with two amazing children, for allowing me to make a living doing something I truly love, for always being there when I need Him, for blessing me with a wonderful, fulfilling, and happy life, and such a warm, loving family to share it with.

OTHER BOOKS BY SCOTT KELBY

The Lightroom CC Book for Digital Photographers

Photoshop for Lightroom Users

How Do I Do That In Lightroom?

Professional Portrait Retouching Techniques for Photographers Using Photoshop

The Digital Photography Book, parts 1, 2, 3, 4 & 5

The Best of The Digital Photography Book Series

Light It, Shoot It, Retouch It: Learn Step by Step How to Go from Empty Studio to Finished Image

The Adobe Photoshop CC Book for Digital Photographers

Professional Sports Photography Workflow

It's a Jesus Thing: The Book for Wanna Be-lievers

ABOUT THE AUTHOR

Scott Kelby

Scott is Editor, Publisher, and co-founder of *Photoshop User* magazine, co-host of *The Grid*, the weekly, live talk show for photographers, and Executive Producer of the top-rated weekly show *Photoshop User TV*.

He is President and CEO of KelbyOne, an online educational community for learning Photoshop, Lightroom, and photography.

Scott is a photographer, designer, and award-winning author of more than 60 books, including *Photoshop for Lightroom Users*; *Professional Portrait Retouching Techniques for Photographers Using Photoshop* ; *Light It*; *Shoot It*; *Retouch It*; *The Adobe Photoshop Book for Digital Photographers*; and *The Best of The Digital Photography Book Series*.

For the past five years, Scott has been honored with the distinction of being the world's #1 best-selling author of photography technique books. His book, *The Digital Photography Book*, part 1, is now the best-selling book on digital photography in history. And, he recently received the prestigious HIPA Award for his contributions to photography education worldwide.

His books have been translated into dozens of different languages, including Chinese, Russian, Spanish, Korean, Polish, Taiwanese, French, German, Italian, Japanese, Dutch, Arabic, Swedish, Turkish, Hebrew, and Portuguese, among others, and he is a recipient of the prestigious ASP International Award, presented annually by the American Society of Photographers for "…contributions in a special or significant way to the ideals of Professional Photography as an art and a science."

Scott is Training Director for the official Adobe Photoshop Seminar Tour and Conference Technical Chair for the Photoshop World Conference & Expo. He's a frequent speaker at conferences and trade shows around the world, is featured in a series of online learning courses at KelbyOne.com, and has been training Photoshop users and photographers since 1993.

For more information on Scott, visit him at:

His daily blog: **scottkelby.com**

Twitter: **@scottkelby**

Instagram: **instagram.com/scottkelby**

Facebook: **facebook.com/skelby**

Google+: **Scottgplus.com**

www.kelbyone.com

CONTENTS

CONTENTS

Chapter 3

SCREAM OF THE CROP 93
how to resize and crop photos

Chapter 4

edIT 123
which mode do I use: quick, guided, or expert?

CONTENTS

CONTENTS

CONTENTS

Chapter 10

SHARPEN YOUR TEETH 297

sharpening techniques

Chapter 11

FINE PRINT 317

printing, color management, and my Elements 14 workflow

It's really important to me that you get a lot out of reading this book, and one way I can help is to get you to read these 10 quick things about the book that you'll wish later you knew now. For example, it's here that I tell you about where to download something important, and if you skip over this, eventually you'll send me an email asking where it is, but by then you'll be really aggravated, and well… it's gonna get ugly. We can skip all that (and more), if you take two minutes now to read these 10 quick things. I promise to make it worth your while.

Ten Things You'll Wish You Had Known Before Reading This Book

(1) You don't have to read this book in order.

You can treat this as a "jump-in-any-where" book, because I didn't write it as a "build-on-what-you-learned-in-Chapter-1" type of book. For example, if you just bought this book, and you want to learn how to convert an image to black and white, you can just turn to Chapter 9, find that technique, and you'll be able to follow along and do it immediately, because I walk you through each step. So, if you're a more advanced Elements user, don't let it throw you that I say stuff like "Go under the Image menu, under Adjust Color, and choose Levels," rather than just saying "Open Levels." I did that so everybody could follow along no matter where they are in the Elements experience.

(2) Not everything about Elements is in this book.

I tried hard not to make this a giant encyclopedia of Elements features. So, I didn't include tutorials on every feature in Elements. Instead, it's more like a recipe book—you can flip through it and pick out the things that you want to do to your photos and follow the steps to get there. Basically, I just focused on the most important, most asked-about, and most useful things for digital photographers. In short— it's the funk and not the junk.

(Continued)

(3) Practice along with some of the same photos I used here in the book.

As you're going through the book, and you come to a technique like "Adding Contrast and Drama to Cloudy Skies," you might not have a cloudy sky image hanging around. I made most of the images used in the techniques available for you to download, so you can follow along with them. You can find them at **http://kelbyone.com/books/elements14** (see, this is one of those things I was talking about that you'd miss if you skipped this and went right to Chapter 1).

(4) There's a bonus chapter on portrait retouching.

Every time Adobe adds a bunch of new features to Elements, I add those features to this book, and what you're holding in your hands is the 14th edition of the book. If I did nothing but add all the new features in each edition, this book would probably be over a thousand pages by now (and sadly, cost triple the price). So, rather than just cutting pages to make room for the new stuff (and to keep the cost of the book affordable), I've put the Retouching Portraits chapter online for you as a bonus chapter. That way, you still get the techniques, but without paying more money (and having to lug around a 22-lb. book). You can find this bonus retouching chapter on the book's companion webpage at the web address I just mentioned in #3.

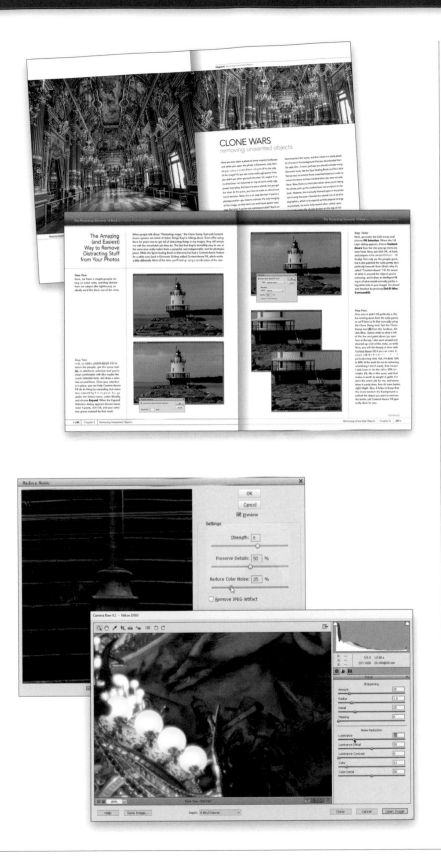

(5) The intro pages at the beginning of each chapter are not what they seem.

The chapter introductions are designed to give you a quick mental break between chapters, and honestly, they have little to do with what's in the chapter. In fact, they have little to do with anything, but writing these quirky chapter intros has become kind of a tradition in all my books, so if you're one of those really "serious" types, I'm begging you, skip them and just go right into the chapter because they'll just get on your nerves. However, the short intros at the beginning of each individual project, up at the top of the page, are usually pretty important. If you skip over them, you might wind up missing stuff that isn't mentioned in the technique itself. So, if you find yourself working on a technique, and you're thinking to yourself, "Why are we doing this?" it's probably because you skipped over that intro. So, just make sure you read it first, and then go to Step One. It'll make a difference—I promise.

(6) There are things in Elements 14 and in Camera Raw that do the exact same thing.

For example, there's a way to reduce noise in a photo in Camera Raw and there's a way to do it in the Elements Editor, as well. And, they look almost identical. What this means to you is that some things are covered twice in the book. As you go through the book, and you start to think, "This sounds familiar," now you know why. By the way, in my own workflow, if I can do the exact same task in Camera Raw or the Editor, I always choose to do it in Camera Raw, because it's faster (there are no progress bars in Camera Raw) and it's non-destructive (so I can always change my mind later).

(Continued)

(7) I included my Elements 14 work-flow, but don't read it yet.

At the end of Chapter 11, I included a special tutorial detailing my own Elements 14 workflow. But, please don't read it until you've read the rest of the book, because it assumes that you've read everything else in the book already, and understand the basic concepts, so it doesn't spell everything out (or it would be one really, really long drawn-out tutorial).

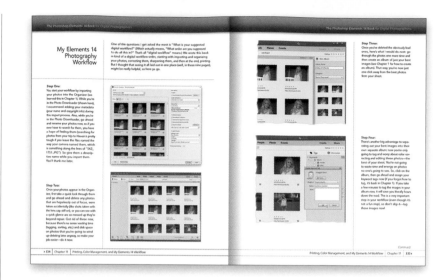

(8) What new stuff is in this book?

Elements 14 is a significant upgrade for photographers, and thankfully Adobe continued with their tradition of taking some of the coolest features from the full-blown version of Photoshop CC and bringing them over to Elements (but usually in a much more refined or easier-to-use way, so it feels right at home here in Elements). Some of the big features they brought over in this update include Photoshop's Shake Reduction filter (it helps sharpen photos that are blurry due to camera movement when you took the shot), and the amazing Haze Removal filter, which cuts through hazy or foggy images with just a simple slider (this has been a huge hit with users in Photoshop CC and Lightroom CC), along with improved panoramas, a simple-to-use Straighten tool, auto Smart Looks in Quick mode, some new Guided mode effects, like Speed Effect that gives the effect of slow shutter-speed motion, plus a lot more. And, of course, all the cool new stuff is covered here in the book.

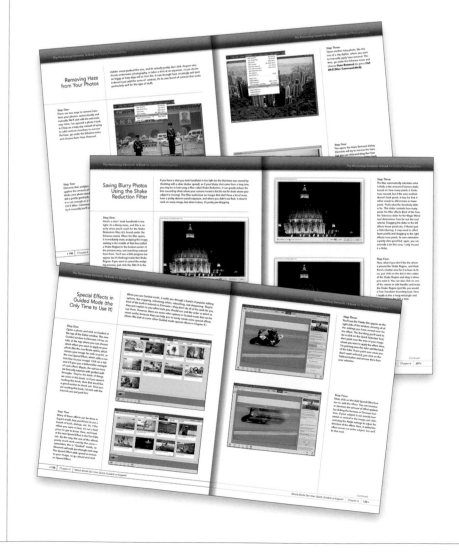

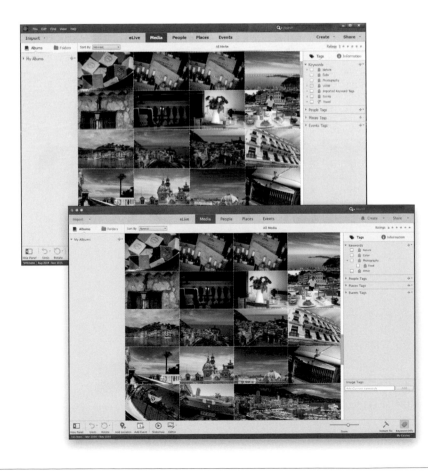

(9) Photography is evolving, Elements is evolving, and this book has to, too.

If it looks like a lot of the book is dedicated to covering Camera Raw, it's because it has become the "go-to" tool for today's photographers. It offers so many advantages, and it's not just its non-destructive nature (it doesn't ever harm your RAW original—it kind of treats it like we treated negatives back in the day). Beyond that, it's so much faster, more flexible, and just easier to understand and learn, so it makes sense to do as much as we can in Camera Raw first before we take the image fully into Elements (not to mention the fact that Camera Raw is *not* just for RAW images—it works with JPEGs and TIFFs, too). Camera Raw is where photographers today are focusing their time and efforts, so I dedicate quite a bit to making sure you're making the most of it in your Elements workflow.

(10) This book is for Windows and Mac users.

Elements 14 is available for both Windows and Macintosh platforms, and the two versions are nearly identical. However, there are three keys on the Mac keyboard that have different names from the same keys on a PC keyboard, but don't worry, I give you both the Windows and Mac shortcuts every time I mention a shortcut (which I do a lot). Also, the Editor in Elements 14 is the same on both platforms, but the Organizer (where we sort and organize our images) was only made available on the Mac starting with Elements 9. As a result, there are some Organizer functions that still aren't available on the Mac yet, and I've noted it in the book wherever this is the case.

Okay, that's the scoop. Thanks for taking a few minutes to read this, and now it's time to turn the page and get to work.

ORGANIZED CHAOS
managing photos using the organizer

If you're reading this chapter opener (and you are, by the way), it's safe to assume that you already read the warning about these openers in the introduction to the book (by the way, nobody reads that, so if you did, you get 500 bonus points, and a chance to play later in our lightning round). Anyway, if you read that and you're here now, you must be okay with reading these, knowing full well in advance that these have little instructional (or literary) value of any kind. Now, once you turn the page, I turn all serious on you, and the fun and games are over, and it's just you and me, and most of the time I'll be screaming at you (stuff like, "No, no—that's too much sharpening you goober!" and "Are you kidding me? You call that a Levels adjustment?" and "Who spilled my mocha Frappuccino?"), so although we're all friendly now, that all ends when you turn the page, because then we're down to business. That's why, if you're a meany Mr. Frumpypants type who feels that joking has no place in a serious book of learning like this, then you can: (a) turn the page and get to the discipline and order you crave, or (b) if you're not sure, you can take this quick quiz that will help you determine the early warning signs of someone who should skip all the rest of the chapter openers and focus on the "real" learning (and yelling). Question #1: When was the last time you used the word "poopy" in a sentence when not directly addressing or referring to a toddler? Was it: (a) During a morning HR meeting? (b) During a legal deposition? (c) During your wedding vows? Or, (d) you haven't said that word in a meaningful way since you were three. If you even attempted to answer this question, you're clear to read the rest of the chapter openers. Oh, by the way: pee pee. (Hee hee!)

Importing Your Photos

One of the major goals of Adobe Photoshop Elements is simply to make your life easier and the Photo Downloader is there to help do just that. Adobe has not only made the process of getting your photos from your digital camera into the Elements Organizer much easier, they also included some automation to make the task faster. Why? So you can get back to shooting faster. Here's how to import your photos and take advantage of this automation:

Step One:

When you attach a memory card reader to your computer (or attach your camera directly using a USB cable), the Elements Organizer – Photo Downloader standard dialog appears onscreen (if you have it set that way; by the way, it will also download photos from your mobile phone). The first thing it does is it searches the card for photos, and then it tells you how many photos it has found, and how much memory (hard disk space) those photos represent.

TIP: Import in Bulk

If you have a lot of images on your computer that you'd like to import into the Organizer, a new feature was added in Elements 14 that lets you easily import a large number of im-ages at once. Just go under the File menu, under Get Photos and Videos, and choose **In Bulk**.

Step Two:

The Import Settings section is where you decide how the photos are imported. You get to choose where (on your hard disk) they'll be saved to, and you can choose to create subfolders with photos sorted by a custom name, today's date, when they were shot, and a host of attributes you can choose from the Create Subfolder(s) pop-up menu (as shown here).

Step Three:

If you want to rename files as they're imported, you can do that in the next field down. You can use the built-in naming conventions, but I recommend choosing **Custom Name** from the Rename Files pop-up menu, so you can enter a name that makes sense to you. You can also choose to have the date the photo was shot appear before your custom name. Choosing Custom Name reveals a text field under the Rename Files pop-up menu where you can type your new name (you get a preview of how it will look). By the way, it automatically appends a four-digit number starting with 0001 at the end of your filename to keep each photo from having the same name.

TIP: Storing the Original Name

If you're fanatical (or required by your job) and want to store the original file-name, turn on the Preserve Current Filename in XMP checkbox and your original filename will be stored in the photo's metadata.

Step Four:

The last setting here is Delete Options. Basically, it's this: do you want the pho-tos deleted off your memory card after import, or do you want to leave the originals on the card? What's the right choice? There is no right choice—it's up to you. If you have only one memory card, and it's full, and you want to keep shooting, well…the decision is pretty much made for you. You'll need to delete the photos to keep shooting. If you've got other cards, you might want to leave the originals on the card until you can make a secure backup of your photos, then erase the card later.

(Continued)

Step Five:

Beneath the Delete Options pop-up menu is the Automatic Download check-box (this feature is currently only available in the PC version of Elements 14) and this feature is designed to let you skip the Photo Downloader. When you plug in a memory card reader, or camera, it just downloads your photos using your default preferences, with no input from you (well, except it asks whether you want to erase the original photos on the card or not). Now, where are these default preferences set? They're set in the Organizer's Preferences. Just go under the Organizer's Edit menu, under Preferences, and choose **Camera or Card Reader**. This brings up the Preferences dialog you see here.

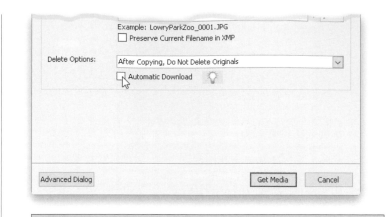

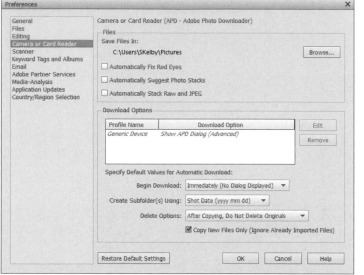

Step Six:

Here is where you decide what happens when you turn on the Automatic Download checkbox in the Photo Downloader. You get to choose a default location to save your photos (like your Pictures folder), and whether you want it to automatically fix any photos that it detects have red eye. You can also choose to have it automatically suggest photo stacks (it groups photos it thinks belong together), or make a keyword tag. You can have settings for specific cameras or card readers (if you want separate settings for your mobile phone, or a particular camera). At the bottom, you've got some other options (when to begin the downloading, if you're going to have subfolders, and your delete options). Click OK when the preferences are set the way you want them.

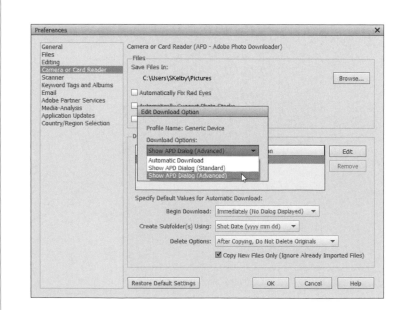

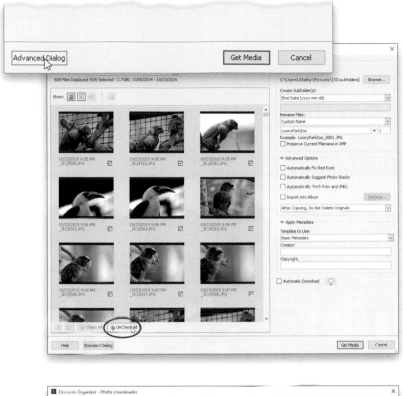

Step Seven:

Okay, back to the Photo Downloader. Now, at this point, all the photos on the card will be imported, but if you want to import just a few selected photos, then you'll need to click on the Advanced Dialog button at the bottom-left corner of the dialog (shown at the top). That expands the dialog and displays thumbnails of all the photos on the card. By default, every photo has a checkbox turned on below it, indicating that every photo will be imported. If you just want some of these photos imported, then you'll need to click the UnCheck All button at the bottom left of your thumbnails. This turns off all the photos' checkboxes, which enables you to then go and turn on the checkboxes below only the photos you actually want imported.

Step Eight:

When you look at the right side of the dialog, you'll see some familiar Save Options (the subfolder choice, renaming files), and in the Advanced Options section, you'll see choices to automatically fix red eyes, suggest photo stacks, make a tag, import into an album, and delete options. Another nice feature is the ability to embed metadata (like your name and your copyright info) directly into the digital file, just like your camera embeds information into your digital camera images. So, just type in your name and your copyright info, and these are embedded into each photo automatically as they're imported. This is a good thing. When you click Get Media, your photos are imported (well, at least the photos with a checkmark under them). If you want to ignore these advanced features and just use the standard dialog, click on the Standard Dialog button.

Backing Up Your Photos to a Disc or Hard Drive

When you think about backing up, I'd like you to consider this: it's not a matter of if your hard drive will crash, it's a matter of when. I've personally had new and old computers crash. So many times that now I'm totally paranoid about it. Sorry, but it's a harsh fact of computer life. You can protect yourself, though, by backing up your entire catalog to a disc or hard drive, and/or using an online backup, so your photos are protected in an off-site location. So even if your hard drive dies or your computer is lost, stolen, damaged in a fire, flood, or hurricane, you can retrieve your images.

Step One:

To back up your catalog to a hard drive or disc, you simply go under the Organizer's File menu and choose **Backup Catalog** (as shown here; currently in the Mac version of Elements 14, you can only back up to a hard drive).

TIP: Back Up to an External Hard Drive

We recommend backing up to an external hard drive. They're much larger than a CD, or even a DVD, and easier to manage. Plus, you can always take them with you or to a nice off-site location to really keep your backups safe. You can get a 1-TB external hard drive for around $50, and a 3-TB drive for around $90.

Step Two:

This brings up a dialog where you decide whether to do a Full Backup (you choose this the first time you back up your catalog), or an Incremental Backup (which is what you'll choose after your first backup, as it only backs up the files that have changed since your last backup, which is a big time saver). In this case, since this is your first time, choose Full Backup (as shown here), then click the Next button.

Step Three:

When you click Next, the Destination Settings screen appears, which is basically where you tell Elements to back up your stuff to. If it's a DVD or CD, just insert a blank DVD or CD into your DVD/CD drive and choose that drive from the list. Give your disc a name, click the Save Backup button, and it does its thing. Same thing for a hard drive—just choose it from the list and click the Save Backup button.

Importing Photos from Your Scanner

If you're reading this and thinking: "But this is supposed to be a book for digital photographers. Why is he talking about scanning?" Then ask yourself this: "Do I have any older photos lying around that I wish were on my computer?" If the answer is "Yes," then this tutorial is for you. We'll take a quick look at importing scanned images into the Organizer.

Step One:

In the Elements Organizer, go under the File menu, under Get Photos and Videos, and choose **From Scanner**. By the way, in the Organizer, you can also use the shortcut **Ctrl-U** to import photos from your scanner or click on Import just below the menu bar and choose **From Scanner**. (*Note:* This feature is currently only available in the PC version of Elements 14.)

Step Two:

Once the Get Photos from Scanner dialog is open, choose your scanner from the Scanner pop-up menu. Choose a high Quality setting (I generally choose the highest quality, unless the photo is for an email to my insurance company for a claim—then I'm not as concerned), then click OK to bring in the scanned photo. See? Pretty straightforward stuff.

We all have our personal preferences. Some people like to cram as many photos onscreen at once as they can, while others like to see the photos in the Organizer's Media Browser at the largest view possible. Luckily, you have total control over the size they're displayed at.

Changing the Size of Your Photo Thumbnails

Step One:
The size of your thumbnails is controlled by a slider below the right side of the Media Browser. Click-and-drag the Zoom slider to the right to make them bigger and to the left to make them smaller.

TIP: Jumping Up a Size
To jump up one size at a time, click on a thumbnail, then press-and-hold the **Ctrl (Mac: Command) key** and press the **+** (plus sign) **key**. To go down in size, press **Ctrl-–** (minus sign; **Mac: Command-–**).

Step Two:
To jump to the largest possible view, just double-click on your thumbnail. At this large view, you can enter a caption directly below the photo by clicking on the placeholder text (which reads "Click here to add caption") and typing in your caption. (*Note:* If you don't see this text, go under the View menu and choose **Details**.) Press **Esc** to return to the grid view, or click on the Grid button in the top left of the Media Browser.

Seeing Full-Screen Previews

If you like seeing a super-big view of your photos, then use Elements' Full Screen view. It shows you a huge preview of a selected thumbnail without having to leave the Organizer. Here's how:

Step One:
To see a full-screen preview of your currently selected photo(s), go under the View menu, and choose **Full Screen** (or press **F11 [Mac: Command-F11]**).

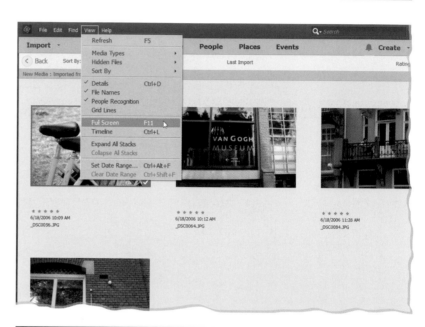

Step Two:
This brings you into Full Screen view, and your photo should appear large on-screen with everything else black around it. This is really a way to launch into a slide show, but if you don't do anything here, you're simply just viewing your photos in a larger view. If you want to return to the Media Browser, press the **Esc key** on your keyboard. But wait, there's more.

Step Three:

Once your photo(s) appears full screen, there's a control palette at the bottom of the screen where you can control your viewing options—click the Play button to start moving through your photos and click the Pause button to stop. You can also click the Right Arrow and Left Arrow buttons to view the next or previous photo.

Step Four:

One more thing: Try clicking the Toggle Film Strip button on the control palette (or just press **Ctrl-F [Mac: Command-F]**). This opens a filmstrip view of your photos on the bottom of the screen. So you don't necessarily have to click the Right Arrow button or press the Right Arrow key a bunch of times to get to a photo that's 25 photos into your list. You can just scroll the filmstrip until you see it and click on it. Nifty, huh?

Sorting Photos by Date and Viewing Filenames

When photos are imported into the Organizer, the Organizer automatically sorts them by date. How does it know on which dates the photos were taken? The time and date are embedded into the photo by your digital camera at the moment the photo is taken (this info is called EXIF data). The Organizer reads this info and then sorts your photos automatically by date, putting the newest ones on top. You can change that, though, and you can choose whether or not to view your filenames.

Step One:
By default, the newest photos are displayed first, so basically, your last photo shoot will be the first photos in the Organizer. You can see the exact date and time each photograph was taken by going under the View menu, and choosing **Details**. If you want to see the filenames, then under the View menu, choose **File Names**, as well.

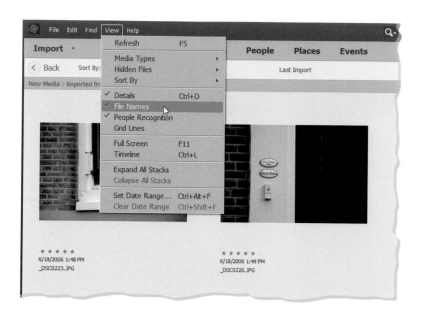

Step Two:
If you'd prefer to see your photos in reverse order (the oldest photos up top), then choose **Oldest** from the Sort By pop-up menu above the top left of the Media Browser. There you have it!

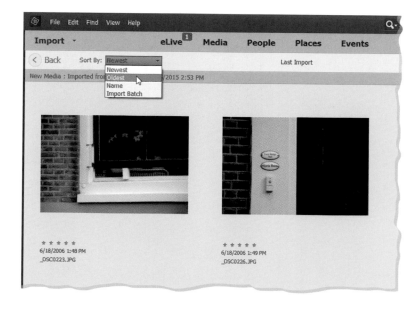

Let's say you travel between time zones and you import a bunch of photos. Well, they're all going to show up with the date and time that was set in your camera from your home location, not where you traveled. No sweat, though. If you ever want to change them to account for the time zone changes (or any other date/time you'd like), Elements has a way.

Change the Time & Date of Your Photos (Great, If You Travel)

File	Edit	Find	View	Help

Undo Import Media	Ctrl+Z
Redo	Ctrl+Y
Copy	Ctrl+C
Select All	Ctrl+A
Deselect	Ctrl+Shift+A
Delete Selected Items from Catalog...	Del
Rotate Selected Photos 90° Left	Ctrl+Left Arrow
Rotate Selected Photos 90° Right	Ctrl+Right Arrow
Edit with Photoshop Elements Editor...	Ctrl+I
Edit with Premiere Elements Editor...	Ctrl+M
Edit with Photoshop...	Ctrl+H
Photomerge®	▶
Adjust Date and Time of Selected Items...	Ctrl+J
Add Caption to Selected Items...	Ctrl+Shift+T
Update Thumbnail for Selected Items	Ctrl+Shift+U
Ratings	▶
Visibility	▶

Adjust Date and Time of Selected Items ✕

- ○ Change to a specified date and time
- ○ Change to match file's date and time
- ○ Shift to new starting date and time
- ◉ Shift by set number of hours (time zone adjust)

[OK] [Cancel]

Time Zone Adjust ✕

- ◉ Ahead
- ○ Back

[3 ▲▼] Hours

[OK] [Cancel]

Step One:
First, select all the photos you want to set the time and date for by Ctrl-clicking (Mac: Command-clicking) on each image (or Shift-clicking on the first and last images if they are contiguous) in the Media Browser. Then, go under the Organizer's Edit menu and choose **Adjust Date and Time of Selected Items** (or press **Ctrl-J [Mac: Command-J]**).

Step Two:
This brings up a dialog asking how you want to handle the date and time for these photos. For this example, select Shift by Set Number of Hours (Time Zone Adjust) and click OK.

Step Three:
This brings up the Time Zone Adjust dialog where you just choose whether you want to move the time ahead or back, and by how many hours. When you're done, click OK and the date/time for the photos will get changed.

Finding Photos Fast by Their Month & Year

By default, the Organizer sorts your photos by date and time, with the most recent photos appearing at the top. You know and I know that it's hard to always remember when you took some of your favorite photos, though. With the Timeline, you can at least get pretty close. Let's say you're trying to find photos you took in Amsterdam last summer. You may not remember exactly whether it was June or July, but by moving a slider you can hone in and find them really fast.

Step One:

First things first. You need to display the Timeline to use it. Go under the View menu and choose Timeline (or just press **Ctrl-L [Mac: Command-L]**). It'll appear right above the Media Browser. We're going to assume you're trying to find photos you took in Amsterdam last summer (as mentioned above). You see those bars along the Timeline that look like the little bar charts from Microsoft Excel? Well, the higher the bar, the more photos that appear in that month. So click on any month in 2015 and the photos taken in that month will appear in the Media Browser. As you slide your cursor to the left (or right), you'll see each month's name appear. When you move to July, photos taken in July 2015 will appear. Take a quick look and see if any of those photos are the ones from that trip. If they're not in July, scroll on the Timeline to June, and those photos will be visible.

Although finding your photos by month and year is fairly handy, the real power of the Organizer appears when you assign tags (keywords) to your photos. This simple step makes finding the exact photos you want very fast and very easy. The first step is to decide whether you can use the pre-made tags that Adobe puts there for you or whether you need to create your own. In this situation, you're going to create your own custom tags.

Tagging Your Photos (with Keyword Tags)

Step One:
Start by finding the Tags palette in the Organizer (it's on the right side of the window). Adobe's default set of keyword tag categories will appear in a vertical list. Now, there are a few different ways to tag photos, so let's take a look at them all. In the end, they all do the same thing, just in a different way.

Step Two: The Really Easy Way
Let's start by tagging the really easy way. Type a tag name in the Add Custom Keywords text field at the top of the Image Tags palette (right below the Tags palette). Then in the Media Browser, click on the photo (Ctrl-click [Mac: Command-click] to select multiple photos) you want to assign this tag to and click the Add button to the right of the text field. The tag will automatically be created and applied to the selected photo(s).

TIP: Use an Existing Keyword Tag
Since the Image Tags text field dynamically displays existing keyword tags (in a pop-up menu) based on the letters you type, you can use it to assign an existing keyword tag to your photos instead of creating a brand new one.

(Continued)

Step Three: The More Customized and Visual Way

The thing about Step Two is that it automatically creates your tag in the Other category. As you start tagging, you may want to categorize your tags and even create your own categories. So, let's start by creating a custom category (in this case, we're going to create a category for shots of sports). Click on the Create New Keyword Tag button (the little green plus sign) at the top right of the Tags palette and choose **New Category** from the pop-up menu. This brings up the Create Category dialog. Type in a name for your category (I typed "Sports"). Now choose an icon from the Category Icon list and then click OK. (The icon choices are all pretty lame, so we'll just choose the blue tag icon here.)

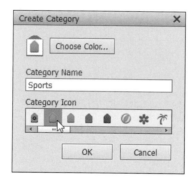

Step Four:

To create your own custom tag, click on the Create New Keyword Tag button again and choose **New Keyword Tag**. This brings up the Create Keyword Tag dialog. Choose Sports from the Category pop-up menu (if it's not already chosen), then in the Name field, type in a name for your new tag (here I entered "Lightning vs Capitals"). If you want to add additional notes about the photos, you can add them in the Note field, and you can choose a photo as an icon by clicking the Edit Icon button. Now click OK to create your tag.

Step Five:

Next, you'll assign this tag to all the photos from this shoot. In the Media Browser, scroll to the photos from that shoot. We'll start by tagging just one photo, so click on your new tag that appears in your Keywords list in the Tags palette and drag-and-drop that tag onto any one of the photos. That photo is now "tagged" and you'll see a small tag icon appear below the right side of the photo's thumbnail.

Step Six:

So at this point, we've only tagged one photo from this shoot. Drag-and-drop that same tag onto three more photos from the shoot, so a total of four photos are tagged. Now, in the Tags palette, click in the box to the left of the tag, and just those photos with that tag appear in the Media Browser. To see all your photos again, click in the box again.

Tagging Multiple Photos

Okay, if you had to tag any more than a few photos, you've probably realized that dragging-and-dropping the tag onto each photo is a pain in the neck. If you had a whole photo shoot, that process would take forever and you'd probably be getting ready to send Adobe (or me for even showing you this feature) a nasty email. You'll be happy to know there are faster ways than this one-tag-at-a-time method. For example…

Step One:

To tag all the photos from your shoot at the same time, try this: First, click on any photo from the shoot. Then press-and-hold the Ctrl (Mac: Command) key and click on other photos from that particular shoot. As you click on them, they'll become selected (each selected photo will have a blue stroke around it). Or, if all the photos are contiguous, click on the first image in the series, press-and-hold the Shift key, and then click on the last image in the series to select them all.

Step Two:

Now, drag-and-drop your chosen tag onto any one of those selected photos, and all of the selected photos will have that tag. If you want to see just the photos from that shoot, click in the box to the left of that tag in the Tags palette and only photos with that tag will appear. By the way, if you decide you want to remove a tag from a photo, just Right-click on the tag icon below the photo and from the pop-up menu that appears, choose **Remove Keyword Tag**. If you have more than one tag applied, you can choose which tag you want removed by Right-clicking on its icon.

Assigning Multiple Tags to One Photo

Okay, what if you want to assign a keyword tag to a photo, but you also want to assign other keyword tags (perhaps an "Upload to Website" tag and a "Make Prints" tag) to that photo, as well? Here's how:

Step One:
To assign multiple tags at once, first, of course, you have to create the tags you need, so go ahead and create your new tags by clicking on the Create New Keyword Tag button and choosing **New Keyword Tag** from the pop-up menu. Name them "Upload to Website," "Make Prints," and two others specific to this shoot. Now you have four tags you can assign. To assign all four tags at once, just press-and-hold the Ctrl (Mac: Command) key, then in the Tags palette, click on each tag you want to assign (Mountains, Lakes, Make Prints, and Upload to Website).

Step Two:
Then, click-and-drag those selected tags, and as you drag, you'll see you're dragging four tag icons as one group. Drop them onto a photo, and all four tags will be applied at once. If you want to apply the tags to more than one photo at a time, first press-and-hold the Ctrl (Mac: Command) key and click on all the photos you want to have all four tags. Then, go to the Tags palette, press-and-hold the Ctrl key again, and click on all the tags you want to apply. Drag those tags onto any one of the selected photos, and all the tags will be applied at once. Cool.

Tagging Images of People

You're either going to think this is the coolest, most advanced technology in all of Elements, or you're going to think it's creepy and very Big Brother-ish (from the book by George Orwell, not the TV show). Either way, it's here to help you tag people easier because the Organizer can automatically find photos of people for you—as it has some sort of weird science, facial-recognition software built in (that at one point was developed for the CIA, which is all the more reason it belongs in Elements).

Step One:

Let's say you want to quickly find all the photos of your sister. In the Organizer, at the top, click on People. By default, this shows all the people in your catalog that you haven't tagged with a name, and that are in at least four photos. To see all unnamed people, turn off the Hide Small Stacks checkbox at the top left.

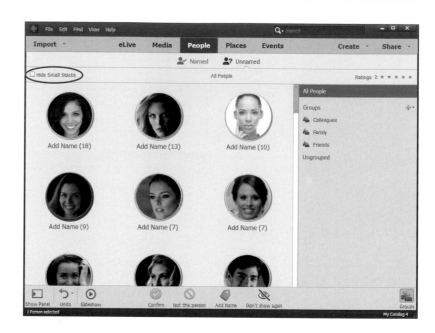

Step Two:

Just click on Add Name beneath one of the image thumbnails, type in a name to tag the photo(s) with, and press Enter (Mac: Return) or click the checkmark. If this keyword doesn't already exist, this will create a new one. If Elements found something that isn't a person in a photo (like the mask at the bottom here) or is someone you don't know (like from a travel photo), click on the thumbnail and click the Don't Show Again button at the bottom. The thumbnail will be removed from People view. If multiple images contain the same people, they'll be stacked beneath the thumbnail, and the name you add to the thumbnail will be added to them, as well.

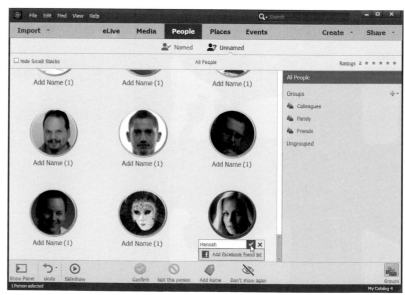

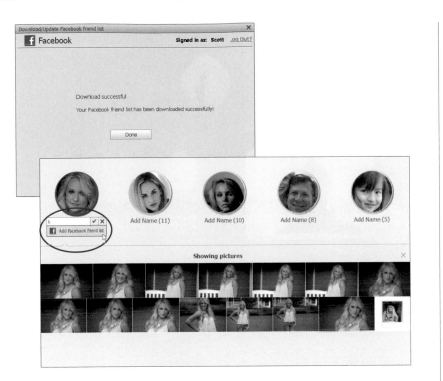

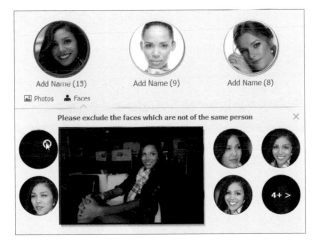

TIP: Use Your Facebook Friend List
When you start typing a name, Elements will ask if you want to download your Facebook friend list. If you set up Elements to be authorized to work with your Facebook account, it'll download your Facebook friend list (seen here). Now, in addition to any names you've already added starting with the same letter, the names of your Facebook friends starting with the same letter will also appear in a pop-up menu when you start typing a name in the Add Name field.

Step Three:
When you hover your cursor over a thumbnail, Photos and Faces buttons will appear below it. Click on Photos to see all the photos that person is in. Click on Faces to see a close-up of the person's face in each image. If you hover your cursor over one of these close-ups, a preview of the entire image will appear to its right. If this isn't the same person as the rest of the images, you have two options. The first is to click the international symbol for "No!" that appears in the top right of the close-up and Elements will remove that image from the stack. The second is to click on that close-up to select it, click the Add Name button in the taskbar at the bottom, then add that person's name in the dialog that appears, and they will be removed from the stack. Once you're done removing people that don't match from your stack, add the remaining person's name as we did in Step Two. That will move the entire stack under the Named header.

(Continued)

Step Four:

When you finish adding names to your people photos, the photos will all be stacked by name under the Named header, like you see here. If you move your cursor over a stack from left to right (or right to left), it will scroll through the images in your stack, so you don't have to open the stack to see the rest of the photos in it. If Elements thinks there might be untagged photos of the same person, you'll see an exclamation point in a blue triangle to the left of their name. Click on that triangle to see the faces tagged as that person and the faces Elements thinks could be that person. If it is the same person, click on the checkmark that appears at the top left of the close-up when you move your cursor over it. If it's not, click on the No! symbol. The Groups palette that appears on the right works much like the Tags palette. You can add new groups or use the default ones for Friends and Family. Just drag-and-drop the group name onto the photo stack to add those photos to the group.

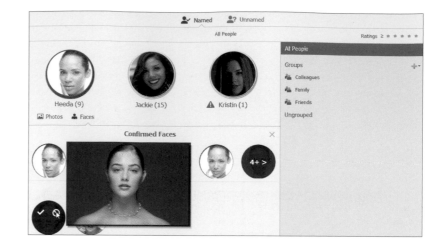

Step Five:

If Elements didn't recognize a face, you can always add it manually. In the Media Browser, double-click on the image with the person you want to tag, then click the Mark Face icon in the bottom taskbar. Click-and-drag the rectangle over the person's face, resize it by dragging any of the corner handles, and give 'em a name and click the green checkmark.

TIP: Train Elements to Find Faces

The more you tag and the more you use this face tagging technology, the better you train Elements to find faces. Each time you tag faces, it gets more and more accurate.

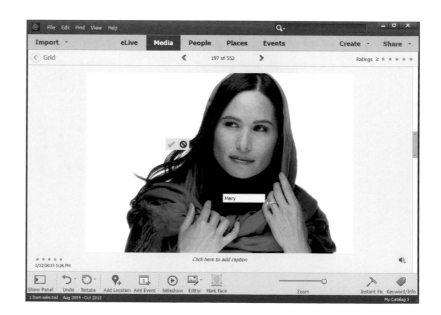

Once you've tagged all your photos, you may want to create a collection of just the best photos (the ones you'll show to your friends, family, or clients). You do that by creating an "album" (which used to be called a collection in earlier versions of Elements). An advantage of albums is that once photos are in an album, you can put the photos in the order you want them to appear (you can't do that with tags). This is especially important when you start creating your own slide shows and web galleries.

Albums: It's How You Put Photos in Order One by One

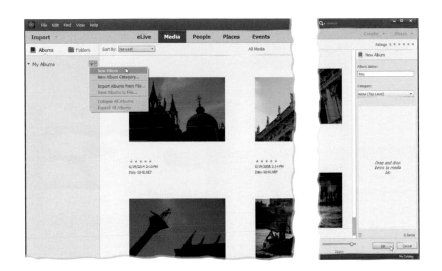

Step One:
To create an album, go to My Albums in the Albums palette on the top-left side of the Organizer (it's below the Import button). You create a new album by clicking on the Create New Album button (the green plus sign), and from the pop-up menu, choosing **New Album**. When the New Album pane appears on the right, enter a name for your album. You can then drag-and-drop images onto the New Album pane to add them to that album, or just click OK and add them after.

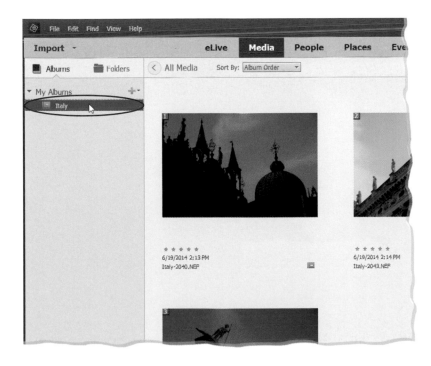

Step Two:
Now that your album has been created, you can either (a) drag the album icon onto the photos you want in your album, or (b) Ctrl-click (Mac: Command-click) on the photos to select them and then drag-and-drop them onto your album icon under My Albums. Either way, the photos will be added to your album. To see just those photos, click on your album name. Now, to put the photos in the order you want, set the Sort By pop-up menu at the top to **Album Order**, then just click on any photo and drag it into position. The Organizer automatically numbers the photos for you in each thumbnail's top-left corner, so it's easy to see what's going on as you click-and-drag. To return to all of your images, click on the All Media button in the top-left corner of the Media Browser.

Choosing Your Own Icons for Keyword Tags

By default, a keyword tag uses the first photo you add to that tag as its icon. Most of the time, these icons are so small that you probably can't tell what the icon represents. That's why you'll probably want to choose your own photo icons instead.

Step One:

It's easier to choose an icon once you've created a keyword tag and tagged a few photos. Once you've done that, Right-click on your tag, and choose **Edit** from the pop-up menu. This brings up the Edit Keyword Tag dialog. In this dialog, click on the Edit Icon button to launch the dialog you see here on the right.

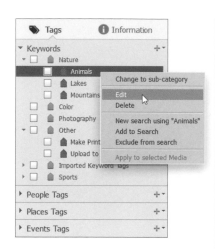
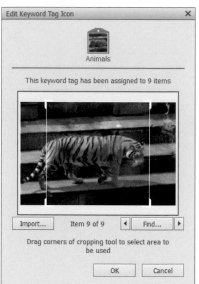

Step Two:

You'll see the first photo you tagged with this keyword in the preview window (this is why it's best to edit the icon after you've added tags to the photos). If you don't want to use this first photo, click the arrow buttons under the bottom-right corner of the preview window to scroll through your photos. Once you find the photo you want to use, click on the little cropping border (in the preview window) to isolate part of the photo. This gives you a better close-up photo that's easier to see as an icon. Then click OK in the open dialogs and that cropped image becomes your icon.

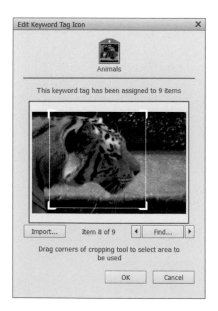

There will be plenty of times when you create a keyword tag or an album and later decide you don't want it anymore. Here's how to get rid of them:

Deleting Keyword Tags or Albums

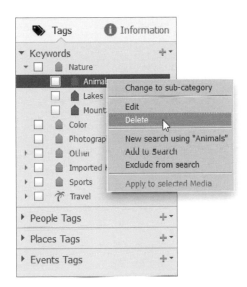

Step One:
To delete a keyword tag or album, Right-click on the keyword tag or album you want to delete in the Tags palette on the right side of the Organizer or under My Albums in the Albums palette on the left, and choose Delete from the pop-up menu.

Step Two:
If you're deleting a tag, it brings up a warning dialog letting you know that deleting the tag will remove it from all your photos and Saved Searches. If you want to remove that tag, click OK. If you're deleting an album, it asks if you're sure you want to delete the album. Click OK and it's gone. However, it does not delete these photos from your main catalog—it just deletes that album.

Seeing Your Photo's Metadata (EXIF Info)

When you take a photo with a digital camera, a host of information about that photo is embedded into the photo by the camera itself. It contains just about everything, including the make and model of the camera that took the photo, the exact time the photo was taken, what the f-stop setting was, what the focal length of the lens was, and whether or not the flash fired when you took the shot. You can view all this info (called Exchangeable Image File [EXIF] data—also known as metadata) from right within the Organizer. Here's how:

Step One:
To view a photo's EXIF data, click on the image in the Media Browser and then click on Information in the top right of the Organizer (if you don't see it, click on the Keyword/Info icon on the right side of the taskbar at the bottom of the window) to open the palette.

TIP: Information Palette Shortcut
You can also just press **Alt-Enter (Mac: Option-Return)** to open and close the palette.

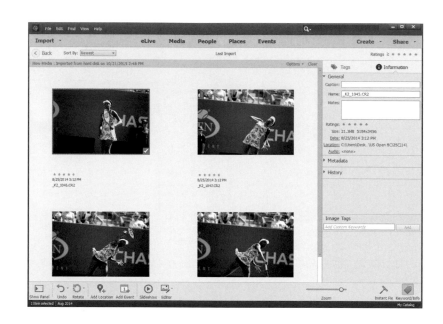

Step Two:
When the Information palette appears, you'll see a General section, a Metadata section, and a History section. Click on Metadata to expand the section. This shows an abbreviated version of the photo's EXIF data (basically, the make, model, ISO, exposure, shutter speed, f-stop, aperture, focal length of the lens, and the status of the flash). Of course, the camera embeds much more info than this. To see the full EXIF data, click on the Complete button (the right of the two buttons) to the right of the word "Metadata," and you'll get more information on this file than you'd probably ever want to know.

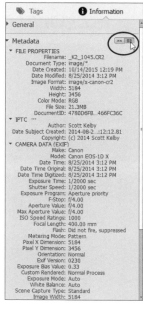

As soon as you press the shutter button, your digital camera automatically embeds information into your photos. But you can also add your own info if you want. This includes simple things like a photo caption (that can appear onscreen when you display your photos in a slide show), or notes for your personal use, either of which can be used to help you search for photos later, or you can add copyright and contact info.

Adding Your Own Info to Photos

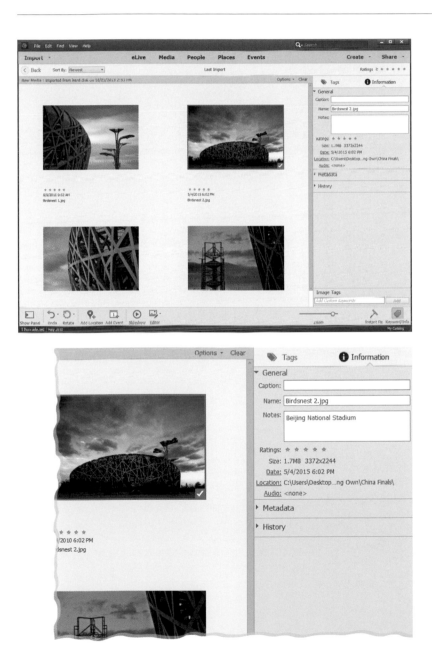

Step One:
First, click on the photo in the Media Browser that you want to add your own info to, and then click on Information in the top right of the Organizer (or you can use the keyboard shortcut **Alt-Enter [Mac: Option-Return]**).

Step Two:
In the Information palette, you'll see General, Metadata, and History sections. By default, the General section is selected. In this section, the first field is for adding a caption (I know, that's pretty self-explanatory), and then the photo's filename appears below that. It's the third field down—Notes—where you add your own personal notes about the photo.

(Continued)

Step Three:

To add your copyright and contact info to your photos, you'll have to select multiple photos, so Ctrl-click (Mac: Command-click) on the photos you want to add this info to, and then click on Information on the right. In the palette, you'll see the number of photos you've selected, as well as an Edit IPTC Information button. Click that button.

Step Four:

This brings up the Edit IPTC Information dialog (shown here). You'll see several IPTC metadata categories on the left-hand side. In the fields below each category, simply type in the information that you'd like to add to your photos (in the example shown here, I just added my basic copyright info in the IPTC Status section). Click Save, and that info will be added to all your selected photos.

TIP: Remove Metadata

There's a Remove IPTC Metadata button at the bottom left of the dialog that lets you delete your metadata. This can be useful if you don't want those metadata-creepers looking at your camera settings like aperture, shutter speed, or even the make/model of your camera.

Aside from actually doing things to fix your photos, finding them will be the most common task you do in Elements. If you've tagged them, then it's easy to find groups of photos. But finding just one photo can be a little harder (not really too hard, though). You first have to narrow the number of photos to a small group. Then you'll look through that group until you find the one you want. I know, it sounds complicated but it's really not. Here are the most popular searching methods:

Finding Photos

From the Timeline:

We saw this one earlier. The Timeline (from the View menu, choose **Timeline** to see it), which is a horizontal bar across the top of the Media Browser, shows you all the photos in your catalog. Months and years are represented along the Timeline. The years are visible below the Timeline; the small bars above the Timeline are individual months. If there is no bar visible, there are no photos stored in that month. A short bar means just a few photos were taken that month; a tall bar means lots of photos. If you hover your cursor over a bar, the month it represents will appear. To see the photos taken in that month, click on the bar and only those photos will be displayed in the Media Browser. Once you've clicked on a month, you can click-and-drag the locator bar to the right or left to display different months.

Using Keyword Tags:

If there's a particular shot you're looking for, and you've tagged all your shots with a particular tag, then just go to the Tags palette and click in the box to the left of that tag. Now only shots with that tag will appear in the Media Browser.

(Continued)

By Details (Metadata):

If you want to do a search with more options to really narrow down the re-sults, then go under the Organizer's Find menu and choose **By Details (Metadata)**. In the resulting dialog, you pick your search criteria from pop-up menus, and you can add as many different lines of criteria as you'd like by clicking on the + (plus sign) button on the far-right side of each criteria line. Here, I searched for the keyword Barcelona, but added more criteria, so it only searches for my 5-star images taken with my Canon 5D. You can also save this search by turning on the Save this Search Criteria as Saved Search check-box at the bottom and giving the search a name. To use a saved search again, simply click on the magnifying glass icon in the search field at the top right of the Organizer, and choose **Saved Searches**.

By Caption or Note:

If you've added personal notes within tags or you've added captions to indi-vidual photos, you can search those fields to help you narrow your search. Just go under the Organizer's Find menu and choose **By Caption or Note**. Then, in the resulting dialog, enter the word(s) that you think may appear in the photo's caption or note, and click OK. Only pho-tos that have that word in a caption or note will appear in the Media Browser.

Find by Details (Metadata)

Search for all files that match the criteria entered below and save them as Saved Search. Saved Searches are albums that automatically collect files that match the criteria defined below. Use the Add button to enter additional criteria, and the Minus button to remove criteria.

Search Criteria

Search for files which match: ⦿ Any one of the following search criteria[OR]
◯ All of the following search criteria[AND]

Keyword Tags ▾ Include Barcelona ▾ -
Rating ▾ Is ▾ 5 ▾ stars -
Camera Model ▾ Contains ▾ Canon 5D - +

The model name or number of the camera used to take the photo

☐ Save this Search Criteria as Saved Search
Name:

Search Cancel

Find by Caption or Note

Find items with caption or note:
Market in Barcelona

⦿ Match only the beginning of words in Captions and Notes.
◯ Match any part of any word in Captions and Notes.

OK Cancel

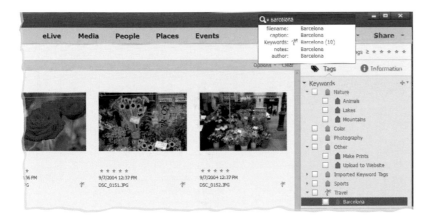

By History:

The Organizer keeps track of when you imported each photo and when you last shared it (via email, print, webpage, etc.); so if you can remember any of those dates, you're in luck. Just go under the Organizer's Find menu, under By History, and choose which attribute you want to search under in the submenu. (*Note:* Some of the options shown here are currently not available in the Elements 14 version for the Mac.) A dialog with a list of names or locations and dates will appear. Click on a date or name, click OK, and only photos that fit that criterion will appear in the Media Browser.

By Textual Information:

Elements has a Search field that basically lets you search all text information in a photo—not just keyword tags, but all of the metadata and stuff that gets stored with your photos. In fact, it's probably one of the most powerful and easiest ways to search, since you don't have to worry as much about what you're looking for and where to look for it. Just go to the Search field in the top right of the Organizer window and type in your search terms. Here, I entered Barcelona and it found all of the photos taken with that keyword.

Finding Duplicate Photos

If you're like most photographers out there, when you take a photo of someone (or something), you don't just take one. You take 18 or more. It's totally normal. We figure the more photos we take, the better chance we have that at least one photo will be exactly what we want. The problem comes when we're trying to organize our photos. We tend to build up huge libraries of photos that include a bunch of duplicates. I'm not talking exact filename duplicates (as if we imported the same photo twice), but duplicates in that one photo looks just like another. Well, Elements can help you find them.

Step One:

Let's say you took some vacation photos, and you wanted to quickly sort through them to find the best ones. Chances are you probably shot a bunch of each place you visited to make sure you had at least one good one of each. You only really need one keeper, right? In the Organizer, select the group of photos you want to search through (you can press **Ctrl-A [Mac: Command-A]** to Select All, click on an album, or just Ctrl-click [Mac: Command-click] on as many images as you want to sort through). Then, go under the Find menu, under By Visual Searches, and choose **Duplicate Photos**. Depending on how many photos you're looking through, it can take anywhere from a few seconds for 50 photos to a few minutes for a few thousand.

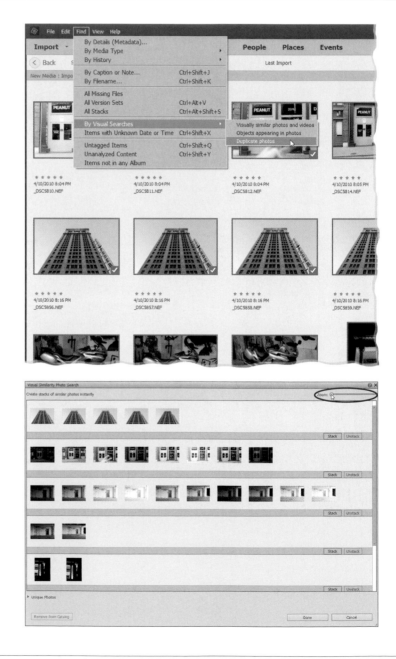

Step Two:

When Elements is done, you'll see the Visually Similar Photo Search dialog open. Elements will put each series of photos that it finds similar into suggested groups. For me, it was kinda hard to really see what was in each group, because the thumbnails are so small. Since we're going to actually do things with the photos in these series, you may want to increase the size of the thumbnails of the photos using the slider at the top right (circled here).

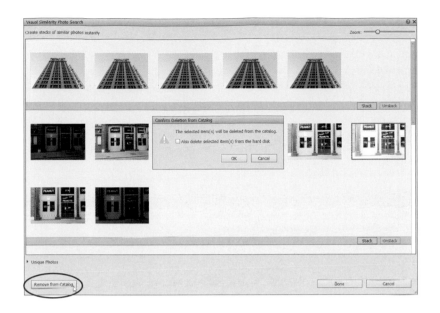

Step Three:

At this point, you've got two choices for what you can do with these suggested duplicate photos: First, you can look through the photos to find the best one from the series (which is why increasing the thumbnail size is important here), and then delete the rest, since you'll probably never use them. To do that, simply click on one of the photos (or Ctrl-click to select multiple ones) and click the Remove From Catalog button at the bottom left of the dialog (circled here). If you do that, Elements will give you the option to simply remove the photos from the catalog or remove them from the hard disk, as well. I also remove them from the hard disk altogether, since I don't need them anymore.

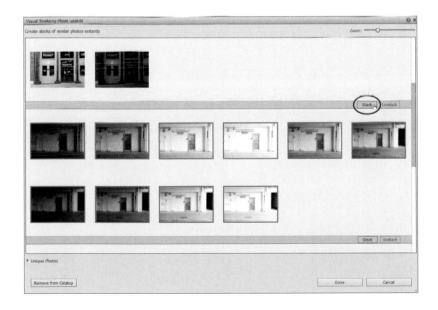

Step Four:

Your other option is to group the series of photos together in a stack. That way, when you're looking at them in the Organizer, you'll have fewer photos to look through since the entire series will be stacked. To stack the photos together, just click the Stack button above the right side of each group. Or, if you only want to stack certain photos from the group together, then select them first, and click the Stack button. When you're done stacking (or removing the photos from the catalog), just click the Done button in the lower-right corner to return to the Organizer.

Creating a Slide Show

If you've ever wanted a quick and easy way to show your photos off on your computer or laptop, then slide shows are one of the best. Add some music, a couple of transitions, and you've got a really nice way to let people sit back and enjoy your work.

Step One:
In the Organizer, Ctrl-click (Mac: Command-click) on the photos you want to display in a slide show, then click on Create in the top right of the window, and choose **Slideshow**.

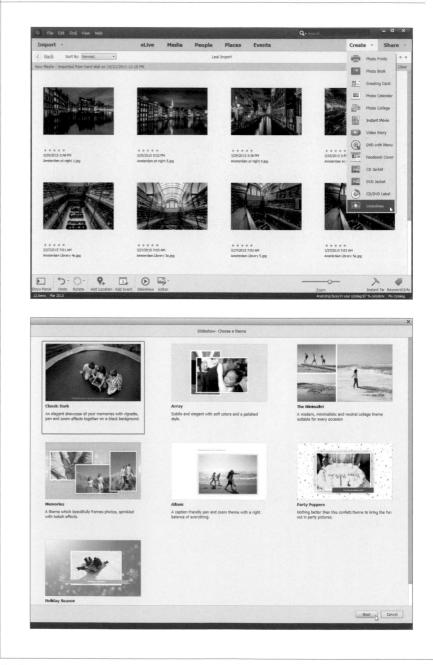

Step Two:
Your first choice is the overall theme you want for the slide show. My personal favorite is the first one: Classic Dark. But, there are a few others you can choose from, too. Once you make your choice, click Next.

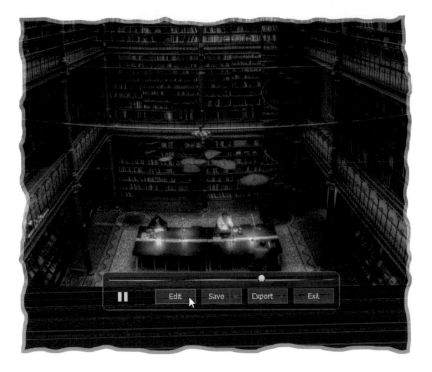

Step Three:
The next window actually launches you right into the slide show. If everything is good and you like the music (I doubt you will), then you could always be done with it and click Save or Export in the options at the bottom. But, if you want to customize it a little, then click Edit, instead.

Step Four:
This puts the slide show in edit mode, and you'll see some icons at the bottom of the window that let you change some of your options: Themes will let you choose another slide show theme (like we did in Step Two), if you'd like to change yours. Audio is probably one of the most important. Slide shows need music, big time! When you click the Audio button, you'll have some options for music that Elements includes, but you can also click Browse to choose your own music file on your computer. There's also a Speed pop-up to the right that lets you sync your slide show to the music, and you can even choose the pace (Normal or Brisk).

(Continued)

Step Five:

If you've added captions to your photos, then you can turn the Captions button on or off by just clicking on it. And, you can also add text-only slides, if you want to put your name on a slide at the beginning or end of the slide show (here, I added my name to the beginning).

Step Six:

Finally, you'll want to save the slide show, so you can get back to it again. And, if you want to preview it, just click the Preview button. From there, you can even export the slide show to Facebook or just save it as a file on your hard drive that you could send to someone else to view. Just click on Export in the top right.

I love stacks, because as much as I try to compare my photos and get rid of the ones that I have duplicates of, I inevitably wind up with several photos that look the same. Well, there's a feature called stacking and it works just like its real-world counterpart does—it stacks several photos on top of each other and you'll just see the top one. So if you have 20 shots of the same scene, you don't have to have all 20 cluttering up your Media Browser. Instead, you can have just one that represents all of them with the other 19 underneath it.

Reducing Clutter by Stacking Your Photos

Step One:
With the Organizer open, press-and-hold the Ctrl (Mac: Command) key on your keyboard and click on all the photos you want to add to your stack (or if the images are contiguous, simply click on the first image in the series, press-and-hold the Shift key, and click on the last image in the series). Once they're all selected, go under the Organizer's Edit menu, under Stack, and choose **Stack Selected Photos** in the submenu.

Step Two:
No dialog appears, it just happens—your other photos now are stacked behind the first photo you selected (think of it as multiple layers, and on each layer is a photo, stacked one on top of another). You'll know a photo thumbnail contains a stack because a Stack icon (which looks like a little stack of paper) will appear in the upper-right corner of your photo. You'll also see a right-facing arrow to the right of the image thumbnail.

(Continued)

Step Three:

Once your photos are stacked, you can view these photos at any time by clicking on the photo with the Stack icon, and then going under the Edit menu, under Stack, and choosing **Expand Photos in Stack**, or just clicking on the right-facing arrow to the right of the image thumbnail. This is like doing a Find, where all the photos in your stack will appear in the Media Browser within a gray shaded area so you can see them without unstacking them. Then, to collapse the stack, just click on the left-facing arrow that appears to the right of the last image thumbnail in the stack.

Step Four:

If you do want to unstack the photos, select the photo with the Stack icon in the Media Browser, then go under the Edit menu, under Stack, and choose **Unstack Photos**. If you decide you don't want to keep any of the photos in your stack, select the photo with the Stack icon in the Media Browser, go back under the Edit menu, under Stack, and choose **Flatten Stack**. It's like flattening your layers—all that's left is that first photo. However, when you choose to flatten, you will have the choice of deleting the photos from your hard disk or not.

Places in the Organizer is a way to view your photos based on where they were taken. It works great if you use your cell phone to take a lot of photos (which many people do nowadays), because your phone typically embeds location info right into the photo. But it doesn't stop there. If you have a photo that doesn't have the location info in it, it's really simple to add it after the fact, so you can see all your photos on a map.

Places: Viewing Your Photos on a Map

Step One:
In the Organizer, click on Places at the top of the window to switch to the Map view of your photos. In this example, I already have photos with location info in them, so if I click on Pinned at the top of the window, Elements shows where they were taken on the map.

Step Two:
As you look at the map, you'll see exactly how many photos were taken in each location. If you double-click on one of the locations on the map, Elements will automatically show those photos in the Media Browser.

(Continued)

Step Three:

This is a really good way to create an album based on places you've visited, because Elements does a lot of the work for you. Just click on a location on the map and all of the photos will appear. Then, click on the Create New Album button (the green plus sign) at the top left of the window (if you don't see My Albums, click on the Show Panel icon at the bottom left of the window), choose **New Album**, give it a descriptive name, and you're ready to go.

Step Four:

But what happens if you have photos without location or GPS info in them? Just click on Unpinned at the top of the window. That opens the panel on the left, where you'll see all your photos with no GPS info associated with them.

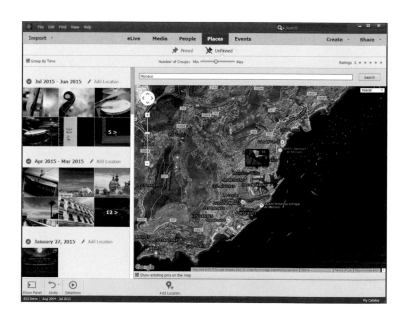

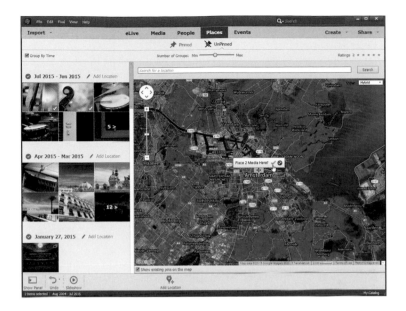

Step Five:

To associate a photo with a place, you can do one of two things: First, you could just drag-and-drop the photo from the panel onto the map to add it to a location (or Ctrl-click [Mac: Command-click] on several photos to select them, then drag-and-drop all of them onto the map at once). When it appears on the map, just click the little green checkmark to confirm that that is indeed where you want it to go.

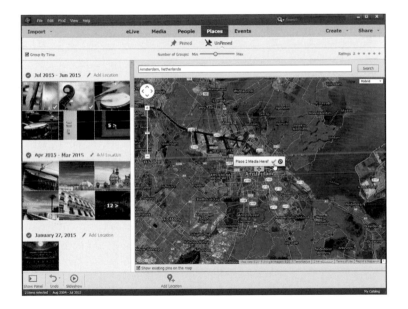

Step Six:

If you can't find the exact location on the map, then try searching for it. Select the photos you're going to add to that location, then type in the location in the Search for a Location field above the map, and click the Search button. Depending on how specific you are in your location, you may get one or more suggestions that pop down from the search field. If so, just click on the correct one, and the location will show up on the map, with Elements asking if you want to place those photos in that location. Just click that little green checkmark to associate your selected photos with that location. You gotta love this stuff, huh?

TIP: Locations Stay with Your Images

What's really cool is that if you have GPS info associated with your photos, any time you share them on places like Flickr (or any other photo sharing service that supports GPS info), your locations will automatically travel along with your images, so you won't have to add the locations again on each site.

Quickly Email Your Photos

You've probably done the same thing I have whenever you want to email photos to someone. First, you resize the photo, since you don't want to email a full-resolution file. Then, you save the photo as a JPEG, launch your email program, and attach the photo to the email. But, if you're using the Elements Organizer, there's actually a better and faster way to do it.

Step One:
Before you do anything, you have to set up Elements to work with your email. So, first go under the Edit (Mac: Elements) menu, under Preferences, and choose **Email**. In the Email preferences, click on the New button, give this email profile a descriptive name, and then choose whichever email provider you use from the Service Provider pop-up menu. Click OK.

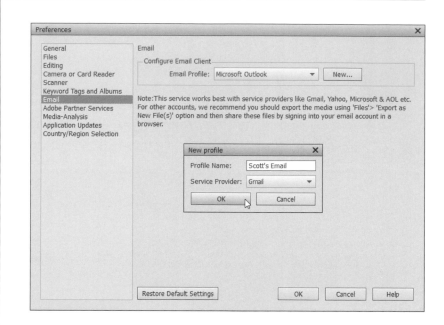

Step Two:
From there, add your email address, your name, and the password for that email account, and then click the Validate button to confirm that Elements will work with your email account. When you're done, you can click OK at the bottom right to close the Preferences dialog.

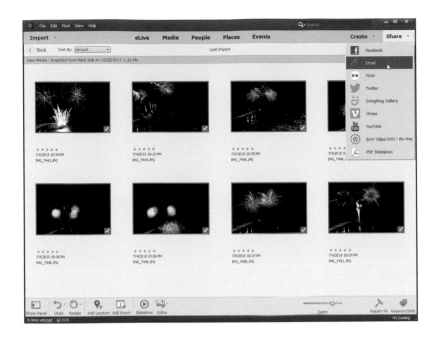

Step Three:
Now, just select the photos in the Organizer that you want to email, then click on Share (in the top right of the window), and choose **Email**.

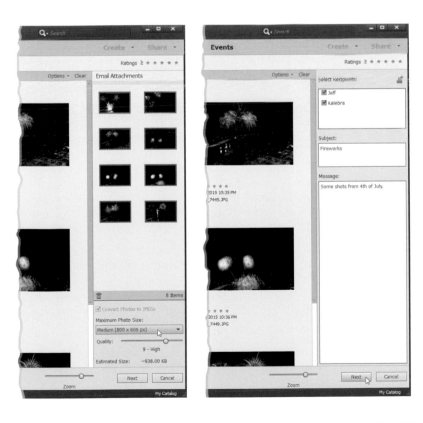

Step Four:
In the Email Attachments palette, choose a preset for the size you want the photos resized to (I usually go with Medium). Click Next, select the recipients (click on the little icon to the right to add them), and then enter a subject line and any message you want included. Finally, click Next and your photos will automatically be resized (not the originals, though) and emailed off to your friends and family.

RAW JUSTICE
processing your images using camera raw

When I searched The Internet Movie Database (IMDb) for movies or TV shows containing the word "Raw," I was pleasantly surprised to find out just how many choices I actually had. However, I went with the 1994 movie *Raw Justice*, but I don't want you to think for one minute that I was influenced in any way by the fact that the star of the movie was Pamela Anderson. That would be incredibly shallow of me. Like any serious movie buff, I was drawn to this movie by what drew most of the audience to this movie: actor Robert Hays (who could forget his role in 2007's *Nicky's Birthday Camera* or the Michael Tuchner–directed film *Trenchcoat*?). Of course, the fact that Stacy Keach was in the movie was just the icing on the cake, but everybody knows the real draw of this flick clearly was Hays. However, what I found most puzzling was this: in the movie poster, Pamela Anderson totally dominates the poster with a large, full-color, ¾-length pose of her wearing a skimpy black dress, thigh-high boots, and holding a pistol at her side, but yet the other actors appear only as tiny black-and-white, backscreened head-shots. I have to admit, this really puzzles me, because while Pamela Anderson is a fine actress—one of the best, in fact—I feel, on some level, they were trying to fool you into watching a movie thinking it was about Pamela Anderson's acting, when in fact it was really about the act-ing eye candy that is Hays. This is called "bait and switch" (though you probably are more familiar with the terms "tuck and roll" or perhaps "Bartles & Jaymes"). Anyway, I think, while "Raw Justice" makes a great title for a chap-ter on processing your images in Camera Raw, there is no real justice in that this finely crafted classic of modern cinematography wound up going straight to DVD.

45

Opening Your Photos into Camera Raw

Although Adobe Camera Raw was created to process photos taken in your camera's RAW format, it's not just for RAW photos, because you can process your JPEG, TIFF, and PSD photos in Camera Raw, as well. So even though your JPEG, TIFF, and PSD photos won't have all of the advantages of RAW photos, at least you'll have all of the intuitive controls Camera Raw brings to the table.

Step One:

We'll start with the simplest thing first: opening a RAW photo from the Organizer. If you click on a RAW photo to select it in the Organizer, then click on the down-facing arrow to the right of the Editor icon (on the taskbar at the bottom of the window) and choose **Photo Editor** from the pop-up menu, it automatically takes the photo over to the Elements Editor and opens it in Camera Raw.

Step Two:

To open more than one RAW photo at a time, go to the Organizer, Ctrl-click (Mac: Command-click) on all the photos you want to open, then choose an option from the Editor icon's pop-up menu (as shown here, or just press **Ctrl-I [Mac: Command-I]**). It follows the same scheme—it takes them over to the Editor and opens them in Camera Raw. On the left side of the Camera Raw dialog, you can see a filmstrip with all of the photos you selected.

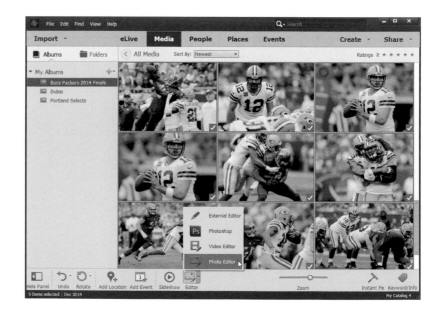

Step Three:

Okay, so opening RAW photos is pretty much a no-brainer, but what if you want to open a JPEG, TIFF, or PSD in Camera Raw? Go under the Editor's File menu and choose **Open in Camera Raw**. In the Open dialog, navigate to the photo you want to open, click on it, and click Open.

Step Four:

When you click the Open button, that JPEG, TIFF, or PSD is opened in the Camera Raw interface, as shown here (notice how JPEG appears up in the title bar, just to the right of Camera Raw 9.2?). *Note:* When you make adjustments to a JPEG, TIFF, or PSD in Camera Raw and you click either the Open Image button (to open the adjusted photo in Elements) or the Done button (to save the edits you made in Camera Raw), unlike when editing RAW photos, you are now actually affecting the pixels of the original photo. Of course, there is a Cancel button in Camera Raw and even if you open the photo in Elements, if you don't save your changes, the original photo remains untouched. Also, if you have a layered PSD file open in Camera Raw and you click the Open Image button, Elements will flatten your layers as it opens the photo.

Miss the JPEG Look? Try Applying a Camera Profile

If you've ever looked at a JPEG photo on the LCD screen on the back of your digital camera, and then wondered why your RAW image doesn't look as good, it's because your camera adds color correction, sharpening, contrast, etc., to your JPEG images while they're still in the camera. But when you choose to shoot in RAW, you're telling the camera, "Don't do all that processing—just leave it raw and untouched, and I'll process it myself." But, if you'd like that JPEG-processed look as a starting place for your RAW photo editing, you can use Camera Raw's Camera Profile feature to get you close.

Step One:
As I mentioned above, when you shoot in RAW, you're telling the camera to pretty much leave the photo alone, and you'll do all the processing yourself using Camera Raw. Each camera has its own brand of RAW, so Adobe Camera Raw applies a Camera Profile based on the camera that took the shot (it reads the embedded EXIF data, so it knows which camera you used). Anyway, if you click on the Camera Calibration icon (the icon on the right above the right-side Panel area), you'll see the built-in default Camera Profile (Adobe Standard) used to interpret your RAW photo.

Step Two:
If you click-and-hold on the Name pop-up menu at the top of the panel, a menu pops up with a list of profiles for the camera you took the shot with (as seen here, for images taken with a Canon digital camera). Adobe recommends that you start by choosing **Camera Standard** (as shown here) to see how that looks to you.

Step Three:
Depending on the individual photo you're editing, Camera Standard might not be the right choice, but as the photographer, this is a call you have to make (in other words, it's up to you to choose which one looks best to you). I usually wind up using either Camera Standard or Camera Landscape for images taken with a Canon camera, because I think Landscape looks the most like the JPEGs I see on the back of my camera. But again, if you're not shooting Canon, Landscape may not be one of the available choices (Nikons have eight picture styles and Canons have five). If you don't shoot Canon or Nikon, then you'll only have Adobe Standard, and possibly Camera Standard or one other, to choose from, but you can create your own custom profiles using Adobe's free DNG Profile Editor utility, available from Adobe at http://kel.by/1trwAbm.

Before: Using the default Adobe Standard profile

Step Four:
Here's a before/after with only one thing done to this photo: I chose Camera Landscape (as shown in the pop-up menu in Step Three). Again, this is designed to replicate color looks you could have chosen in the camera, so if you want to have Camera Raw give you a similar look as a starting point, this is how it's done. Also, since Camera Raw allows you to open more than one image at a time (in fact, you can open hundreds at a time), you could open a few hundred images, then click the Select All button that will appear at the top-left corner of the window, change the camera profile for the first-selected image, and then all the other images will have that same profile automatically applied. Now, you can just click the Done button.

After: Using the Camera Landscape profile

The Essential Adjustments: White Balance

If you've ever taken a photo indoors, chances are the photo came out with kind of a yellowish tint. Unless, of course, you took the shot in an office, and then it probably had a green tint. Even if you just took a shot of somebody in a shadow, the whole photo probably looked like it had a blue tint. Those are white balance problems. If you've properly set your white balance in the camera, you won't see these distracting tints (the photos will just look normal), but most people shoot with their cameras set to Auto White Balance, and well…don't worry, we can fix it really easily in Camera Raw.

Step One:
On the right side of the Camera Raw window, there's a section for adjusting the white balance. Think of this as "the place we go to get rid of yellow, blue, red, or green tints that appear on photos." There are three ways to correct this, and we'll start with choosing a new white balance from the White Balance pop-up menu. By default, Camera Raw displays your photo using your camera's white balance setting, called As Shot. Here, I had been shooting indoors under regular lighting, so my white balance had been set to Tungsten, but then I went into a room with natural light and didn't change my white balance, so the first few shots came out with a bluish tint (as seen here—yeech!).

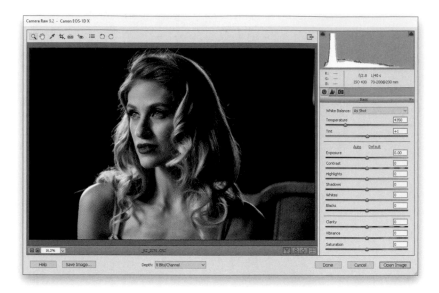

Step Two:
To change the white balance, click on the White Balance pop-up menu and choose a preset. Just choose the preset that most closely matches what the lighting situation was when you originally took the photo. Here, I tried each preset and Daylight seemed to look best—it removed the bluish tint. *Note:* You will only get this complete list of white balance presets (Cloudy, Shade, etc.) when working with RAW images. If you open a JPEG, TIFF, or PSD in Camera Raw, your only preset choice (besides As Shot and creating a custom white balance) is Auto.

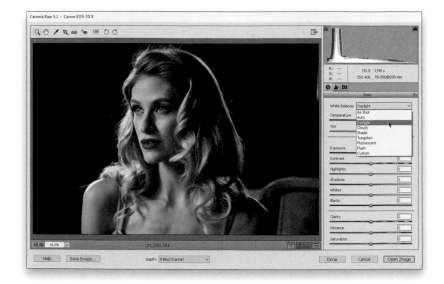

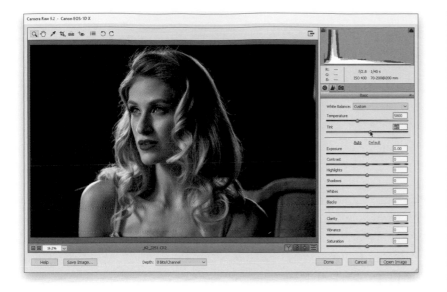

Step Three:

Although the Daylight setting is the best of the built-in presets here, if you don't think it's right on the money, then you can simply use it as a starting point (hey, at least it gets you in the ballpark, right?). So, I would choose Daylight first, and if I thought this still made her a bit too blue, I would then drag the Temperature slider to the right (toward the yellow side of the slider) to warm the photo up just a little bit more. In this example, the Daylight preset was close, but she was still a little too blue, so I dragged the Temperature slider a little bit toward yellow. She also looked a little red, so I moved the Tint slider a tiny bit toward green (as shown here).

Step Four:

The second method of setting your white balance is to use just the Temperature and Tint sliders (although most of the time you'll only use the Temperature slider, as most of your problems will be too much [or too little] yellow or blue). The sliders themselves give you a clue on which way to drag (on the Temperature slider, blue is on the left and it slowly transitions over to yellow). This makes getting the color you want so much easier—just drag in the direction of the color you want. By the way, when you adjust either of these sliders, your White Balance pop-up menu changes to Custom (as shown).

(Continued)

Step Five:

The third method, using the White Balance tool, is perhaps the most accurate because it takes a white balance reading from the photo itself. You just click on the White Balance tool **(I)** in the toolbar at the top left (it's circled in red here), and then click it on something in your photo that's supposed to be a light gray (that's right—you properly set the white balance by clicking on something that's light gray). So, take the tool and click it once on, in this case, the strap on her dress (as shown here) and it sets the white balance for you. If you don't like how it looks (maybe it's still too blue), then just click on a different light gray area until it looks good to you.

Step Six:

Now, here's the thing: although this can give you a perfectly accurate white balance, it doesn't mean that it will look good (for example, people usually look better with a slightly warm white balance). White balance is a creative decision, and the most important thing is that your photo looks good to you. So don't get caught up in that "I don't like the way the white balance looks, but I know it's accurate" thing that sucks some people in—set your white balance so it looks right to you. You are the bottom line. You're the photographer. It's your photo, so make it look its best. Accurate is not another word for good. Okay, I'm off the soapbox, and it's time for a tip: Want to quickly reset your white balance to the As Shot setting? Just double-click on the White Balance tool up in the toolbar (as shown here).

Step Seven:

One last thing: once you have the White Balance tool, if you Right-click within your photo, a White Balance preset pop-up menu appears under your cursor (as shown here), so you can quickly choose a preset.

Step Eight:

Here's a before/after so you can see what a difference setting a proper white balance makes (by the way, you can see a quick before/after of your white balance edit by pressing **P** on your keyboard to toggle the Preview on/off).

TIP: Using a Gray Card

To help you find that neutral light gray color in your images, we've included an 18% gray card for you in the back of this book (it's perforated so you can tear it out). Just put this card into your scene (or have your subject hold it), take the shot, and when you open the image in Camera Raw, click the White Balance tool on the card to instantly set your white balance.

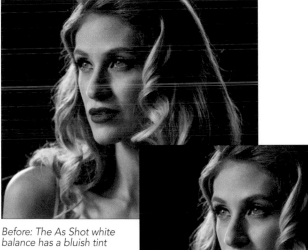

Before: The As Shot white balance has a bluish tint

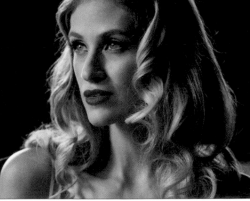

After: With one click of the White Balance tool, everything comes together

The Essential Adjustments: Exposure

The next thing I fix (after adjusting the white balance) is the photo's exposure. Now, some might argue that this is the most essential adjustment of them all, but if your photo looks way too blue, nobody will notice if the photo's underexposed by a third of a stop, so I fix the white balance first, then I worry about exposure. However, exposure in Camera Raw isn't just the Exposure slider. It's actually five sliders: Exposure (midtones), Blacks (deep shadows), Shadows (regular shadows), Highlights (well-named), and Whites (extreme highlights).

Step One:

I recommend (and so does Adobe) starting with the top tonal slider in the Basic panel (Exposure) and working your way down through the other sliders in order, which is a different workflow than in earlier versions of Camera Raw, where it didn't matter too much which slider you moved when. However, in Elements 14, it works best if you start by getting the Exposure (midtones) set first, and then if things look kind of washed out, adding some Contrast (the Contrast slider in Elements 14 is way, way better than the one in older versions, which I generally avoided). This photo, well, it's a mess. Taken in harsh, unflattering light, it needs some serious Camera Raw help.

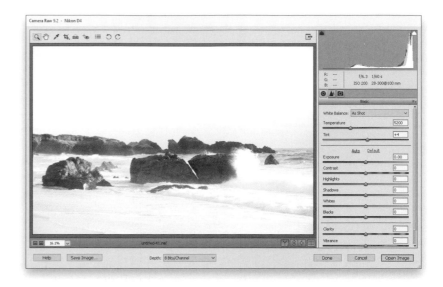

Step Two:

Start by adjusting the Exposure slider. This photo is way overexposed, so drag it to the left to darken the midtones and the overall exposure. Here, I dragged it over to –2.30 (it looks a lot better already), but the image is still kind of flat looking, and that's why your next step should be to adjust the contrast (by the way, although you can drag the Contrast slider to the left to make things less contrasty, I can't remember an occasion where I wanted my image to look more flat, so I don't drag to the left. Ever. But, hey, that's just me).

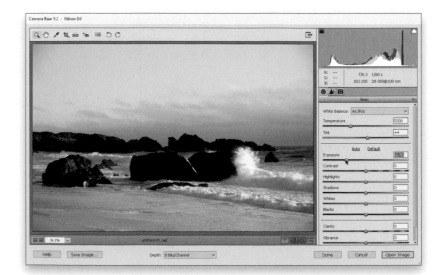

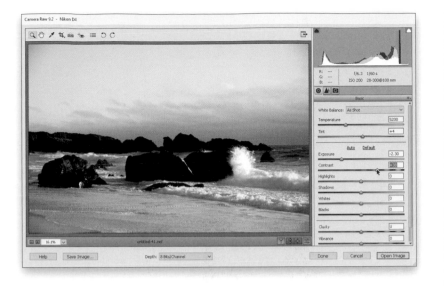

Step Three:

Increase the contrast using the Contrast slider, which makes the bright areas brighter and the dark areas darker (here, I dragged it to the right to +38, which helped deal with the flat, low-contrast look). These two steps—adjusting the Exposure and then the Contrast slider (if necessary)—should be your starting points every time. This top-down approach helps, because the other sliders build off this exposure foundation, and it will keep you from having to constantly keep tweaking slider after slider. So, think of these two as the foundation of your exposure, and the rest are kind of optional based on the image you're working on.

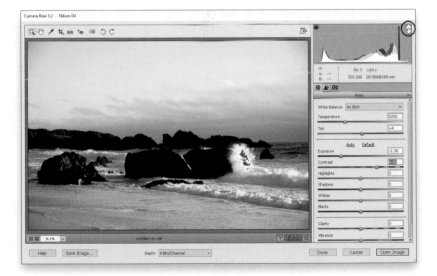

Step Four:

Before we go any further, increasing our contrast to where we wanted it created a highlight clipping problem (part of our photo got so bright that it won't have any detail in that area at all. It's blown out. If all that sounds bad, well, that's 'cause it is). Luckily, Camera Raw gives you a warning if you're clipping, in the upper-right corner of the histogram. See that triangle? That's the highlight clipping warning (although I just call it "the white triangle of death"; the one in the upper-left corner is the shadow clipping warning). Now, if you do see a white triangle, don't freak out. First, go up and click directly on that white triangle and the areas that are clipping will appear in red (look in the wave here). We do this to find out if what's clipping is an area of important detail, or if it's like a tiny highlight on a chrome bumper or something meaningless in the background of your image.

(Continued)

Step Five:

If that red highlight shows over an area you feel has important detail (we can try to get a little back in that wave), go to the Highlights slider and drag it to the left until the red areas disappear (here, I dragged the Highlights slider to the left to –8). So, I look to the Highlights slider to recover clipped highlights first, and then if that doesn't do the trick, I try lowering the Exposure amount, but I rarely have to do that.

TIP: The Color Warning Triangles

If you see a red, yellow, blue, etc., highlight or shadow clipping warning triangle (rather than white), it's not great, but it's not nearly as bad as white. It means you're clipping just that one color channel (and there's still detail in the other channels).

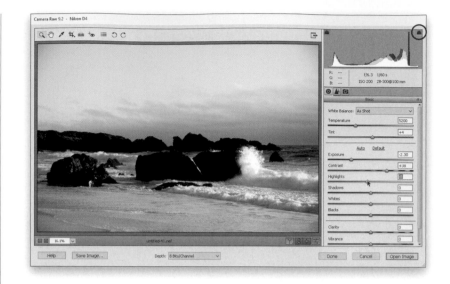

Step Six:

The next slider down, Shadows, is another one you only use if there's a problem (just like the Highlights slider), but in this case, the problem is we can't see much detail in the rocks in the middle. That's when you reach for the Shadows slider—drag it to the right to brighten the shadows (like I did here, where I dragged it over to +25) and look how you can now see the rocks in the middle better. This caused the highlights to clip again, so I dragged the Highlights slider to –18.

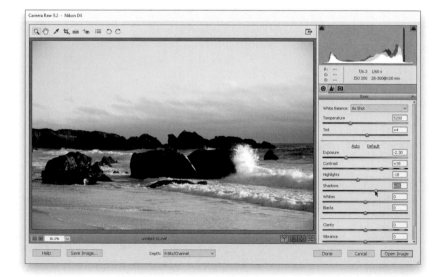

Step Seven:
Before we leave the Shadows slider, we need to switch to another image for just a moment (we'll come back to the other image shortly), because I want to point out that one of the most common times you'll use the Shadows slider is when your subject is backlit like this one, where the sky is pretty well exposed, but the foreground is really dark. When I was standing there, of course, my eye compensated perfectly for the two vastly different exposures, but our cameras still aren't as sophisticated as the human eye, so we get shots that look like this. Start by bumping up the Exposure and then the Contrast, if necessary (the Shadows slider will work much better when you tweak these first).

Step Eight:
Now, drag the Shadows slider way over to the right to open up that canoe and the foreground, so the whole image looks more balanced (here, I dragged over to +58). Now we can jump back to our original image.

(Continued)

Step Nine:

The last two essential exposure sliders are the Whites and Blacks. If you're used to working with Levels in Photoshop, you'll totally get these, because they're like setting your highlight and shadow points (or your white and black points). Most of the time, if I use the Whites slider (which controls the brightest highlights), I find myself dragging it to the right to make sure the whites are nice and bright white (and not light gray), but in this instance, I was using the Whites slider to pull the whites back a bit (to help hide the fact that it was shot in harsh, direct daylight), so I dragged it to the left (to darken the whites) to around –33. I also increased the deepest shadows by dragging the Blacks slider to the left just a little bit (here, I dragged over to –8). I still use this slider if, near the end of the editing process, I think the color needs more oomph, as this helps the colors look saturated and less washed out. Here's a before/after, but I did add two last finishing touches, which were to increase the Clarity a little (more on this coming up on page 62) and I increased the Vibrance amount a bit. Again, I recommend doing all of this in a top-to-bottom order, but just understand that not every image will need an adjustment to the Highlights and Shadows—only mess with those if you have a problem in those areas. Otherwise, skip 'em.

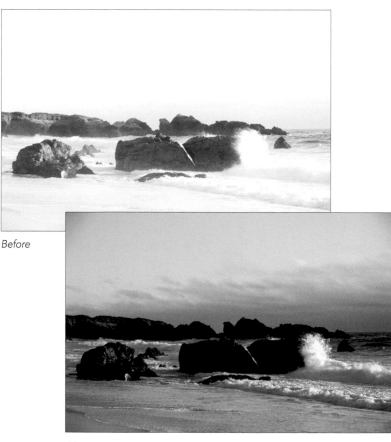

Before

After

If you're not quite comfortable with manually adjusting each image, Camera Raw does come with a one-click Auto function, which takes a stab at correcting the overall exposure of your image (including contrast, shadows, highlights, etc.), and at this point in Camera Raw's evolution, it's really not that bad. If you like the results, you can set up Camera Raw's preferences so every photo, upon opening in Camera Raw, will be auto adjusted using that same feature. You also now have the option to add individual Auto corrections, and we'll take a look at how to do that, too.

Letting Camera Raw Auto Correct Your Photos

Step One:
Once you have an image open in Camera Raw, you can have Camera Raw take a stab at setting the overall exposure (using the controls in the Basic panel) for you by clicking on the Auto button (shown circled in red here). In older versions of Camera Raw, this Auto correction feature was…well…let's just say it was less than stellar, but it has gotten much better since then, and now it does a somewhat decent job (especially if you're stuck and not sure what to do), so click on it and see how it looks. If it doesn't look good, no sweat—just press **Ctrl-Z (Mac: Command-Z)** to Undo.

Step Two:
You can set up Camera Raw so it automatically performs an Auto Tone adjustment each time you open a photo—just click on the Preferences icon up in Camera Raw's toolbar (it's the third icon from the right), and when the dialog appears, turn on the checkbox for Apply Auto Tone Adjustments (shown circled here), then click OK. Now, Camera Raw will evaluate each image and try to correct it. If you don't like its tonal corrections, then you can just click on the Default button, which appears to the right of the Auto button (the Auto button will be grayed out because it has already been applied).

(Continued)

Step Three:

While the Auto button can do a pretty good job at making a proper exposure, sometimes it's absolutely dreadful. Say you have an image that's intentionally kinda dark, like a low-key image or when you shot someone on a black background. When you click on the Auto button, it tries to make it a daylight shot and it's just a disaster. Here, though, it made it a little darker, but it's not too bad.

Step Four:

Now, here's the problem: when you hit Auto, it's applying Auto Shadows, Auto Highlights, Auto everything. But, what Adobe added here in Camera Raw (well, hid here; this one's buried) is the option to add individual Auto corrections, like Auto Temperature and Auto Tint, and a way for you to set the white point and black point automatically. So, it's kinda like an Auto White Balance and an Auto Levels, but they're all separate. For example, you can add a separate Auto correction for Tint and a separate one for Temperature. You don't have to do them both; you can do one or the other. Same thing with Whites and Blacks. I've set this back to the default, here, so we can try this out.

Step Five:

So, let's start with the Whites and Blacks. All you have to do is press-and-hold the Shift key, double-click on the Whites slider knob, and it sets the white point for you. Done. Set. Do the same with the Blacks slider. Boom—it sets the blacks. Look at the difference with just those two; it does a nice job.

Step Six:

If you want Auto White Balance, just go up, press-and-hold the Shift key, and double-click on the Temperature slider knob. If you need to adjust the Tint, do the same there. If it does something you don't like, release the Shift key, double-click on the knob, and it will return to the default. So, you can't ever mess things up. I think this is a very hidden, but very powerful little tool here.

Adding Punch to Your Images with Clarity

This is one of my favorite features in Camera Raw, and whenever I show it in a class, it never fails to get "Ooohhs" and "Ahhhhs." I think it's because it's just one simple slider, yet it does so much to add "snap" to your image. The Clarity slider (which is well-named) basically increases the midtone contrast in a way that gives your photo more punch and impact, without actually sharpening the image. I add lots of Clarity anytime I want to enhance the texture in an image, and it works great on everything from landscapes to cityscapes, from travel photos to portraits of men—anything where emphasizing texture would look good.

Step One:
The Clarity slider is found in the bottom section of the Basic panel in Camera Raw, right above the Vibrance and Saturation sliders. (Although its official name is Clarity, I heard that at one point Adobe engineers considered naming it "Punch" instead, as they felt using it added punch to the image.) To clearly see the effects of Clarity, first zoom in to a 100% view by double-clicking on the Zoom tool up in the toolbar (it looks like a magnifying glass). In the example shown here, I only zoomed to 25% so you could see more of the image.

Step Two:
Using the Clarity control couldn't be easier—drag the slider to the right to increase the amount of punch (midtone contrast) in your image (compare the top and bottom images shown here). Here, I dragged it over to +100, which is something you really couldn't get away with in earlier versions of Camera Raw (you'd get horrible halos around everything), but now you can crank that puppy up and it looks awesome! Any image I edit where I want to emphasize the texture (landscapes, cityscapes, sports photos, etc.) gets between +25 and +50 Clarity, but now you can crank it up even higher in most cases (as seen here).

Step Three:
Of course, there are subjects where you don't want to emphasize texture (like women and children), and in those cases, I don't apply any positive Clarity. However, you can also use the Clarity control in reverse—to soften skin. This is called adding negative Clarity, meaning you can apply less than 0 (zero) to reduce the midtone contrast, which gives you a softening effect. Here's an original image without any negative Clarity applied.

Step Four:
Now drag the Clarity slider to the left (which gives you a negative amount of Clarity), and take a look at how much softer our subject's skin looks. Everything else in the image looks softer too, so it's an overall softening, but in the bonus chapter on retouching (which you can find on the book's companion web-page, mentioned in the book's introduction), you'll learn how to apply softening just to your subject's skin, while leaving the rest of the image sharp.

Making Your Colors More Vibrant

Besides the White Balance control, there's only one other adjustment for color that you want to use to make your colors more vibrant, and that's the Vibrance slider. Rather than making all your colors more saturated (which is what the Saturation slider does), the Vibrance slider is smarter—it affects the least saturated colors the most, it affects the already saturated colors the least, and it does its darndest to avoid flesh tones as much as possible. It's one very savvy slider, and since it came around, I avoid the Saturation slider at all costs.

Step One:

Here's an image where the colors are kind of flat and dull. If I used the Saturation slider, every color in the image would get the same amount of saturation, so I do my best to stay away from it (in fact, the only time I use the Saturation slider anymore is when I'm removing color to create a color tint effect or a black-and-white conversion).

Step Two:

Drag the Vibrance slider to the right, and you'll notice the colors become more vibrant (it's a well-named slider), but without the color becoming cartoonish, which is typical of what the Saturation slider would do. You'll notice in the image here that the color isn't "over the top" but rather subtle, and maybe that's what I like best about it.

There are some distinct advantages to cropping your photo in Camera Raw, rather than in Elements itself, and perhaps the #1 benefit is that you can return to Camera Raw later and return to the uncropped image. (Here's one difference in how Camera Raw handles RAW photos vs. JPEG, TIFF, and PSD photos: this "return to Camera Raw later and return to the uncropped image" holds true even for them, as long as you haven't overwritten the original JPEG, TIFF, or PSD file. To avoid overwriting, when you save the JPEG, TIFF, or PSD, in Elements, change the filename.)

Cropping and Straightening

Step One:

The fourth tool in Camera Raw's toolbar is the Crop tool. By default, it pretty much works like the Crop tool in Elements (you click-and-drag it out around the area you want to keep), but it does offer some features that Elements doesn't—like access to a list of preset cropping ratios. To get them, click-and-hold on the Crop tool and a pop-up menu will appear (as shown here). The Normal setting gives you the standard drag-it-where-you-want-it cropping. However, if you choose one of the cropping presets, then your cropping is constrained to a specific ratio. For example, choose the 2-to-3 ratio, click-and-drag it out, and you'll see that it keeps the same aspect ratio as your original uncropped photo.

Step Two:

Here's the 2-to-3-ratio cropping border dragged out over my image. The area that will be cropped away appears dimmed, and the clear area inside the cropping border is how your final cropped photo will appear. If it's a RAW photo, and you reopen it later and click on the Crop tool, the cropping border will still be visible onscreen, so you can move it, resize it, or remove it altogether by simply pressing the **Esc key** or the **Backspace (Mac: Delete) key** on your keyboard (or by choosing **Clear Crop** from the Crop tool's pop-up menu).

(Continued)

Step Three:

If you want your photo cropped to an aspect ratio that isn't in the pre-sets, like 3 to 5, for example, choose **Custom** from the Crop tool's pop-up menu to bring up the dialog you see here. Just type in your custom size, click OK, and it will now appear in the pop-up menu.

Step Four:

Here, we're going to create a custom crop so our photo winds up having a 3 to 5 aspect ratio, so type in your cus-tom size, click OK, click-and-drag out the cropping border, and the area in-side it will be a 3-to-5 ratio. Click on any other tool in the toolbar or press **Enter (Mac: Return)**, and you'll see the final cropped image. Once you click on the Open Image button in Camera Raw, the image is cropped to your specs and opened in the Editor. If, instead, you click on the Done button, Camera Raw closes and your photo is untouch-ed, but it keeps your cropping border in position for the future.

Step Five:

If you save a cropped JPEG, TIFF, or PSD photo out of Camera Raw (by clicking on the Save Image button on the bottom left of the Camera Raw window), the only option is to save it as a DNG (Digital Negative) file. DNG files open in Camera Raw, so by doing this, you can bring back those cropped areas if you decide to change the crop. Your original JPEG, TIFF, or PSD will also keep the cropping border if you simply click the Done button, or once you open the cropped photo in the Editor, save it from there with a new filename. Just open the original photo in Camera Raw again, and click on the Crop tool to see the border.

Step Six:

If you have a number of similar photos you need to crop the same way, you're going to love this: First, select all the photos you want to crop (either in the Organizer or in the Open dialog), then open them all in Camera Raw. When you open multiple photos, they appear in a vertical filmstrip along the left side of Camera Raw (as shown here). Click on the Select All button (it's above the filmstrip) and then crop the currently selected photo as you'd like. As you apply your cropping, look at the filmstrip and you'll see all the thumbnails update with their new cropping instructions. A tiny Crop icon will also appear in the bottom-left corner of each thumbnail, letting you know that these photos have been cropped in Camera Raw.

(Continued)

Step Seven:

Another form of cropping is actually straightening your photos using the Straighten tool. It's a close cousin of the Crop tool because what it does is essentially rotates your cropping border, so when you open the photo, it's straight. In the Camera Raw toolbar, choose the Straighten tool (it's immediately to the right of the Crop tool, and shown circled here in red). Now, click-and-drag it along the horizon line in your photo (as shown here). When you release the mouse button, a cropping border appears and that border is automatically rotated to the exact amount needed to straighten the photo.

Step Eight:

You won't actually see the rotated photo until you click on another tool (which I've done here) or open it in Elements (which means, if you click Save Image or Done, Camera Raw closes, and the straightening information is saved along with the file. So, if you open this file again in Camera Raw, that straightening crop border will still be in place). If you click Open Image, the photo opens in Elements, but only the area inside the cropping border is visible, and the rest is cropped off. Again, if this is a RAW photo (or you haven't overwritten your JPEG, TIFF, or PSD file), you can always return to Camera Raw and remove this cropping border to get the original uncropped photo back.

TIP: Canceling Your Straightening

If you want to cancel your straightening, just press the **Esc key** on your keyboard, and the straightening border will go away.

One of the coolest things about Camera Raw is the ability to apply changes to one photo, and then have those same changes applied to as many other similar images as you'd like. It's a form of built-in automation, and it can save an incredible amount of time in editing your shoots.

Editing Multiple Photos at Once

Step One:
Start off in the Organizer by selecting a group of RAW photos that were shot in the same, or very similar, lighting conditions (click on one photo, press-and-hold the Ctrl [Mac: Command] key, and click on the other photos), then open these images in Camera Raw.

Step Two:
The selected photos will appear along the left side of the Camera Raw window. First, click on the photo you want to edit (this will be your target photo—the one all the adjustments will be based upon), then click the Select All button at the top left of the window to select all the other images (as shown here).

(Continued)

Step Three:

Go ahead and adjust the photo the way you'd like. You can see the settings I used here, for this photo. You'll notice that the changes you make to the photo you selected first are being applied to all the photos in the Camera Raw filmstrip on the left (you can see their thumbnails update as you're making adjustments).

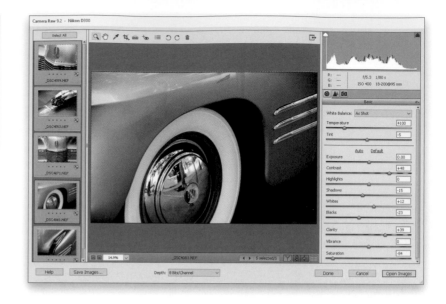

Step Four:

When you're done making adjustments, you have a choice to make: (a) if you click the Open Images button, all of your selected images will open in the Elements Editor (so if you're adjusting 120 images, you might want to give that some thought before clicking the Open Images button), or (b) you can just click the Done button, which applies all your changes to the images without opening them in Elements. So, your changes are applied to all the images, but you won't see those changes until you open the images later (you will, though, see the changes reflected in the Organizer. I usually choose [b] when editing lots of images at once). That's it—how to make changes to one image and have them applied to a bunch of images at the same time.

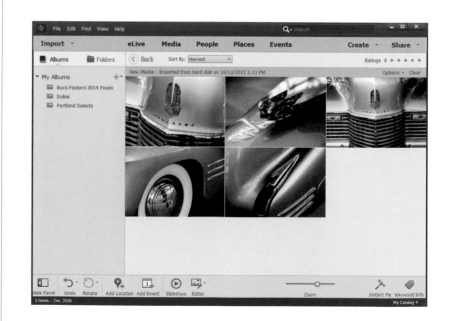

Adobe created DNG (an open archival format for RAW photos) because, at this point in time, each camera manufacturer has its own proprietary RAW file format. If, one day, one or more manufacturers abandon their proprietary format for something new (like Kodak did with their Photo CD format), will we still be able to open our RAW photos? With DNG, it's not proprietary—Adobe made it an open archival format, ensuring that your negatives can be opened in the future, but besides that, DNG brings another couple of advantages, as well.

The Advantages of Adobe's DNG Format for RAW Photos

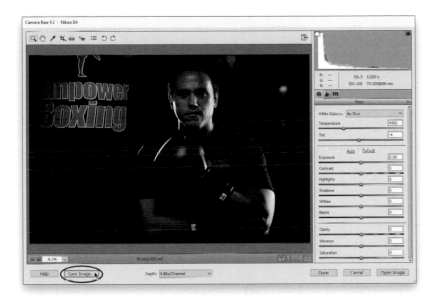

Step One:
There are three advantages to converting your RAW files to Adobe DNG: (1) DNG files are generally about 20% smaller. (2) DNG files don't need an XMP sidecar file to store Camera Raw edits, metadata, and keywords—the info's embedded into the DNG file, so you only have one file to keep track of. And, (3) DNG is an open format, so you'll be able to open them in the future (as I mentioned in the intro above). If you have a RAW image open in Camera Raw, you can save it as an Adobe DNG by clicking the Save Image button (as shown here) to bring up the Save Options dialog (seen in the next step). *Note:* There's really no advantage to saving TIFF, JPEG, or PSD files as DNGs, so I only convert RAW photos.

Step Two:
When the Save Options dialog appears, in the middle of the dialog, you'll see the File Extension pop-up menu is set to DNG (shown here). Below that, under Format: Digital Negative, is a set of options for saving your DNGs.

(Continued)

Step Three:

In the Format section is the Embed Fast Load Data checkbox, which uses a smaller embedded RAW preview that makes switching between images faster (I turn this feature on). Below that is a somewhat controversial option, but if used in the right way, I think it's okay. It uses a JPEG-like lossy compression (meaning there is a loss in quality), but the trade-off (just like in JPEG) is that your file sizes are dramatically smaller (about 25% of the size of a full, uncompressed RAW file). So, if there's a loss of quality, why would you use this? Well, I wouldn't use it for my Picks (the best images from a shoot—ones I might print, or a client might see), but what about the hundreds the client rejected or you don't like? Those might (it's your call) be candidates to be compressed to save drive space. It's something to consider. If you do want to do it, turn on that checkbox, then choose (from its pop-up menu) which option is most important to you: saving the same physical dimensions (pixel size) or file size (megapixels). Once you've made your choices, click Save, and you've got a DNG.

TIP: Setting Your DNG Preferences

With Camera Raw open, press **Ctrl-K (Mac: Command-K)** to bring up Camera Raw's Preferences dialog. There are two preferences in the DNG File Handling section: Choose Ignore Sidecar ".xmp" Files only if you use a different RAW processing application (other than Camera Raw or Lightroom), and you want Camera Raw to ignore any XMP files created by that application. If you turn on the Update Embedded JPEG Previews checkbox (and choose your preferred preview size from the pop-up menu), then any changes you make to the DNG will be applied to the preview, as well.

In Elements, we have pro-level sharpening within Camera Raw. So when do you sharpen here, and when in Elements? I generally sharpen my photos twice—once here in Camera Raw (called "capture sharpening"), and then once in Elements at the very end of my editing process, right before I save the final image for print or for the web (called "output sharpening"). Here's how to do the capture sharpening part in Camera Raw:

Sharpening in Camera Raw

Step One:

When you open a RAW image in Camera Raw, by default it applies a small amount of sharpening to your photo (not the JPEGs, TIFFs, or PSDs—only RAW images). You can adjust this amount (or turn if off altogether, if you like) by clicking on the Detail icon (circled here in red), or using the keyboard shortcut **Ctrl-Alt-2 (Mac: Command-Option-2)**. At the top of this panel is the Sharpening section, where by a quick glance you can see that sharpening has already been applied to your RAW photo. If you don't want any sharpening applied at this stage (it's a personal preference), then simply click-and-drag the Amount slider all the way to the left, to lower the amount of sharpening to 0 (zero), and the sharpening is removed. Note: Before I started, I used the Straighten tool to straighten the image.

Step Two:

If you want to turn off this "automatic-by-default" sharpening (so image sharpening is only applied if you go and manually add it yourself), first set the Sharpening Amount slider to 0 (zero), then go to the Camera Raw flyout menu and choose **Save New Camera Raw Defaults** (as shown here). Now, RAW images taken with that camera will not be automatically sharpened.

(Continued)

Step Three:

Before we charge into sharpening, there's one more thing you'll want to know: if you don't actually want sharpening applied, but you'd still like to see what the sharpened image would look like, you can sharpen just the preview, and not the actual file. Just press **Ctrl-K (Mac: Command-K)** while Camera Raw is open, and in the Camera Raw Preferences dialog, choose **Preview Images Only** from the Apply Sharpening To pop-up menu (as shown here), and then click OK to save this as your default. Now the sharpening only affects the preview you see here in Camera Raw, but when you choose to open the file in Elements, the sharpening is not applied.

Step Four:

This may seem kind of obvious (since it tells you this right at the bottom of the Detail panel, as seen in Step One), but so many people miss this that I feel it's worth repeating: before you do any sharpening, you should view your image at a 100% size view, so you can see the sharpening being applied. A quick way to get to a 100% size view is simply to double-click directly on the Zoom tool (the one that looks like a magnifying glass) up in Camera Raw's toolbar. This zooms you right to 100% (you can double-click on the Hand tool later to return to the normal Fit in Window view).

Step Five:

Now that you're at a 100% view, just for kicks, drag the Amount slider way to the right so you can see the sharpening at work. Again, dipping into the realm of the painfully obvious, dragging the Amount slider to the right increases the amount of sharpening. Compare the image shown here with the one in Step Four (where the Sharpening Amount was set to 0), and you can see how much sharper the image now appears, since I dragged it to 100.

TIP: Switch to Full Screen
To have Camera Raw expand to fill your entire screen, click the Full Screen icon at the top right of the preview area.

Step Six:

The next slider down is the Radius slider, which determines how far out the sharpening is applied from the edges being sharpened in your photo. This works pretty much like the Unsharp Mask filter in the Editor. I leave my Radius set at 1 most of the time. I use a Radius of less than 1 if the photo I'm processing is only going to be used on a website, in video editing, or something where it's going to be at a very small size or resolution. I only use a Radius of more than 1 when the image is visibly blurry and needs some "emergency" sharpening, or if it has lots of detail (like this photo, where I pushed the Radius to 1.2). If you decide to increase the Radius amount above 1 (unlike the Unsharp Mask filter, you can only go as high as 3 here), just be careful, because your photo can start to look fake, oversharpened, or even noisy, so be careful out there.

(Continued)

Step Seven:

The next slider down is the Detail slider, which is kind of the "halo avoidance" slider (halos occur when you oversharpen an image and it looks like there's a little halo, or line, traced around your subject or objects in your image, and they look pretty bad). The default setting of 25 is good, but you'd raise the Detail amount (dragging it to the right) when you have shots with lots of tiny important detail, like in landscapes, cityscapes, or the photo here, where I dragged it to 60. Otherwise, I leave it as is. By the way, if you want to see the effect of the Detail slider, make sure you're at a 100% view, then press-and-hold the Alt (Mac: Option) key, and you'll see your preview window turn gray. As you drag the Detail slider to the right, you'll see the edges start to become more pronounced, because the farther you drag to the right, the less protection from halos you get (those edges are those halos starting to appear).

Step Eight:

I'm going to change photos to show you the Masking slider. This one's easier to understand, and for many people, I think it will become invaluable. Here's why: When you apply sharpening, it gets applied to the entire image evenly. But what if you have an image where there are areas you'd like sharpened, but other softer areas that you'd like left alone (like the photo here, where you want to keep her skin soft, but have her eyes, lips, etc., sharpened)? If we weren't in Camera Raw, you could apply the Unsharp Mask filter to a duplicate layer, add a layer mask, and paint away (cover) those softer areas, right? That's kind of what the Masking slider here in Camera Raw does—as you drag it to the right, it reduces the amount of sharpening on non-edge areas. The default Masking setting of 0 (zero) applies sharpening to the entire image. As you drag to the right, the non-edge areas are masked (protected) from being sharpened.

Step Nine:

All four sliders in the Sharpening section of the Detail panel let you have a live preview of what the sharpening is affecting—just press-and-hold the Alt (Mac: Option) key as you drag; your screen will turn grayscale, and the areas that the slider you're dragging will affect appear as edge areas in the Preview area. This is particularly helpful in understanding the Masking slider, so press-and-hold the Alt key and drag the Masking slider to the right. When Masking is set to 0, the screen turns solid white (because sharpening is being evenly applied to everything). As you drag to the right, in the preview (shown here), the parts that are no longer being sharpened turn black (those areas are masked). Any areas you see in white are the only parts of the photo receiving sharpening (perfect for sharpening women, because it avoids sharpening their skin, but sharpens the things you want sharp, like the eyes, hair, eyebrows, lips, edges of her face, and so on). Below is a before/after of our door shot, with these settings—Amount: 110, Radius: 1, Detail: 60, Masking: 0.

Before

After

Reducing Noise in Noisy Photos

This is, hands down, not only one of the most-requested features by photographers, but one of the best since the last Camera Raw upgrade. Now, if you're thinking, "But Scott, didn't Elements and Camera Raw both have built-in noise reduction before?" Yes, yes they did. And did it stink? Yes, yes it did. But, does the current noise reduction rock? Oh yeah! What makes it so amazing is that it removes the noise without greatly reducing the sharpness, detail, and color saturation. Plus, it applies the noise reduction to the RAW image itself (unlike most noise plug-ins).

Step One:
Open your noisy image in Camera Raw (the Noise Reduction feature works best on RAW images, but you can also use it on JPEGs, TIFFs, or PSDs, as well). The image shown here was shot at a high ISO using a Nikon D800, which didn't do a very good job in this low-light situation, so you can see a lot of color noise (those red, green, and blue spots) and luminance noise (the grainy looking gray spots).

Step Two:
Sometimes it's hard to see the noise until you really zoom in tight, so zoom in to at least 100%, and there it is, lurking in the shadows (that's where noise hangs out the most). Click on the Detail icon (it's the middle icon at the top of the Panel area) to access the Noise Reduction controls. I usually get rid of the color noise first, because that makes it easier to see the luminance noise (which comes next). Here's a good rule of thumb to go by when removing color noise: start with the Color slider over at 0 (as shown here) and then slowly drag it to the right until the moment the color noise is gone. *Note:* A bit of color noise reduction is automatically applied to RAW images—the Color slider is set to 25—but, for JPEGs, TIFFs, or PSDs, the Color slider is set to 0.

Step Three:

So, click-and-drag the Color slider to the right, but remember, you'll still see some noise (that's the luminance noise, which we'll deal with next), so what you're looking for here is just for the red, green, and blue color spots to go away. Chances are that you won't have to drag very far at all—just until that color noise all turns gray. If you have to push the Color slider pretty far to the right, you might start to lose some detail, and in that case, you can drag the Color Detail slider to the right a bit, though honestly, I rarely have to do this for color noise.

Step Four:

Now that the color noise is gone, all that's left is the luminance noise, and you'll want to use a similar process: just drag the Luminance slider to the right, and keep dragging until the visible noise disappears (as seen here). You'll generally have to drag this one farther to the right than you did with the Color slider, but that's normal. There are two things that tend to happen when you have to push this slider really far to the right: you lose sharpness (detail) and contrast. Just increase the Luminance Detail slider if things start to get too soft (but I tend not to drag this one too far), and if things start looking flat, add the missing contrast back in using the Luminance Contrast slider (I don't mind cranking this one up a bit, except when I'm working on a portrait, because the flesh tones start to look icky). You probably won't have to touch either one all that often, but it's nice to know they're there if you need them.

(Continued)

Step Five:

Rather than increasing the Luminance Detail a bunch, I generally bump up the Sharpening Amount at the top of the Detail panel (as shown here), which really helps to bring some of the original sharpness and detail back. Here's the final image, zoomed back out, and you can see the noise has been pretty much eliminated, but even with the default settings (if you're fixing a RAW image), you're usually able to keep a lot of the original sharpness and detail. A zoomed-in before/after of the noise reduction we applied is shown below.

Before

After

Removing Red Eye in Camera Raw

Camera Raw has its own built-in Red Eye Removal tool, and there's a pretty good chance it might actually work. Although, if it were me, I might be more inclined to use the regular Red Eye tool in Elements itself, which actually works fairly well, but if you're charging by the hour, this might be a fun place to start. Here's how to use this tool, which periodically works for some people, somewhere. On occasion. Perhaps.

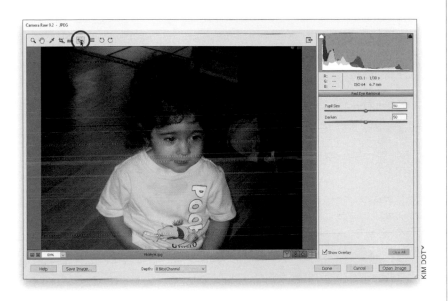

Step One:
Open a photo in Camera Raw that has the dreaded red eye (like the one shown here). To get the Red Eye Removal tool, you can press the letter **E** or just click on its icon up in Camera Raw's toolbar (as shown here).

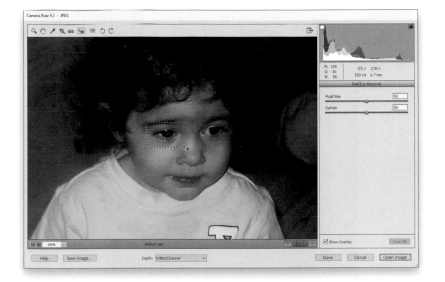

Step Two:
You'll want to zoom in close enough so you can see the red-eye area pretty easily (as I have here, where I just simply zoomed to 100%, using the zoom level pop-up menu in the bottom-left corner of the Camera Raw window). The way this tool works is pretty simple—you click-and-drag the tool around one eye (as shown here) and as you drag, it makes a box around the eye. That tells Camera Raw where the red eye is located.

(Continued)

Step Three:

When you release the mouse button, theoretically it should snap down right around the pupil, making a perfect selection around the area affected by red eye (as seen here). You'll notice the key word here is "theoretically." If it doesn't work for you, then press **Ctrl-Z (Mac: Command-Z)** to undo that attempt, and try again. Before you do, try to help the tool along by increasing the Pupil Size setting (in the Red Eye Removal panel on the right) to around 100 (as I did here).

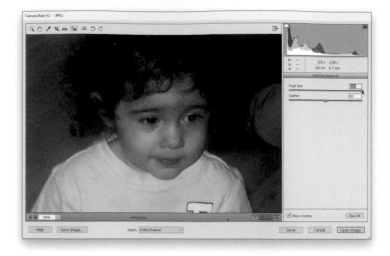

Step Four:

Once that eye looks good, go over to the other eye, drag out that selection again (as shown here), and it does the same thing (the before and after are shown below). One last thing: if the pupil looks too gray after being fixed, then drag the Darken amount to the right. Give it a try on a photo of your own. It's possible it might work.

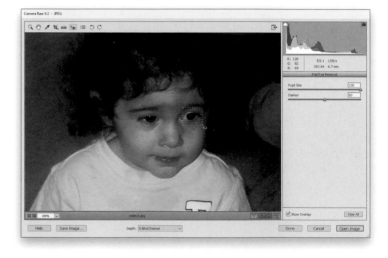

Before

After

As good as today's digital cameras are, there are still some scenes they can't accurately expose for (like backlit situations, for example). Even though the human eye automatically adjusts for these situations, your camera is either going to give you a perfectly exposed sky with a foreground that's too dark, or vice versa. Well, there's a very cool trick (called double processing) that lets you create two versions of the same photo (one exposed for the foreground, one exposed for the sky), and then you combine the two to create an image beyond what your camera can capture!

The Trick for Expanding the Range of Your Photos

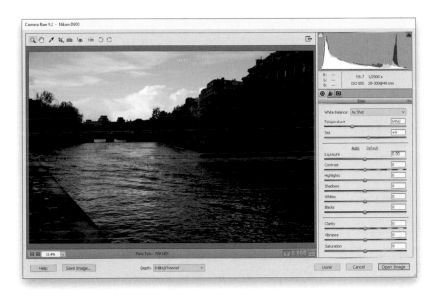

Step One:
Open an image with an exposure problem in Camera Raw. In our example here, the camera properly exposed for the sky in the background, so the buildings and river in the foreground are dark. Of course, or goal is to create something our camera can't—a photo where the buildings, river, and sky are all exposed properly. Plus, by double-processing (editing the same RAW photo twice), we can choose one set of edits for the sky and another for the foreground to create just what we want.

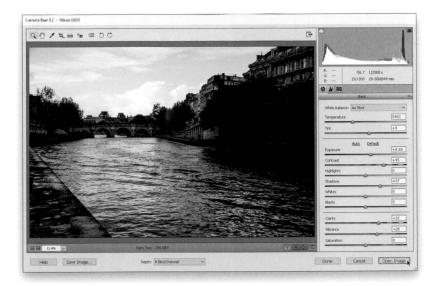

Step Two:
Let's start by making the foreground more visible. Drag the Shadows slider to the right (I dragged it to +37), and then bump up the Exposure slider, as well (here, I dragged it over to +0.65). The buildings and river look kind of "flat" contrast-wise, so bump up the Contrast a bit, too (let's go to +45). Lastly, since the buildings are brick, and we want to accentuate their texture, let's crank the Clarity up to around +32, and then make the little bit of color that's there more vibrant by increasing the Vibrance to around +28. Now, click the Open Image button to create the first version of your photo.

(Continued)

Step Three:

In the Elements Editor, go under the File menu, choose **Save As**, and rename and save this adjusted image. Then go back under the File menu, and under **Open Recently Edited File**, choose the same photo you just opened. It will re-open in Camera Raw. The next step is to create a second version of this image that exposes for the sky, even though it will make the foreground very dark.

Step Four:

So, first click the Default link to reset the sliders to 0, then drag the Exposure slider to the left (I went to –0.30), and drag the Contrast slider to +31 to help define the clouds. I also dragged the Temperature slider a little to the left to make the sky bluer, and lastly, I increased both the Clarity and Vibrance a bit. Once the sky looks good, click Open Image.

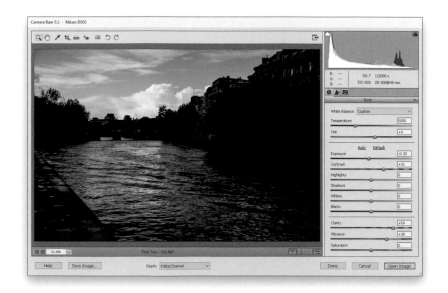

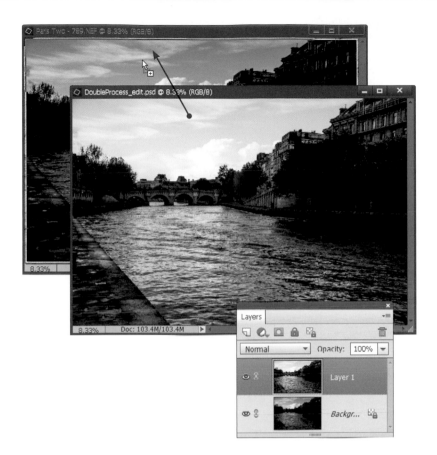

Step Five:

Now you should have both versions of the image open in the Editor: one exposed for the foreground and one exposed for the sky. (*Note:* This is easier if your windows are floating. So, in Elements' General Preferences, turn on the Allow Floating Documents in Expert Mode checkbox, then under the Window menu, under Images, choose **Float All in Windows**.) Arrange the image windows so you can see both onscreen (with the lighter photo in front). Press **V** to get the Move tool, press-and-hold the Shift key, click on the lighter image, and drag-and-drop it on top of the good sky version. The key to this part is holding down the Shift key while you drag between documents, which perfectly aligns the lighter image (that now appears on its own layer in the Layers palette) with the darker version on the Background layer. (This exact alignment of one identical photo over another is referred to as being "pin-registered.") You can now close the lighter document without saving, as both versions of the image are contained within one document.

Step Six:

You now have two versions of your photo, each on a different layer—the darker sky version on the bottom layer and the brighter one exposed for the bridge on the layer directly on top— and they're perfectly aligned, one on top of the other. This is why we call it "double-processing," because you have two versions of the same image, each processed differently. Now we need to combine these two layers into one image that combines the best of both. We'll combine the images with a layer mask (more on layer masks in Chapter 5), but rather than painstakingly painting it, we can cheat and use the Quick Selection tool **(A)**. So, get it from the Toolbox and paint over the sky, and it selects it for you in just a few seconds (as shown here).

(Continued)

Step Seven:

Press **Ctrl-Shift-I (Mac: Command-Shift-I)** to Inverse your selection, so the foreground is selected. Then, go to the Layers palette and click on the Add Layer Mask icon at the top of the palette (shown circled here in red). This converts your selection into a layer mask, which hides the light sky and reveals the darker sky layer in its place (as seen here). It still needs some tweaking (for sure), but at least now you can see what we're aiming for—the brighter foreground bridge from one layer blended with the darker sky from the other layer.

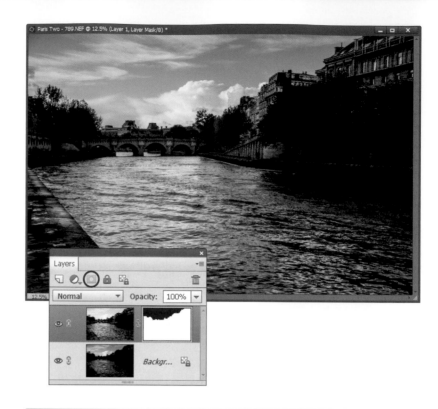

Step Eight:

Now, you're going to lower the Opacity of this top layer (the brighter bridge layer), so it blends in a little better with the darker sky layer. Here, I've lowered it to 80%, and the colors match much better.

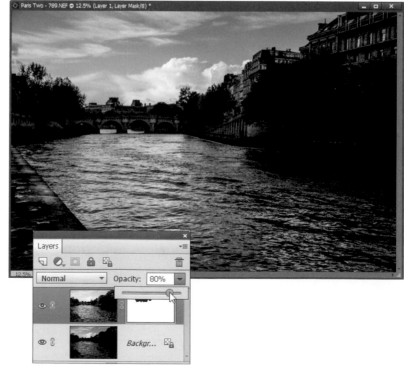

Step Nine:

Now, we have a pretty common problem to deal with here: when we lightened the foreground, we ended up with a bit of noise (I zoomed in here to 100%, so you can see it better). Luckily, that's fairly easy to fix in Camera Raw. First, we'll have to go to the Layers palette and, from the flyout menu at the top right, choose **Flatten Image** to flatten the image down to one layer, and then save it.

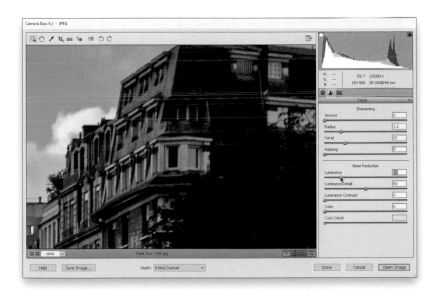

Step 10:

Open the image in Camera Raw and zoom in on the buildings. Now, go to the Detail panel (the middle icon at the top of the panels on the right side of the window) and, under Noise Reduction, drag the Luminance slider to the right until the noise goes away (I dragged it to 20).

(Continued)

Step 11:

Getting rid of the noise made the edges a little soft, so go up to Sharpening and drag the Amount slider to the right a bit (here, I dragged it to 34). Then, to keep the sharpening only on the edges, press-and-hold the Alt (Mac: Option) key and drag the Masking slider to the right. Finally, click Open Image. A before/after of our double-processing is shown below.

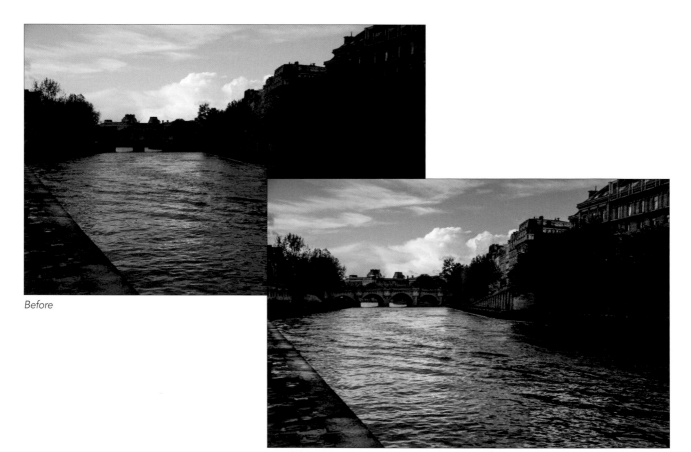

Before

After

One of the easiest ways to make great black-and-white photos (from your color images) is to do your conversion completely within Camera Raw. You're basically just a few sliders away from a stunning black-and-white photo and then all you have left to do is finish off the image by opening it in Photoshop Elements and adding some sharpening. Here's how it's done:

Black & White Conversions in Camera Raw

Step One:
Start by opening a photo you want to convert to black and white. We're going to work from the bottom of the Basic panel up. The next step in converting to black and white is to remove the color from the photo. Go to the Saturation slider and drag it all the way to the left.

TIP: Try the Auto Adjustment
This is one of the rare times I start by clicking the Auto button (you know, the button beneath the Tint slider that looks like a web link), because it usually pumps up the exposure about as high as it can go without too much clipping (if any).

Step Two:
Although this removes all the color, it usually makes for a pretty flat-looking (read as: lame) black-and-white photo. So, go up two sliders to the Clarity slider and drag it over quite a bit to the right to really make the midtones snap (I dragged over to +93).

(Continued)

Step Three:

Now you're going to add extra contrast by (you guessed it) dragging the Contrast slider to the right until the photo gets real contrasty (as shown here). It's important that you set this slider first—before you set the Blacks slider—or you'll wind up setting the blacks, then adjusting the contrast, and then lowering the Blacks slider back down. That's because what the Contrast slider essentially does is makes the darkest parts of the photo darker, and the brightest parts brighter. If the blacks are already very dark, then you add contrast, it makes them too dark, and you wind up backing them off again. So, save yourself the extra step and set the contrast first. After setting the Contrast to +100, I still wanted more contrast, so I dragged the Blacks slider to –63, as well.

Step Four:

The image is pretty dark, so drag the Highlights slider to the right to lighten those areas (I dragged to +100). To enhance the dramatic look, I also upped the Whites to +56. That's it—the quickest way to convert to black and white (and get a nice high-contrast look) right within Camera Raw.

TIP: Change the White Balance

Another thing you might try for RAW images is going through each of the White Balance presets (in the White Balance pop-up menu) to see how they affect your black-and-white photo. You'll be amazed at how this little change can pay off (make sure you try Fluorescent and Tungsten—they often look great in black and white).

Before

After

Photo by Scott Kelby Exposure: 1/1000 sec | Focal Length: 28mm | Aperture Value: ƒ/5.6

SCREAM OF THE CROP
how to resize and crop photos

I love the title of this chapter—it's the name of an album from the band Soulfarm (tell me that Soulfarm wouldn't make a great name for a horror movie!). Anyway, I also found a band named Cash Crop, which would make a great title, too, but when I looked at their album, every song was marked with the Explicit warning. I listened to a 90-second preview of the first track (which was featured in the original motion picture soundtrack for the movie *Sorority Row*), and I immediately knew what kind of music they did. Naughty, naughty music. Anyway, while I was listening, and wincing from time to time as F-bombs exploded all around me, I realized that someone at the iTunes Store must have the full-time job of listening to each song and choosing the 90-second preview. I imagine, at this point, that person has to be 100% completely numb to hearing things like the F-bomb, the S-missile, and the B-grenade (which means

they could totally do a stint as Joe Pesci's nanny). But, I digress. The "Scream of the Crop" title (which would make a great title for a movie about evil corn) is almost ideal for this chapter, except for the fact that this chapter also includes resizing. So, I thought, what the heck, and searched for "resize" and found a song called "Undo Resize" by electronic ambient artist DJ Yanatz Ft. The Designers, and it literally is an 8:31 long background music track with two European-sounding women whispering the names of menu commands from Adobe products. Stuff like "Select All," "Fill," "Distort," "Snap to Grid," and so on. I am not making this up (I listened to the free 90-second preview). It was only 99¢, which is a bargain for 8+ minutes of menu commands set to music. Normally, this many minutes of menu commands set to music would be more like, I dunno, $1.29 or so.

Basic Cropping

After you've sorted your images in the Organizer, one of the first editing tasks you'll probably undertake is cropping a photo. There are a number of different ways to crop a photo in Elements. We'll start with the basic garden-variety options, and then we'll look at some ways to make the task faster and easier.

Step One:
Open the image you want to crop in the Elements Editor, and then press the letter **C** to get the Crop tool (you could always select the tool directly from the Toolbox, but I only recommend doing so if you're charging by the hour).

Step Two:
Click within your photo and drag out a cropping border. By default, you'll see a grid appear within your border. This feature lets you crop photos based on some of the popular composition rules that photographers and designers use. We'll go over this feature more in a moment, so for now click on the None icon in the Grid Overlay section on the right end of the Tool Options Bar. The area to be cropped away will appear dimmed (shaded). You don't have to worry about getting your cropping border right when you first drag it out, because you can edit it by dragging the control handles that appear in each corner and at the center of each side.

TIP: Turn Off the Shading
If you don't like seeing your photo with the cropped-away areas appearing shaded (as in the previous step), you can toggle this shading feature off/on by pressing the **Forward Slash key (/)** on your keyboard. When you press the Forward Slash key, the border remains in place but the shading is turned off.

Step Three:
While you have the cropping border in place, you can rotate the entire border. Just move your cursor outside the border, and your cursor will change into a double-headed arrow. Then, click-and-drag, and the cropping border will rotate in the direction that you drag. (This is a great way to save time if you have a crooked image, because it lets you crop and rotate at the same time.)

(Continued)

Step Four:

Once you have the cropping border where you want it, click on the green checkmark icon at the bottom corner of your cropping border, or just press the **Enter (Mac: Return) key** on your keyboard. To cancel your crop, click the red international symbol for "No Way!" at the bottom corner of the cropping border, or press the **Esc key** on your keyboard.

Step Five:

Elements includes a feature called Crop Suggestions in both Quick and Expert edit modes. It automatically looks at your photo and gives you a few suggestions for ways to crop it. It's pretty simple to use: just hover your cursor over the different thumbnails to see the suggestions. If you find one you like, click on it to select it. If you like the size, but not the placement, simply click inside the cropping border and drag it where you want it, as I did here.

Step Six:

Like I mentioned, Elements includes overlay features to help you crop your photos. The one you'll use the most is called the Rule of Thirds (and is the default overlay). It's essentially a trick that photographers sometimes use to create more interesting compositions. Basically, you visually divide the image you see in your camera's viewfinder into thirds, and then you position your horizon so it goes along either the top imaginary horizontal line or the bottom one. Then, you position the subject (or focal point) at the intersections of those lines (as you'll see in the next step). But if you didn't use the rule in the viewfinder, no sweat! You can use this overlay feature to achieve it. There is one other option in the Grid Overlay section: Grid, which is useful for straightening horizons.

Step Seven:
So, click on the Rule of Thirds icon and then click within your photo and drag out a cropping border. When you drag the cropping border onto your image, you'll see the Rule of Thirds overlay appear over your photo. Try to position your image's horizon along one of the horizontal grid lines, and be sure your focal point (the fireworks, in this case) falls on one of the intersecting points (the top-left intersection, in this example).

Before

After

Auto-Cropping to Standard Sizes

If you're outputting photos for clients, chances are they're going to want them in standard sizes so they can easily find frames to fit. If that's the case, here's how to crop your photos to a predetermined size (like a 5x7", 8x10", etc.):

Step One:
Open an image in the Elements Editor that you want to crop to be a perfect 5x7" for a vertical image, or 7x5" if your image is horizontal. Press **C** to get the Crop tool, then go to the Tool Options Bar and click on the words "No Restriction" in the pop-up menu. From the list of preset crop sizes, choose **5x7 in**. (*Note:* To hide the Rule of Thirds overlay grid, click on the None icon on the right side of the Tool Options Bar.)

TIP: Swapping Fields
The Width and Height fields are populated based on the type of image you open—7x5" for horizontal images and 5x7" for vertical images. If you opened a horizontal image, but your crop is going to be vertical (tall), you'll need to swap the figures in the Width and Height fields by clicking on the Swaps icon between the fields in the Tool Options Bar (as shown here).

Step Two:

Now click-and-drag the Crop tool over the portion of the photo that you want to be 7x5" (if your image is vertical, Elements will automatically adjust your border to 5x7". I made the rulers visible here by pressing **Ctrl-Shift-R [Mac: Command-Shift-R]**). While dragging, you can press-and-hold the Spacebar to adjust the position of your border, if needed.

Step Three:

Once it's set, press the **Enter (Mac: Return) key** and the area inside your cropping border will become 7x5" (as shown here).

TIP: Crop with an Action

You can also use the Actions palette (found under the Window menu) in Elements to crop your photos. In the palette, they are in the Resize and Crop folder. Simply open the image you want to crop, click on the cropping action you want to run, then click on the Play Selection icon at the top right of the palette, and—BAM!—your image is cropped and ready to go.

Cropping to an Exact Custom Size

Okay, now you know how to crop to Elements' built-in preset sizes, but how do you crop to a nonstandard size—a custom size that you determine? Here's how:

Step One:

Open the photo that you want to crop in the Elements Editor. (I want to crop this image to 8x6".) First, press **C** to get the Crop tool. In the Tool Options Bar, you'll see fields for Width and Height. Enter the size you want for Width, followed by the unit of measure you want to use (e.g., enter "in" for inches, "px" for pixels, "cm" for centimeters, "mm" for millimeters, etc.). Next, press the Tab key to jump over to the Height field and enter your desired height, again followed by the unit of measure.

Step Two:

Once you've entered these figures in the Tool Options Bar, click within your photo with the Crop tool and drag out a cropping border. (*Note:* To hide the Rule of Thirds overlay grid, click on the None icon on the right side of the Tool Options Bar.) You'll notice that as you drag, the border is constrained to an 8x6" aspect ratio; no matter how large of an area you select within your image, the area within that border will become your specified size. When you release your mouse button, you'll still have both side handles and corner handles visible, but the side handles will act like corner handles to keep your size constrained.

Step Three:

Once your cropping border is onscreen, you can resize it using the corner handles or you can reposition it by moving your cursor inside the border. Your cursor will change to a Move arrow, and you can now click-and-drag the border into place. You can also use the **Arrow keys** on your keyboard for more precise control. When it looks right to you, press **Enter (Mac: Return)** to finalize your crop or click on the checkmark icon at the bottom right of your cropping border. Here, I made the rulers visible **(Ctrl-Shift-R [Mac: Command-Shift-R])** so you could see that the image measures exactly 8x6".

(Continued)

TIP: Clearing the Fields

Once you've entered a Width and Height in the Tool Options Bar, those dimensions will remain there. To clear the fields, just choose **No Restriction** from the pop-up menu above the Width and Height fields. This will clear the fields, and now you can use the Crop tool for freeform cropping (you can drag it in any direction—it's no longer constrained to your specified size).

COOLER TIP: Changing Dimensions

If you already have a cropping border in place, you can change your dimensions without re-creating the border. All you have to do is enter the new sizes you want in the Width and Height fields in the Tool Options Bar, and Elements will resize your cropping border.

Before

After

Elements has a cool feature that lets you crop your photo into a pre-designed shape (like putting a wedding photo into a heart shape), but even cooler are the edge effects you can create by cropping into one of the pre-designed edge effects that look like old Polaroid transfers. Here's how to put this feature to use to add visual interest to your own photos:

Cropping into a Shape

Step One:
In the Elements Editor, open the photo you want to crop into a pre-designed shape, and press the letter **C** until you get the Cookie Cutter tool.

Step Two:
Now, go down to the Tool Options Bar and click on the shape thumbnail. This brings up the Custom Shape Picker, which contains the default set of 30 shapes. To load more shapes, click on the Shapes pop-up menu at the top of the Picker and a list of built-in shape sets will appear. From this list, choose **Crop Shapes** to load the edge-effect shapes, which automatically crop away areas outside your custom edges.

(Continued)

Step Three:

Once you select the custom edge shape you want to use in the Custom Shape Picker, just click-and-drag it over your image to the size you want it. When you release the mouse button, your photo is cropped to fit within the shape. *Note:* I like Crop Shape 10 (which is shown here) for something simple, and Crop Shape 20 for something a little wilder. The key thing here is to experiment and try different crop shapes to find your favorite.

Step Four:

You'll see a bounding box around the shape, which you can use to resize, rotate, or otherwise mess with your shape. To resize your shape, press-and-hold the Shift key (or choose Defined Proportions from the pop-up menu to the right of the shape thumbnail in the Tool Options Bar) to keep it proportional while you drag a corner handle. To rotate the shape, move your cursor outside the bounding box until your cursor becomes a double-headed arrow, and then click-and-drag. As long as you see that bounding box, you can still edit the shape. When it looks good to you, press **Enter (Mac: Return)** and the parts of your photo outside that shape will be permanently cropped away.

TIP: Tightly Crop Your Image

If you want your image area tightly cropped, so it's the exact size of the shape you drag out, just turn on the Cookie Cutter's Crop checkbox (in the Tool Options Bar) before you drag out your shape. Then when you press Enter to lock in your final shape, Elements will tightly crop the entire image area to the size of your shape. *Note:* The checkerboard pattern you see around the photo is letting you know that the background around the shape is transparent. If you want a white background behind the shape, click on the Create a New Layer icon at the top of the Layers palette, and then drag your new layer below the Shape layer. Press **D**, then **X** to set your Foreground color to white, then press **Alt-Backspace (Mac: Option-Delete)** to fill this layer with white.

Before

After

Using the Crop Tool to Add More Canvas Area

I know the heading for this technique doesn't make much sense—"Using the Crop Tool to Add More Canvas Area." How can the Crop tool (which is designed to crop photos to smaller sizes) actually make the canvas area (white space) around your photo larger? That's what I'm going to show you.

Step One:

In the Elements Editor, open the image to which you want to add additional blank canvas area. Press the letter **D** to set your Background color to its default white. (*Note:* If you want to add a different color canvas, like black, then go under the File menu, under New, and choose **Blank File** to open the New dialog. At the bottom, change the Background Contents pop-up menu to **Background Color**, then click OK. Close the new document, and set your Background color to whatever color you want the canvas to be.)

Step Two:

If you're in Maximize Mode or tabbed viewing, press **Ctrl–** (minus sign; **Mac: Command–**) to zoom out a bit (so your image doesn't take up your whole screen). If your image window is floating, click-and-drag out the bottom corner of the document window to see the gray desktop area around your image. (To enter Maximize Mode, click the Maximize Mode icon in the top-right corner of the image window. To enter tabbed viewing, go under the Window menu, under Images, and choose **Consolidate All to Tabs**.)

Step Three:
Press the letter **C** to switch to the Crop tool and drag out a cropping border to any random size (it doesn't matter how big or little it is at this point).

Step Four:
Next, grab any one of the side or corner handles and drag outside the image area, out into the gray area that surrounds your image. The cropping border extending outside the image is the area that will be added as white canvas space, so position it where you want to add the blank canvas space.

Step Five:
Now, just press the **Enter (Mac: Return) key** to finalize your crop, and when you do, the area outside your image will become white canvas area.

Auto-Cropping Gang-Scanned Photos

A lot of photographers scan photos using a technique called "gang scanning." That's a fancy name for scanning more than one picture at a time. Scanning three or four photos at once with your scanner saves time, but then you eventually have to separate these photos into individual documents. Here's how to have Elements do that for you automatically:

Step One:

Place the photos you want to "gang scan" on the bed of your flatbed scanner. In the Organizer, you can scan the images by going under the File menu, under Get Photos and Videos, and choosing **From Scanner** (they should appear in one Elements document). In the dialog that appears, select where and at what quality you want to save your scanned document. (*Note:* This feature is currently not available in the Elements 14 version for the Mac, so you'll need to use your scanner's software.)

Step Two:

Once your images appear in one document in the Editor, go under the Image menu and choose **Divide Scanned Photos**. It will immediately find the edges of the scanned photos, straighten them if necessary, and then put each photo into its own separate document. Once it has "done its thing," you can close the original gang-scanned document, and you'll be left with just the individual documents.

Straightening Photos with the Straighten Tool

In Elements, there's a simple way to straighten photos, but it's knowing how to set the options for the tool that makes your job dramatically easier. Here's how it's done:

Step One:
Open the photo that needs straightening (the photo shown here looks like it's sloping down to the right). Then, choose the Straighten tool from the Toolbox (or just press the **P key**).

TIP: Straighten in Quick Mode
In Elements 14, you can now also use the Straighten tool in Quick Mode.

Step Two:
Take the Straighten tool and drag it along an edge in the photo that you think should be perfectly horizontal, like a horizon line or the edge of a building.

(Continued)

Step Three:

When you release the mouse button, the image is straightened, but as you see here, the straightening created a problem of its own—the photo now has to be re-cropped because the edges are showing a white background (as the image was rotated until it was straight). That's where the options (which I mentioned in the intro to this technique) come in. You see, the default setting does just what you see here—it rotates the image and leaves it up to you to crop away the mess. However, Elements can do the work for you (see the next step).

Step Four:

Once you click on the Straighten tool, go down to the Tool Options Bar and click on the Remove Background icon.

Step Five:

Also, there's a feature in Elements that lets you get the best of both worlds. For example, what happens if you straighten the photo and crop away the edges, but a key part of your photo gets cropped away with it? You'd normally be outta luck. Instead, go back to the default Grow or Shrink Canvas icon that we started with. Then turn on the Autofill Edges checkbox to the right. This time, Elements will try to automatically patch those areas that would normally be left white. You'll find it works best on skies and water, and areas with non-essential parts of the photo in them. It's not a gimme and it won't work every time, but it's definitely worth a try.

TIP: Straightening Vertically

In this example, we used the Straighten tool along a horizontal plane, but if you wanted to straighten the photo using a vertical object instead (like a column or light pole), just click with the Straighten tool, then press-and-hold the Ctrl (Mac: Command) key before you drag it, and that will do the trick.

If you're more familiar with resizing scanned images, you'll find that resizing images from digital cameras is a bit different, primarily because scanners create high-resolution images (usually 300 ppi or more), but the default setting for most digital cameras usually produces an image that is large in physical dimension, but lower in ppi (usually 72 ppi). The trick is to decrease the physical size of your digital camera image (and increase its resolution) without losing any quality in your photo. Here's the trick:

Resizing Digital Camera Photos

Step One:
Open the digital camera image that you want to resize. Press **Ctrl-Shift-R (Mac: Command-Shift-R)** to make Elements' rulers visible. Check out the rulers to see the approximate dimensions of your image. As you can see from the rulers in the example here, this photo is around 39x62".

Step Two:
Go under the Image menu, under Resize, and choose **Image Size** to bring up the Image Size dialog. In the Document Size section, the Resolution setting is 72 pixels/inch (ppi). A resolution of 72 ppi is considered low resolution and is ideal for photos that will only be viewed onscreen (such as web graphics, slide shows, etc.). This res is too low, though, to get high-quality results from a color inkjet printer, color laser printer, or for use on a printing press.

(Continued)

Step Three:

If we plan to output this photo to any printing device, it's pretty clear that we'll need to increase the resolution to get good results. I wish we could just type in the resolution we'd like it to be in the Resolution field (such as 200 or 240 ppi), but unfortunately, this "re-sampling" makes our low-res photo appear soft (blurry) and pixelated. That's why we need to make sure the Resample Image checkbox is turned off (as shown here). That way, when we type in the setting that we need in the Resolution field, Elements automatically adjusts the Width and Height fields for the image in the exact same proportion. As your Width and Height decrease (with Resample Image turned off), your Resolution increases. Best of all, there's absolutely no loss of quality. Pretty cool!

Image Size	✕
❓ Learn more about: Image Size	OK
	Cancel
Pixel Dimensions: 35.9M	Help
Width: 4472 pixels	
Height: 2808 pixels	
Document Size:	
Width: 62.111 Inches ▼	
Height: 39 Inches ▼	
Resolution: 72 Pixels/Inch ▼	
☑ Scale Styles	
☑ Constrain Proportions	
☐ Resample Image:	
Bicubic (best for smooth gradients) ▼	

Step Four:

Here I've turned off Resample Image, then I typed 240 in the Resolution field (for output to a color inkjet printer—I know, you probably think you need a lot more resolution, but you don't. In fact, I never print with a resolution higher than 240 ppi). At a resolution of 240 ppi here, I can actually print a photo that is around 18 inches wide by around 12 inches high.

Image Size	✕
❓ Learn more about: Image Size	OK
	Cancel
Pixel Dimensions: 35.9M	Help
Width: 4472 pixels	
Height: 2808 pixels	
Document Size:	
Width: 18.633 Inches ▼	
Height: 11.7 Inches ▼	
Resolution: 240 Pixels/Inch ▼	
☑ Scale Styles	
☑ Constrain Proportions	
☐ Resample Image:	
Bicubic (best for smooth gradients) ▼	

Image Size

Learn more about: Image Size

OK

Cancel

Help

Pixel Dimensions: 35.9M

Width: 4472 pixels

Height: 2808 pixels

Document Size:

Width: 24.844 Inches

Height: 15.6 Inches

Resolution: 180 Pixels/Inch

☑ Scale Styles

☑ Constrain Proportions

☐ Resample Image:

Bicubic (best for smooth gradients)

Step Five:

Here, I've lowered the Resolution setting to 180 ppi. (Again, you don't need nearly as much resolution as you'd think, but 180 ppi is pretty much as low as you should go when printing to a color inkjet printer.) As you can see, the Width of my image is now almost 25" and the height is almost 16". Best of all, we did it without damaging a single pixel, because we were able to turn off Resample Image.

Step Six:

When you click OK, you won't see the image window change at all—it will appear at the exact same size onscreen. But now look at the rulers—you can see that your image's dimensions have changed. Resizing using this technique does three big things: (1) it gets your physical dimensions down to size (the photo now fits on a 16x24" sheet); (2) it increases the resolution enough so you can output this image on a color inkjet printer; and (3) you haven't softened or pixelated the image in any way—the quality remains the same—all because you turned off Resample Image. *Note:* Do not turn off Resample Image for images that you scan on a scanner—they start as high-res images in the first place. Turning off Resample Image is only for photos taken with a digital camera at a low resolution.

Resizing and How to Reach Those Hidden Free Transform Handles

What happens if you drag a large photo onto a smaller photo in Elements? (This happens all the time, especially if you're collaging or combining two or more photos.) You have to resize the photo using Free Transform, right? Right. But here's the catch—when you bring up Free Transform, at least two (or, more likely, all four) of the handles that you need to resize the image are out of reach. You see the center point, but not the handles you need to reach to resize. Here's how to get around that hurdle quickly and easily:

Step One:
Open two different-sized photos in the Elements Editor. Use the Move tool **(V)** to drag-and-drop the larger photo on top of the smaller one (if you're in tabbed viewing, drag one image onto the other image's thumbnail in the Photo Bin). To resize a photo on a layer, press **Ctrl-T (Mac: Command-T)** to bring up the Free Transform command. Next, press-and-hold the Shift key to constrain your proportions (or turn on the Constrain Proportions checkbox in the Tool Options Bar), grab one of the Free Transform corner handles, and (a) drag inward to shrink the photo, or (b) drag outward to increase its size (not more than 20%, to keep from making the photo look soft and pixelated). But wait, there's a problem. The problem is—you can't even see the Free Transform handles in this image.

Step Two:
To instantly have full access to all of Free Transform's handles, just press **Ctrl-0** (zero; **Mac: Command-0**), and Elements will instantly zoom out of your document window and surround your photo with gray desktop, making every handle well within reach. Try it once, and you'll use this trick again and again. *Note:* You must choose Free Transform first for this trick to work.

There is a different set of rules we use for maintaining as much quality as possible when making an image smaller, and there are a couple of different ways to do just that (we'll cover the two main ones here). Luckily, maintaining image quality is much easier when sizing down than when scaling up (in fact, photos often look dramatically better—and sharper—when scaled down, especially if you follow these guidelines).

Making Your Photos Smaller (Downsizing)

Downsizing photos where the resolution is already 300 ppi:

Although earlier we discussed how to change image size if your digital camera gives you 72-ppi images with large physical dimensions (like 24x42" deep), what do you do if your camera gives you 300-ppi images at smaller physical dimensions (like a 10x6" at 300 ppi)? Basically, you turn on Resample Image (in the Image Size dialog—go under the Image menu, under Resize, and choose **Image Size**), then simply type the desired size (in this example, we want a 4x6" final image size), and click OK (don't change the Resolution setting, just click OK). The image will be scaled down to size, and the resolution will remain at 300 ppi. *IMPORTANT:* When you scale down using this method, it's likely that the image will soften a little bit, so after scaling you'll want to apply the Unsharp Mask filter to bring back any sharpness lost in the resizing (look at the sharpening chapter [Chapter 10] to see what settings to use).

(Continued)

Making one photo smaller without shrinking the whole document:

If you're working with more than one image in the same document, you'll resize a bit differently. To scale down a photo on a layer, first click on that photo's layer in the Layers palette, then press **Ctrl-T (Mac: Command-T)** to bring up Free Transform. Press-and-hold the Shift key to keep the photo proportional (or turn on the Constrain Proportions checkbox in the Tool Options Bar), grab a corner handle, and drag inward. When it looks good to you, press the **Enter (Mac: Return) key**. If the image looks softer after resizing it, apply the Unsharp Mask filter (again, see the sharpening chapter).

Resizing problems when dragging between documents:

This one gets a lot of people, because at first glance it just doesn't make sense. You have two documents, approximately the same size, side-by-side onscreen. But when you drag a 72-ppi photo (of a statue, in this case) onto a 300-ppi document (Untitled-1), the photo appears really small. Why is that? Simply put: resolution. Although the documents appear to be the same size, they're not. The tip-off that you're not really seeing them at the same size is found in the title bar of each photo. For instance, the photo of the statue is displayed at 100%, but the Untitled-1 document is displayed at only 25%. So, to get more predictable results, make sure both documents are at the same viewing size and resolution (check in the Image Size dialog).

Elements has a pretty slick little utility that lets you take a folder full of images and do any (or all) of the following automatically at one time: (1) rename them; (2) resize them; (3) change their resolution; (4) color correct and sharpen them; and (5) save them in the file format of your choice (JPEG, TIFF, etc.). If you find yourself processing a lot of images, this can save a ton of time. Better yet, since the whole process is automated, you can teach someone else to do the processing for you, like your spouse, your child, a neighbor's child, passersby, local officials, etc.

Automated Saving and Resizing

Step One:
In the Elements Editor, go under the File menu and choose **Process Multiple Files**.

Step Two:
When the Process Multiple Files dialog opens, the first thing you have to do is choose the folder of photos you want to process by clicking on the Browse button in the Source section of the dialog. Then, navigate to the folder you want and click OK (Mac: Choose). If you already have some photos open in Elements, you can choose Opened Files from the Process Files From pop-up menu (or you can choose Import to import files). Then, in the Destination section, you decide whether you want the new copies to be saved in the same folder (by turning on the Same as Source checkbox), or copied into a different folder (in which case, click on the section's Browse button and choose that folder).

(Continued)

Step Three:

The next section is File Naming. If you want your files automatically renamed when they're processed, turn on the Rename Files checkbox, then in the fields directly below that checkbox, type the name you want these new files to have and choose how you want the numbering to appear after the name (a two-digit number, three-digit, etc.). Then, choose the number with which you want to start numbering images. You'll see a preview of how your file naming will appear just below the document name field (shown circled here).

Step Four:

In the Image Size section, you decide if you want to resize the images (by turning on the Resize Images checkbox), and you enter the width and height you want for your finished photos. You can also choose to change the resolution. If you want to change their file type (like from RAW to JPEG Max Quality), you choose that in the bottom section—File Type. Just turn on the Convert Files To checkbox, and then choose your format from the pop-up menu.

Step Five:

On the top-right side of the dialog, there is a list of Quick Fix cosmetic changes you can make to these photos, as well, including Auto Levels (to adjust the overall color balance and contrast), Auto Contrast (this is kind of lame if you ask me), Auto Color (it's not bad), and Sharpen (it works well). Also on the right is a Labels section, where you can add a custom watermark or a caption to these photos. Now, just click OK and Elements does its thing, totally automated based on the choices you made in this dialog. How cool is that?

We've all run into situations where our image is a little smaller than the area where we need it to fit. For example, if you resize a digital camera image so it fits within a traditional 8x10" image area, you'll have extra space either above or below your image (or both). That's where the Recompose Tool comes in—it lets you resize one part of your image, while keeping the important parts intact (basically, it analyzes the image and stretches, or shrinks, parts of the image it thinks aren't as important). Here's how to use it:

Resizing Just Parts of Your Image Using the Recompose Tool

Step One:
Create a new document at 8x10" and 240 ppi. Open a digital camera image, get the Move tool **(V)**, and drag-and-drop it onto the new document, then press **Ctrl-T (Mac: Command-T)** to bring up Free Transform. Press-and-hold the Shift key (or turn on the Constrain Proportions checkbox in the Tool Options Bar), then grab a corner point and drag inward to scale the image down, so it fits within the 8x10" area (as shown here on top), and press **Enter (Mac: Return)**. Now, in the image on top, there's white space above and below the photo. If you want it to fill the 8x10" space, you could use Free Transform to stretch the image to do so, but you'd get a stretched version of the SUV (seen at bottom). This is where Recompose comes in.

Step Two:
Click on the Recompose tool **(W)** in the Toolbox. The way the tool works is you tell Elements which areas of the photo you want to make sure it preserves and which areas of the photo are okay to remove/squish/expand/get rid of. This is all done using the four tools at the left end of the Tool Options Bar (circled in red here at the bottom).

(Continued)

Step Three:

Click on the Mark for Protection tool (the brush with the plus sign), and paint some loose squiggly lines over the areas of the photo you want to make sure Elements protects. These are the important areas that you don't want to see transformed in any way (here I painted over the SUV and some of the sand dunes). If you make a mistake and paint on something you didn't want to, just use the tool's corresponding Erase tool to the right of the Mark for Protection tool.

Step Four:

Now you have to tell Elements what parts of the photo are okay to get rid of or stretch out. Click on the Mark for Removal tool in the Tool Options Bar (the brush with the minus sign) and paint some lines over the non-essential areas of the photo. No need to go crazy here, a couple of quick brush strokes will do just fine.

Step Five:

Click on the top-center handle and drag it upward until it reaches the edge of your document (remember, you already set the document to 8x10). You'll notice that Elements won't stretch the SUV now, but rather just the sky at the top. Do the same thing with the bottom-center handle. Drag it downward until it reaches the edge. It may stretch the texture in the area you've selected a little, but it's not anything most people will notice. And if it is, then try going back and adjusting the areas to protect/unprotect and sometimes you'll get better results. But in this case, the SUV (which is the most important part of the photo) was left alone, and only the sky and sand were stretched to fit the 8x10 print that we'd like to make.

TIP: Use the Preset Pop-Up Menu

The Recompose tool has a preset pop-up menu in the Tool Options Bar with some common print sizes, so when you select one of them, it automatically recomposes your photo to that specific size.

Photo by Scott Kelby | Exposure: 1/800 sec | Focal Length: 18mm | Aperture Value: ƒ/4

edIT
which mode do I use: quick, guided, or expert?

Man, did I luck out on the name of this chapter: edIT. It's actually named after the popular DJ, producer, and musician, and that right there is enough for me, especially since he gets to work with hip-hop artists and rappers. I love rappers, because they use such colorful phrases—stuff you usually only hear from fans at a Redskins football game when a receiver is wide open in the flat and drops a ball thrown right into his hands. But when the fans say it, they're yelling, which can really get on your nerves. In a rap song, even though they're saying the same things, since it's set to music, it just floats by. In fact, a lot of times, when you're listening to rap, they'll say something and you stop and think, "Did he really just say what I thought he said?" but you try to convince yourself that's not what you heard because nobody dropped an easy pass. I always wonder what rappers have to be so angry about. They're rich, successful entrepreneurs, and everybody obviously wants to hang out with them and go to "da club" and drink Cristal and look thoroughly bored at all the women gesticulating around them. They should be really happy, one would think, but often they sound very grumpy, which always strikes me as odd for millionaire celebrity rappers, which I assume DJ edIT produces or mixes. By the way, a "mix," I believe, is what you add to gin (like juice) when you're chillin' with your posse in your crib (which must mean you have small children sleeping in your home). Anyway, I thought I would help out by writing some positive, non-angry, upbeat lyrics that edIT can show to his rapper friends so they'll sound more like the happy millionaire celebrities that they are. Please don't laugh—this is my first rap for my peeps and my crew, so I'm just rappin' lyrical for me, and one for my homies. (See, that's rap talk, right?) Okay, here goes: "I was having lots of fun at Busch Gardens today. I rode an awesome roller coaster and didn't have to pay. I drove there in my new limo and the driver's real nice. And we're listening to some snappy tunes from cool Vanilla Ice." See? Rap can be happy and super-edgy, too! Peace out. Word. Wikki-wikki.

Photo Quick Fix in Quick Mode

Quick edit mode is kinda like a stripped down version of Expert mode. If you're new to Elements, it's not a bad place to start. I'm usually against "quick" modes and "auto-fix" stuff, but the way they've implemented this is actually really nice, and I think it works great for beginners. Plus, they've added some cool new features in Elements 14. (*Note:* We look at some other Quick mode special effects in Chapter 9.)

Step One:

Open a photo and click on Quick at the top of the Editor window. First things first: forget about the left side of the window. The tools in the Toolbox make using Quick mode too much like using Expert mode (but without all of the options that Expert mode has). So, if you find that you need the tools here, you're better off going into Expert mode to do what you need to do.

Step Two:

In the preview area of Quick mode, you can see side-by-side, before-and-after versions of the photo you're correcting (before on the top or left; after on the bottom or right). To see this view, from the View pop-up menu above the top left of the preview area, select **Before & After (Horizontal or Vertical)**. In the Palette Bin on the right side of the window is a group of nested palettes offering tonal and lighting fixes you can apply to your photo. Start with the Smart Fix palette at the top. Click on the Auto button and Smart Fix will automatically analyze the photo and try to balance the overall tone (adjusting the shadows and highlights), while fixing any obvious color casts while it's at it. In a lot of cases, this feature does a surprisingly good job. There's also a slider within the Smart Fix palette that you can use to increase (or decrease) the effect, or you can click on the thumbnails beneath the slider.

Step Three:

If you're not happy with the Smart Fix results, don't try to stack more "fixes" on top of it. Instead, click the Reset Image icon (the curved arrow above a straight line that appears above the top right of the Palette Bin) to reset the photo to how it looked when you first entered Quick mode. Now, let's take a look at each setting individually: First, click on Exposure to open its palette. The Exposure setting is like the heavy hitter—if the whole photo is too dark or too bright, then this is where to go. You'll see its palette also has a slider and thumbnails right below it. They're different ways of doing the same thing. If you like using the thumbnails, just click on the one that looks closest to how bright or dark you'd like your photo to be. As you do that, you'll see the slider move each time. Usually, though, I just drag the slider (as shown here) until I'm happy with the overall exposure.

Step Four:

More often than not, just adjusting the exposure won't fix the whole photo. You'll usually end up in the next palette, which is Lighting. Here you can choose to work on the shadows, midtones, or highlights separately. The Shadows slider is particularly helpful because we tend to lose a lot of detail in the shadows. Drag it to the right a little bit, and watch how it opens up the dark shadow areas in your photo (mainly the detail in the darker areas of the buildings in this photo). The Highlights slider will add some detail back to the sky here, as well. For this one, I increased the Shadows slider to 7, the Midtones slider to 11, and the Highlights slider to 13. I tend to stay away from the Auto Levels and Auto Contrast buttons, because chances are, if Smart Fix didn't work well, then neither will they.

(Continued)

Step Five:

The next palette down, Color, has only really one setting that I think is worthwhile. You'll see at the top of the palette you can control the Saturation, Hue, and Vibrance. The Saturation adjustment adds or removes color saturation in the whole photo. It's worth trying out and maybe even clicking the Auto button. Sometimes the photo looks good, but most of the time, the Vibrance setting is the most useful here. While Saturation adds color to everything in the photo, Vibrance tends to only add color saturation to the colors that need it, while leaving the other colors alone, so you don't get that fakey look. It's also great on portraits because it tends to leave skin tones alone and only adds color saturation to everything else.

Step Six:

While the Color palette helps us fix the overall color saturation in a photo, the Balance palette right below helps remove color casts (like when an indoor photo looks really yellow). It's pretty simple to use to control the temperature and the tint in the photo. I'll warn you ahead of time, though, small adjustments here make *big* changes, so be careful. The Temperature adjustment lets you add more blue or more yellow/red to a photo. Basically, adding blue removes yellow and adding more yellow removes blue. Photos taken indoors at night are perfect candidates for this since they tend to look really yellow, so dragging the slider toward blue helps balance (hence the name of this palette) the photo. You can also control the Tint (greens and magentas), but honestly, you won't notice much of a problem there in most cases. But if you do, it works the same—adding more green removes magenta, and adding more magenta removes a greenish color cast.

Step Seven:

The final step here is to sharpen your photo. I always click on the Zoom tool in the Toolbox, and zoom in a little further, so I can see the details. Then, just click the Auto button in the Sharpen palette and watch the results. If the photo isn't sharp enough for you, drag the slider to the right to increase the amount of sharpening. But, be careful, because oversharpening can ruin the photo by becoming too obvious, and it can introduce color shifts and halos around objects.

Step Eight:

There are a couple other things you can do while you're here in Quick mode (basically, think of this as a "one-stop shop" for quickly fixing images). Below the preview area is an icon you can click on to rotate your photo (this photo doesn't need to be rotated, but hey, ya never know). And, I know I told you to forget about the Toolbox on the left, but there is a Crop tool there, so if you need to do a quick crop, you can do it here.

Step Nine:

Okay, so you've color corrected, fixed the contrast, sharpened your image, and even cropped it down to size (if it needed it). So, how do you leave Quick mode and return to Expert mode? Just click on Expert at the top of the window (the same place you went to, to get into Quick mode). It basically applies all the changes to your photo and returns you to the normal Expert editing mode.

Special Effects in Guided Mode (the Only Time to Use It)

When you use Guided mode, it walks you through a bunch of popular editing options, like cropping, enhancing colors, retouching, and sharpening. They're kind of like built-in tutorials in Elements—they don't do all of the work for you, they just explain to you what tools you should use and the order in which to use them. However, there are some other options in Guided mode that can be more useful, because they can help you to easily create some special effects. (*Note:* We look at some other Guided mode special effects in Chapter 9.)

Step One:
Open a photo and click on Guided at the top of the Editor window. The new Guided window in Elements 14 has six tabs at the top where you can choose which effect you want to apply to your photo (like the new Resize option, which resizes your image for web or print, or the new Speed Effect, which adds a motion blur to your image). Click on a tab and it'll give you a before/after example of each effect. (Again, the options here are basically tutorials with guided walk-throughs. They're the kinds of things we cover in this book, so if you weren't reading this book, then that would be a good section to check out. Since you *are* reading this book, I'd stick with the tutorials you just paid for.)

Step Two:
Many of these effects can be done in Expert mode, but you'd have to use a bunch of tools, dialogs, etc. So, if the effect you want is here, it's not a bad place to get to know. Here, we'll look at the new Speed Effect in the Fun Edits tab. By the way, the rest of the effects pretty much work exactly the same—remember, this is "Guided" mode, so Elements will walk you through each step. The Speed Effect adds speed or motion to your image, so go ahead and click on Speed Effect.

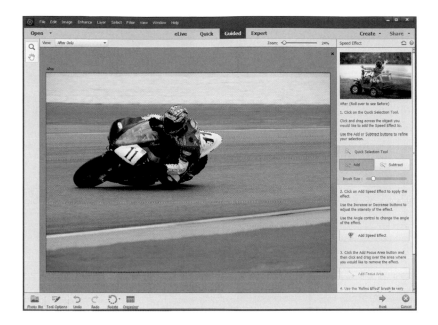

Step Three:

You'll see the Palette Bin appear on the right side of the window, showing all of the settings you have control over for the effect. The first thing you'll want to do is click on the Quick Selection Tool, then paint over the area of your image where you want to apply the effect. Here, I'm painting over the rider and the back of the bike. If you paint over areas you don't want selected, just click on the Subtract button and remove them from your selection.

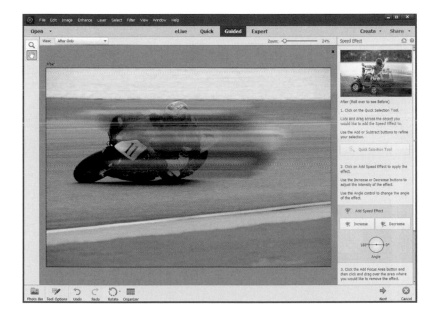

Step Four:

Next, click on the Add Speed Effect button to add the effect. You can increase or decrease the amount of effect applied, by clicking the Increase or Decrease buttons. If your subject is not exactly horizontal or vertical in the image, just click-and-drag the Angle settings to adjust the direction of the effect. Here, it added the effect across our entire subject, but we'll fix that next.

(Continued)

Step Five:

Click on the Add Focus Area button, and then click-and-drag over the areas where you want to remove the effect. Here, I'm removing it from the front of the bike and the front of the rider. If you'd like to refine the effect a bit, just click on the Refine Effect button and use the Add and Subtract buttons to paint more or less of the blur effect from your selected area. You can also adjust the opacity of the effect while you're painting.

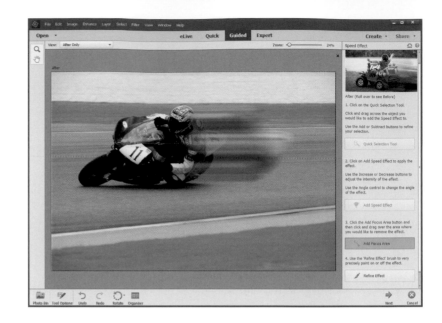

Step Six:

When you're ready, click the Next button at the bottom right. Here, you'll choose what you want to do next with your image—save it, continue editing it, or share it to Facebook, Flickr, Twitter, or SmugMug (if you choose to share it to one of these sites, Elements will ask you for authorization first). So, just click on your choice and you're done. Here, we'll choose to continue editing in Expert mode.

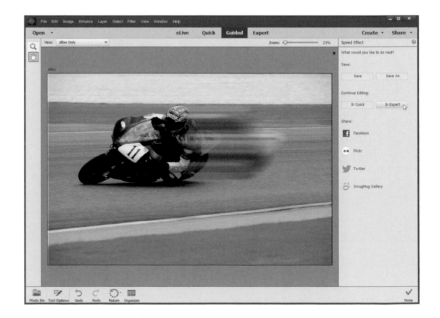

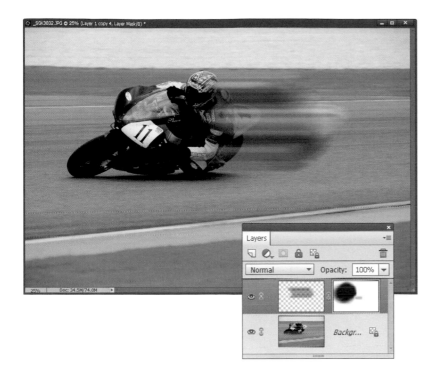

Step Seven:
When the image opens in Expert mode. take a look in the Layers palette, and you'll see Elements has added a layer here, along with a layer mask. Since the whole effect is layer based, you can always reduce the opacity of the layer to pull back the overall effect if you find it's too strong.

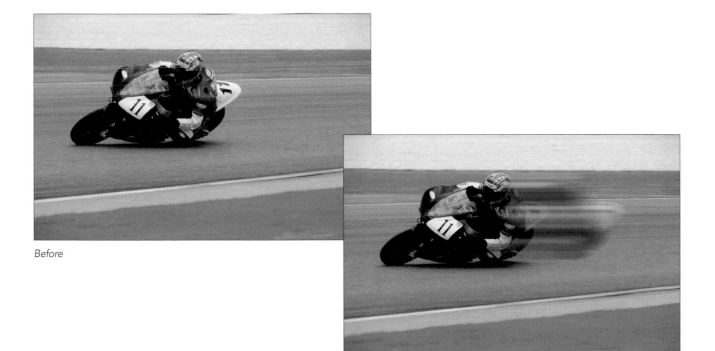

Before

After

A Quick Look at Expert Mode (It's Not Just for Experts!)

Okay, I know the third editing mode is called "Expert" mode, but don't let the name fool you—it's not just for experts. In fact, most of what you'll do in this book is done in Expert mode because, let's face it, that's where all the cool stuff is. You go into Expert mode when you want to do things like retouching photos, or adding text, or modifying just a specific portion of a photo, because it's got a ton of features like layers, layer masks (which are covered in Chapter 5), and much more. So, get it out of your mind that Expert mode is just for experts. It's for you, even if you're not a seasoned pro at Elements.

Step One:

Open an image and then click on Expert at the top of the Editor window, which will take you into the full Elements Editor (if you're not already there) with all the bells and whistles. By the way, if you were to go into Expert mode after applying a Guided edit, you'd actually see all the layers and effects that Elements has applied.

Step Two:

Over on the left side of the window, one of the first things you'll notice is that there are a bunch of tools in the Toolbox. These tools are broken up into categories: View, Select, Enhance, Draw, Modify, and Color. As a photographer using Elements (which I assume you are, since you bought this book), you won't use the Draw tools much (except for the Brush tool) and you won't use the Modify tools much either (except for cropping and straightening). But, you'll use the Select and Enhance tools plenty.

Step Three:

Go ahead and click on one of the tools in the Toolbox. It can be any tool, so just click around a few times and then look at the bottom of the window beneath the preview area. You'll see a context-sensitive Tool Options Bar appear for each tool (here, I clicked on the Quick Selection tool). Since most tools have different settings, you'll notice it changes based on which tool you click on. This is a really important area, so make sure you get accustomed to it. (*Note:* To hide/show the Tool Options Bar, press **F5**.)

TIP: Getting to Tools Quickly

If you're going to be using Expert mode a lot, then it's a good idea to get used to the keyboard shortcuts for the most commonly used tools. If you hover your cursor over each tool in the Toolbox, you'll see a tool tip appear with the name of the tool followed by its one-letter keyboard shortcut.

(Continued)

Step Four:

Now look over at the bottom-right of the window. There are five icons there. Click on the Layers icon to open/close the Layers palette on the right side of the window. Layers are one of the key elements to working inside of Expert mode and there's actually a whole chapter devoted to them (Chapter 5). For now, just know that you should probably keep that palette open all the time, since you'll be using it a lot.

Step Five:

Click on the More icon to access some of the other palettes. As for the other icons, you (as a photographer, at least) probably won't use them as much.

TIP: Undock the Layers Palette
To undock the Layers palette from the right side of the window, choose **Custom Workspace** from the More icon's pop-up menu, then click on the Layers palette's tab and drag it out of the nested palettes. This will minimize the size of the palette, giving you more room in your work area. To hide the other palettes, choose **Close Tab Group** from the active palette's flyout menu (click on the down-facing triangle icon at the top right of the palette).

Step Six:
Finally, don't forget the menu bar at the very top of the window. That's the launch pad for a lot of the things we'll do in the book. So, for example, if you read "Go to the Layer menu," that means to go to the Layer menu up in the menu bar. And, if you read something like "Go to the Layers palette," that means to go to the palette we just talked about in Step Four.

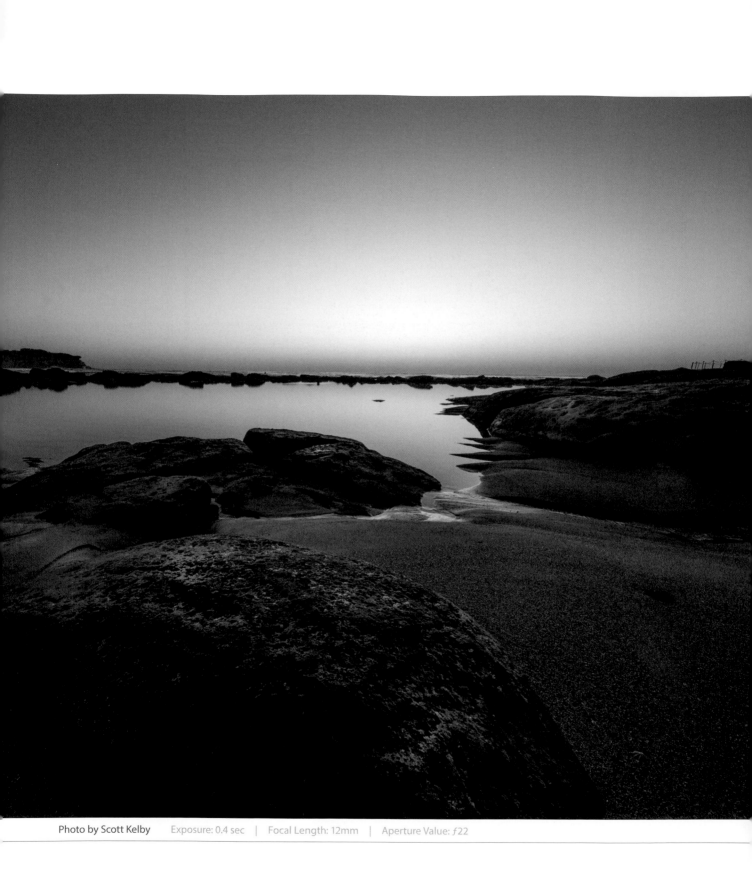

LAYER CAKE
working with layers

One of the problems with people is you can't always get them to stand in front of a white background, so you can easily select them, so you can then place them on a different background. It's just not fair. If I were elected president, one of my first priorities would be to sign an executive order requiring all registered voters to carry with them a white seamless roll at all times. Can you imagine how much easier life would be? For example, let's say you're a sports photographer for an NFL *Monday Night Football* game with one of those Canon telephoto lenses that are longer than the underground tube for a particle accelerator, and just as the quarterback steps into the pocket to complete a pass, a fullback comes up from behind, quickly unfurls a white, seamless backdrop, and lets you make the shot. Do you know how fast you'd get a job at *Sports Illustrated*? Do you know how long I've waited to use "unfurl" in a sentence and actually use it in the proper context? Well, let's just say at least since I was 12 (three long years ago). Anyway, in this chapter, you'll learn all about working with layers, along with one of the best things about layers—layer masks, which you can use to treat everyone, every object, everything, as though it was shot on a white seamless background. By the way, in case you were wondering, the name for this chapter, "Layer Cake," is based on the 2004 movie of the same name starring Daniel Craig, Sienna Miller, and Michael Gambon.

Layer Basics

This tutorial is only meant for those of you who don't really understand why you would use layers. If you already know why layers are important, then skip this and go straight to the next one, where we dive right into building things with layers. So, let's talk a little bit about layers and how they're the foundation of everything you do in Elements. Think of it this way: you'd never dream of drawing on a printed photograph with a black marker and then expect to go back and erase that drawing, would you? Well, that's exactly what you're doing if you don't use layers in Elements and you work on the original image.

Step One:
Picture this: you're holding a printed photo (we're using one of Corey here, but it can be any printed photo). The point is, imagine you set that photo down on the desk, grabbed a black marker, and started drawing on it—fake eyebrows, a mustache, and maybe even a funny beard.

BRAD MOORE

Step Two:
Now, what would happen if you grabbed a damp towel and tried to erase what you just drew? One of two things would most likely happen: (a) you would start to erase the drawing marks, but you'd probably start to ruin the photo under them, as well, or (b) you wouldn't be able to erase anything (if you used a permanent marker) and you'd be stuck with a pretty funny-looking photo.

BRAD MOORE

BRAD MOORE

Step Three:

Let's take this example one step further. Back up to the point where you have a photo that you want to draw over. This time, though, you also have a sheet of transparent plastic.

BRAD MOORE

Step Four:

Now when you place the photo down on the desk and get ready to draw, you place the transparent sheet of plastic over it. Just like before, imagine taking a black marker and drawing over the photo. However, unlike before, you're not drawing directly on the photo it-self—instead, you're drawing on the transparent plastic. It looks the same, though, right?

(Continued)

Step Five:

After you see the final result, you'll probably decide that Corey looks much better without a mustache and beard. Once again, try erasing what you just drew with that damp cloth. Now it's a breeze. Or, if you're unhappy with the entire project, then just toss the transparent sheet of plastic into the garbage and start over again. By using that transparent sheet of plastic, you've gained a tremendous amount of flexibility.

BRAD MOORE

Step Six:

Okay, enough imagining. I promise we'll actually be using Elements for the rest of the chapter. Go ahead and open a photo in the Editor by clicking on the File menu and choosing **Open** (or just press **Ctrl-O [Mac: Command-O]**). Navigate to the photo you want (or just use the photo of Corey), click on it, and click Open. Now you'll see the photo, but more importantly, notice the Layers palette (if you don't see it, just go under the Window menu and choose **Layers**). You should notice that there's only one layer in the Layers palette—it's called Background.

PETER HURLEY

Step Seven:

Select the Brush tool from the Toolbox (or just press **B**), then click on the Brush thumbnail down in the Tool Options Bar to open the Brush Picker, and select a small, hard-edged brush. Press the letter **D** to set your Foreground color to black and start painting on the photo. Have at it—a funny face with glasses, a mustache, whatever you want!

Step Eight:

After you're done painting on the photo, you'll inevitably think it looked much better before the vandalism (sorry, I meant to say artwork). So, select the Eraser tool **(E)** from the Toolbox and try to erase those brush strokes away. See what happens? Not only do you erase away the black brush strokes, but the underlying photo is erased, as well (you see white here because my Background color is set to white). Not good, but as you can imagine, there's a better way to do this. Go ahead and close this image, but make sure you don't save the changes.

(Continued)

Step Nine:

Let's bring this example back around to the photo with the transparent sheet of plastic. Remember how well it worked to isolate our drawing on the transparent sheet of plastic? Well, layers give us the same benefit. Open a new image (or use the same one of Corey) and click on the Create a New Layer icon at the top of the Layers palette (circled in red here). You'll see a new layer, named Layer 1, now appears on top of the Background layer. This new layer is just like that transparent sheet of plastic.

Step 10:

Press B to select the Brush tool again, like you did in Step Seven. Click once on Layer 1 in the Layers palette to make sure it's selected (you've got to click on a layer to select it in the Layers palette. If you don't, then you may be working on the wrong layer. Always look for the layer that is highlighted in color. That is the current or active layer and the one that you'll be editing). Then, start painting on it just like before. Everything should look and act exactly the same.

Step 11:

Finally, to bring this example back around full circle, select the Eraser tool again and erase away any of those brush strokes. You'll see that you can easily erase them without affecting the original photo. That's because you created your changes on a separate, blank layer on top of the photo. You never touched the original photo, just the layer on top of it.

There you have it my friends—the totally basic introduction to layers. Don't forget to stop by the website (mentioned in the book's introduction) to download the images to follow along with. Now, roll your sleeves up and get ready—we've got some really cool stuff ahead.

Using Multiple Layers

The main idea behind this tutorial is to use multiple images and get used to the way layer stacking works. Working with one image is great, but you'll get an even better understanding of layers when you start bringing multiple images into one Elements document. There are going to be plenty of times where you want to take a layer from one image and add it into another image you're working on. A great example would be blending multiple photos together to create some type of collage.

Step One:

First off, open the photos that you'd like to combine into one image. Click on the File menu and choose **Open**. Then navigate to each photo and click Open. Here, we're going to combine three images, so I've opened all three and can see them in my workspace. *Note:* To float all three image windows, press **Ctrl-K (Mac: Command-K)** to open the General Preferences, and turn on the Allow Floating Documents in Expert Mode checkbox. Then, in the Window menu, go under Images, and choose **Float All in Windows**.

Step Two:

Now let's create a brand new document to hold what we're about to create. Go under the File menu, under New, and choose **Blank File**. For this example, we're going to create a promo card for a golf tournament. I want my new document to be 7" tall by 5" wide, so from the Preset pop-up menu, choose Photo, then from the Size pop-up menu, choose **Portrait, 5x7**. Since we're just displaying this onscreen, change the resolution to 100 ppi. If we were going to print this, we'd probably use something like 240 ppi. Click OK to create the new blank document.

Step Three:

We need to get the photos into the new blank document now. There are a couple ways to do this and each have their place. First, let's try the one I use the most—copy-and-paste: Click on the first photo of the golfer to bring it to the front and make it the active document. Go under the Select menu and choose **All** to select the entire image. Copy this selection by going under the Edit menu and choosing **Copy**. Now, click over to the blank document and paste the copied photo into it by going under the Edit menu and choosing **Paste**. By the way, we're not going to use the Edit menu for these anymore. The keyboard shortcuts for Copy and Paste are **Ctrl-C (Mac: Command-C)** and **Ctrl-V (Mac: Command-V)**, respectively, and they work a lot faster.

(Continued)

Step Four:

Right after you paste the image, you should see a new layer called Layer 1 appear in the Layers palette right above the Background layer. By default, Elements automatically creates a new layer whenever you paste something into an image. This is a good thing, because it forces us to work on multiple layers. Now, select the Move tool from the Toolbox (or just press **V**), click on the pasted image, and drag it so the golfer is in the top left of the document.

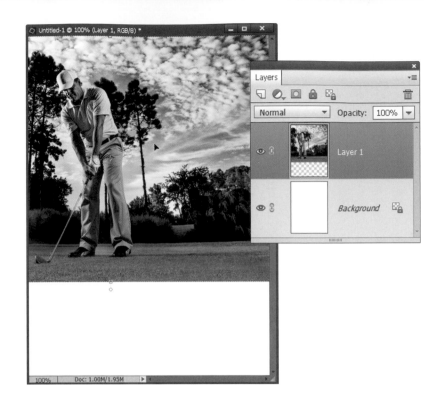

Step Five:

Let's bring another photo into the new document. Before, we used copy-and-paste, but there's another way: you can also click-and-drag images into other documents. Position the new document window and the other photo of the golfer so you can see both of them. Click once on the new photo to make it the active document, and with the Move tool, click-and-hold on the player photo, and drag it over into the new document (that's why you need to be able to see both of them). Once your cursor is over the new document, release the mouse button and this photo will appear as a new layer. Use the Move tool to drag it so the golfer is in the top right of the document.

Step Six:

Close the original photos of the golfer. We don't need them open anymore because we've copied their contents into layers in our new document. (The layers in our new image are not connected to their originals. No matter what you do here, you won't affect the originals.) Now, notice how the golfer on Layer 2 hides the golfer on Layer 1? That's because Layer 2 is on top of Layer 1. Let's swap them by clicking on Layer 1 in the Layers palette and dragging it above Layer 2. Now, you'll see the contents of Layer 1 on top of Layer 2.

TIP: Hide a Layer

You can hide a layer altogether by clicking on the little Eye icon to the left of the layer's thumbnail in the Layers palette.

Step Seven:

Now, we're going to blend these layers together, so select the Eraser tool from the Toolbox (or just press **E**). In the Tool Options Bar, click on the Brush thumbnail to open the Brush Picker, and choose a soft-edged brush. Set the Size to something large (like 250 pixels). Also, set the Opacity to 30%. By using a lower opacity setting, we'll be able to lightly erase away parts of the photos that are on top of each other and give the illusion that they're blending together, since you'll see whatever is below them. If we used a 100% setting, you'd see some obvious seams and erase marks. The lower opacity will allow us to blend things better.

(Continued)

Step Eight:

With Layer 1 (the first image of the golfer) active in the Layers palette, start erasing away the right side of the photo—just a few clicks with the Eraser tool should do it. Remember, though, you're working with a tool that's set to one-third strength (the Opacity setting), so you're only erasing a little bit at a time. The more times you click, the more you'll erase. So, just keep erasing and you'll reveal the contents of Layer 2 (the other image of the golfer), which is below it in the layer stack (press the Left Bracket key to decrease the size of your brush if you need to erase a smaller area). This makes the two photos blend together.

Step Nine:

Finally, let's bring in a finishing logo. Open the image that has the graphics and logo that you want to add. So far, we've been opening JPEG images and dragging them in, but you can just as easily open other types of files, too, including Photoshop (PSD) files. Here, I've got a PSD file that has a logo on its own layer.

Step 10:
Go back to your new image and make sure the top layer in your Layers palette (Layer 1) is active (this is important, because when you bring the logo over to this document, it will appear above whichever layer is active in your Layers palette. So, save time by clicking on the layer you want it to appear above). Now, click-and-drag (or copy-and-paste) the logo from the other image into your new image. It'll appear at the very top of the layer stack, ready to be positioned where you need it. Here, I moved it to the bottom of the image.

Everything Else About Layers

If you think you know layers pretty well now, this tutorial will show you more. Trust me. We're going to build a project—a big project, I know—and along the way, we're going to see all the things in the Layers palette that help you work better. We'll look at moving multiple layers at the same time, linking layers, resizing layers, aligning layers, merging and flattening, and even which features in the Layers palette are worth using and which ones actually hold you up. We'll also see how to get around that dreaded locked Background layer, so you can actually do something with it. By the time you're done with this one, you will be a layers pro.

Step One:

In this tutorial, we're going to create a wedding album page. Start by opening the main image that will be the background of the page. Here, I'm using a texture I downloaded from Fotolia .com. You can find a ton of them just by searching for the word "texture."

©FOTOLIA/ARTSPACE

Step Two:

Before we move on, I've got to share this tip with you (you're seriously going to love me for this one): Ever thought the thumbnails in the Layers palette were too small? Well, you can change them. Every palette has a flyout menu associated with it, and the Layers palette is no different. Click on the little icon with the down-facing arrow and four lines next to it at the top right of the palette. Choose **Panel Options** from this flyout menu, select the largest thumbnail option by clicking on its radio button in the dialog, and then click OK. Now, just sit back and revel in the seemingly inhuman-sized (not really) Layers palette thumbnails.

Step Three:
Notice how the name of the bottom layer in the Layers palette is always "Background"? If you haven't already, you will undoubtedly come to hate that Background layer, because you simply can't do certain things to it. You can't move it with the Move tool and you can't change its position in the layer stacking order, either. Well I'm here to tell you that you can change all that. Make the Background layer a regular layer by just double-clicking on the word Background and clicking OK in the New Layer dialog. Now it's a regular layer. Sweet, huh?

Step Four:
Next, we're going to spice up the background texture a little by adding some depth to it. Since the texture layer isn't the Background layer anymore, we can actually add a layer below it. You could always click on the Create a New Layer icon at the top of the palette to create a new layer on top of the texture layer and then click-and-drag it beneath it, but there's a shortcut: press-and-hold the Ctrl (Mac: Command) key and click on the Create a New Layer icon, and the new layer will automatically be added below the currently selected layer.

(Continued)

Step Five:

Click on the small Eye icon to the left of the texture layer's thumbnail to hide that layer and, with the new blank layer you just added at the bottom active (highlighted), add a white-to-black radial gradient. To do this, select the Gradient tool from the Toolbox **(G)**, click on the down-facing arrow to the right of the Gradient thumbnail in the Tool Options Bar, and choose the Black, White gradient from the Gradient Picker (the third gradient from the left in the top row). Now, click on the Radial Gradient icon (it's the second icon to the right of the Mode pop-up menu), turn on the Reverse checkbox (also in the Tool Options Bar), then starting in the middle of your document, just drag from left to right to add a gradient to the bottom layer.

Step Six:

Next, we're going to use the gradient to give our background texture some depth and dimension. Click on the texture layer's Eye icon again to make it visible. We just added a gradient, but we don't see it anymore because the texture layer now hides it. The Opacity setting, though, will let us blend the two together. So, click on the top texture layer to make it active and then move your cursor over the word "Opacity" in the top right of the Layers palette. You'll see two little arrows appear on either side of the hand cursor. If you click-and-drag your cursor to the left, you'll decrease the Opacity setting, allowing you to see through the texture to the gradient below. Here, I set the Opacity to 92%.

Step Seven:

Open the photos that are going to be included on the album page. (*Note:* This is easiest if you turn on the Allow Floating Documents in Expert Mode checkbox in Elements' General Preferences. Then, you can click on the Layout icon at the bottom of the window and choose **All Floating**.) Here, I'm going to use three wedding photos. Let's start with the vertical photo of the bride. Position the photo so you can see both it and the texture (album) image. With the Move tool **(V)**, click-and-hold on the photo, then drag it into your album image, and place it toward the left. As you can see, it happens to pretty much fit right in and is a good size for what we're looking for. That's not always the case, though, so read on to the next step.

Step Eight:

Let's move on to the next photo. I know that I want two small square photos toward the right of this layout, and just by looking at this image of the bride and groom, you can tell it's not going to work, because it's not square. So, instead of bringing the entire photo in, let's just take a selection. Grab the Rectangular Marquee tool **(M)**, press-and-hold the Shift key (which keeps your selection square), and make a square selection over the area you want (if it's not in the right place at first, simply click-and-drag inside the selection to move it). Now, press **Ctrl-C (Mac: Command-C)** to Copy and then click on the album image and press **Ctrl-V (Mac: Command-V)** to Paste that selected area into the album layout. You'll see only the selected part of the photo is placed and it's on its own layer.

(Continued)

Step Nine:

We got lucky with the first photo of the bride—it was the exact size we wanted. But, I'll be the first to tell you that it will never happen again. More often than not, you'll have to resize the images you add. In this case, the second photo of the couple is still too big. The best way to resize precisely is to press **Ctrl-T (Mac: Command-T)** to go into Free Transform, click on the Scale icon near the left end of the Tool Options Bar, and then enter the exact width and height settings you want. In this case, enter 275 px for the W(idth) setting and 275 px for the H(eight) setting. Don't forget to actually type the "px" (for pixels) after 275 or bad things will happen. Press **Enter (Mac: Return)** when you're done.

Step 10:

Now we need to bring the third photo into the wedding album image. Make a square selection of only the part of the photo where you can see the couple's rings, then copy-and-paste the selection into the wedding album image, just like we did with the last one. Resize it just like in the previous step, so it's exactly 275x275 pixels in size. Finally, use the Move tool to position it somewhere below the other one (no need to be exact, because we'll take care of aligning them in the next step).

Step 11:
As you can see, the two small photos we just added to the album image probably aren't perfectly aligned. We could try to precisely align each one of them with the Move tool, but it's way too hard to really be exact when you're just eyeballing it. Instead, let's use the Align Layers options. First, we need to select the layers we want to align in the Layers palette. So, click on one of the small photo layers in the Layers palette and then Ctrl-click (Mac: Command-click) on the other small photo layer to select multiple layers. You'll be able to tell that both are selected because they'll be highlighted with a color (the layers not selected will not be highlighted).

Step 12:
Now, you need to tell Elements where to align the layers. First, press **Ctrl-A (Mac: Command-A)** to select the whole canvas, so Elements sees a selection edge around the entire album image. Then, with the Move tool still selected, you'll see some Align choices in the middle of the Tool Options Bar. Click on the Right icon to align the selected layers to the right side of the selection. This pushes the two photos up against the right edge of the album image. It's automatic, so there's no manual effort required on your part.

(Continued)

Step 13:

Remember how you selected the two photo layers back in Step 11? Let's say you decide you want to move those two smaller photos somewhere else in the album image. Since they're both still selected, there's a temporary link between the two layers and any moves you make will affect both at the same time. Press **Ctrl-D (Mac: Command-D)** to remove your selection from the entire image, and then, using the Move tool, click-and-drag one of the photos toward the left, so it's not right up against the right edge of the image (I like this placement better actually). The other photo will follow right along. When you're done, just click on one of the layers in the Layers palette to deselect the other.

Step 14:

If you want to create a more permanent connection between the two layers, so that every time you move one of them, the other follows, Elements lets you create a link between them that lasts even after you click on another layer to do something else. To create this link, select both of the smaller photo layers, just like we did before. Then, click on the Link Layers icon at the left of either layer (next to the Eye icon and circled here). Now, click on one of the layers, so only that one is active, and then use the Move tool to move one photo, and both of them will move together. With this permanent link, from now on, you'll only have to select one layer to move and the other(s) will follow.

Step 15:
Let's take a break from copying, pasting, and moving for a minute. As your Layers palette starts growing, you should name your layers to keep things organized. Just double-click on the layer name in the Layers palette, the name will highlight, and you can then type a new name (as seen here for the three photo layers).

Step 16:
Now, back to our album page. Let's add a white stroke around the small photos. Click on the Couple Medium layer in the Layers palette to make it the active layer, then press-and-hold the Ctrl (Mac: Command) key and click on the layer's thumbnail. This puts a selection around whatever is on that layer. Click on the Create a New Layer icon at the top of the palette to create a new layer on top of this layer. From the Edit menu, choose **Stroke (Outline) Selection**. Set the Width to 3 px, the Color to white (click on the swatch), the Location to Inside, and click OK. Press Ctrl-D (Mac: Command-D) to Deselect and you'll see a white stroke around the photo. Go ahead and rename this stroke layer something descriptive, too.

(Continued)

Step 17:

Let's add the same stroke to the other square photo. Repeat the same steps: click on the layer, Ctrl-click on the layer thumbnail, add a new layer, then add your stroke. When the Stroke dialog opens, it should already have the correct settings, so just click OK. Now, deselect and rename your layer.

Step 18:

Next, let's add some simple colored rectangles to the background. Click on the background texture layer in the Layers palette to make it the active layer, then click on the Create a New Layer icon to add a new layer above the background texture, but below the large photo of the couple. Using the Rectangular Marquee tool, make a tall, thin selection to the right of the main couple photo. Click on the Foreground color swatch at the bottom of the Toolbox to open the Color Picker and set the color to R: 137, G: 160, B: 165. Click OK to close the Color Picker.

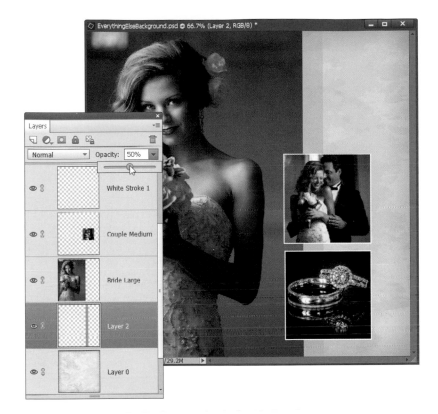

Step 19:
Now, press **Alt-Backspace (Mac: Option-Delete)** to fill that selection with the Foreground color, and then press Ctrl-D (Mac: Command-D) to Deselect. Since the color appears a little obtrusive as it is, let's make it a bit more subtle. At the top right of the Layers palette, reduce the Opacity setting of this layer to 50% (we did this earlier in the project with the texture background for the gradient layer we added below it).

Step 20:
Click on the Create a New Layer icon again to add one more new layer on top of the current rectangle layer. Then, create another thin rectangular selection (thinner than the first one and to its left) with the Rectangular Marquee tool. Press **D**, then **X** to set your Foreground color to white, and press Alt-Backspace (Mac: Option-Delete) to fill that selection with white. Deselect, reduce the layer's Opacity to 70%, and now you've got some extra color and a nice way to separate that large photo from the background.

(Continued)

Step 21:

Another task to do often is delete any layers that aren't needed or that you just don't like. For example, let's say you don't like the teal rectangle you added a few steps back. You could click on the little Eye icon to the left of the layer thumbnail to turn it off, but that still leaves the layer. To delete it permanently, click on that layer and drag it onto the Trash icon at the top right of the Layers palette (as shown here). Once you know you want something removed, deleting layers is a good habit to get into as you're working, because it helps keep file size to a minimum and Elements running faster overall. Plus, it cuts down on clutter in the Layers palette. I kinda like it with the teal rectangle, so I'm not going to delete it, but I wanted to show you how it's done.

Step 22:

Finally, I'd merge any layers that don't need to stay editable. You see, every layer you have in the Layers palette takes up space in your file and your computer's memory. Plus, too many layers are just plain hard to deal with. Who wants an image with 20, 30, or even more layers in it? So I merge (flatten) layers often when I know I don't need to change something. A great example here would be the small square photos and their stroke layers. To merge them, select both layers first (as seen here). Then from the Layers palette's flyout menu, choose **Merge Layers**. This squishes both layers into one. You won't be able to edit the stroke independently of the photo it was around anymore, but you probably don't care at this point. That's it! The über layers project is complete. The only thing left to do is add some type with the Horizontal Type tool, and then save the image as a PSD file, so you can reopen it later and still edit all of the layers if you need to.

Blending layers is the next level of merging your images together. There are a lot of ways to blend layers together that go beyond simply changing the opacity. One of those ways is called blend modes. It's like opacity on steroids, and the effects you can get with blend modes are unlike any other effects you'll find in Elements. That said, I gotta tell ya, there are a lot of blend modes in Elements. My goal here is to show you only those you really need to know about. Most of the blend modes will probably never get used, so we're just going to concentrate on the ones that you're going to use often.

Layer Blend Modes for Photographers

Step One:
One of the first ways you'll see blend modes can help with photos is when you have a photo with a dark or under-exposed area. In our example here, we have a really common problem with portraits taken outdoors. Sometimes the face (or the entire person, in this case) in a portrait will show up a little darker than we'd like. But the Screen blend mode comes in really handy and can fix that in no time flat.

Step Two:
Grab the Lasso tool **(L)** or the Quick Selection tool **(A)** and make a quick selection of our model. Press **Ctrl-J (Mac: Command-J)** to duplicate the selection onto its own layer, so now you'll have two layers in the Layers palette. Then, at the top left of the palette, change the blend mode of the top layer to **Screen**. Because Screen is a lightening blend mode, it has the effect of lightening everything on that layer.

TIP: Use a Shortcut for Screen
You can use the keyboard shortcut **Alt-Shift-S (Mac: Option-Shift-S)** to switch to the Screen blend mode quickly.

(Continued)

Step Three:

Yeah, I know. Right now she looks really bright for her surroundings and there are some weird bright spots, like the one by her hand. You could stop here if you wanted a good prank to play on a friend, but let's assume you want to move on. Get the Eraser tool **(E)**, then click on the Brush thumbnail in the Tool Options Bar, and choose a small, soft-edged brush from the Brush Picker. Click-and-drag to erase away the areas that don't need the lightening effect. Finally, try reducing the Opacity of the layer to about 80% to help it blend in better with the original layer below it.

Step Four:

Another problem that blend modes can help with is when you have a bright, faded area in a photo. Here I've opened a travel photo where the waiter looks good, but the rest of the photo is a little bright and flat-looking. The first step is to duplicate the Background layer by pressing **Ctrl-J (Mac: Command-J)**.

Step Five:

Change the blend mode of the duplicate layer to **Multiply**. Since Multiply is a darkening blend mode, this darkens everything in the photo. It may look just fine like that, so feel free to leave it alone. However, in this photo I think it made the waiter's skin look too saturated and dark. So, get the Quick Selection Tool (press **A** until you have it) and paint on his skin to select it.

Step Six:

Press the **Backspace (Mac: Delete)** key to remove (or erase) his skin, then press **Ctrl-D (Mac: Command-D)** to Deselect. The darkening effect of the Multiply blend mode should now affect the rest of the photo, so it has a little more punch to it. Also, feel free to reduce the opacity of that top layer if the effect is too dark. Here, I reduced it to 75%.

(Continued)

Step Seven:

Here's another example of what Multiply can be used for: Open one of those cool, grungy black frame images, and you'll find most of them have white in the middle where a photo is supposed to go. To start, press **Ctrl-A (Mac: Command-A)** to put a selection around the entire frame image.

Step Eight:

Press **Ctrl-C (Mac: Command-C)** to Copy the frame, then open another image and press **Ctrl-V (Mac: Command-V)** to Paste it into that image. Press **Ctrl-T (Mac: Command-T)** if you need to resize it to fit the photo. Then, change the blend mode of the frame layer to Multiply, and Photoshop will automatically drop out the white and leave you with just the black frame around the photo. No selections, no nuthin'.

Step Nine:

As you'll see in Chapter 9, when you have a photo with a bright sky and a dark foreground, you can use a gradient to act like a graduated neutral density gradient filter. You simply change the gradient layer's blend mode to Overlay or Soft Light. Well, here's a totally different example to improve your photos with the Overlay or Soft Light blend mode: Open a photo and a texture image. It could be something you've downloaded or created in Elements, or you could just take a photo of a wall. Copy-and-paste the texture image into the photo. Change the texture layer to **Overlay** (or Soft Light), and it gives the photo a very rugged and faded style, as seen here.

The Power of Layer Masks

One of the things that Elements never had that the full version of Photoshop did was layer masks. It was always one of the big features that people liked more about the full version of Photoshop. Well, a few versions ago, Adobe decided to add layer masks to Elements. Yup, the same layer masks as Photoshop. These things are a huge help when it comes to working on your photos. Whether it's retouching, color correction, sharpening—you name it—layer masks play a key role. We'll give you a quick introduction here, but you'll see them pop up plenty of times throughout the book.

Step One:

In order to really take advantage of layer masks, you need to have at least two layers. So, go ahead and open two images that you'd like to combine in some way. In this example, we're going to put the photo of the football players into the computer screen and make it look like the two guys jumping are coming out of the screen.

Step Two:

Click on the photo of the players, press **Ctrl-A (Mac: Command-A)** to Select All, then press **Ctrl-C (Mac: Command-C)** to copy the photo. Switch over to the photo of the laptop, and press **Ctrl-V (Mac: Command-V)** to paste the players on top of the laptop screen on a separate layer. Press **Ctrl-T (Mac: Command-T)** to go into Free Transform (if you can't see the edges of the photo or the control handles, press **Ctrl-0** [zero; **Mac: Command-0]**). With the Constrain Proportions checkbox turned on in the Tool Options Bar, grab a corner handle and drag inward to make the image smaller, then move it so the bottom-left corner of the photo meets the white space at the bottom-left corner of the screen. Once you've got the players positioned like you see here, press **Enter (Mac: Return)** to lock in your changes, and close the original photo of them, so you're left with only the document with two layers.

©DOLLAR PHOTO CLUB/LEMBIT

Step Three:

There are two main ways to work with layer masks: selections and brushes. Let's look at selections first. Hide the top layer (the players) by clicking on the Eye icon to the left of it in the Layers palette (it's circled here in red), so you only see the laptop. Now, use the Rectangular Marquee tool **(M)** to make a selection of the white area inside the laptop screen.

Step Four:

Unhide the photo of the players by clicking on the Eye icon again, and just make sure that layer is active (high-lighted). When working with layer masks, a selection tells Elements that you want to keep that portion of a layer and hide the rest of it. Notice I said hide, not delete. Give it a try. Click on the Add Layer Mask icon at the top of the Layers palette (shown circled here) and see what happens.

(Continued)

Step Five:

You should now see only the rectangular area (that was previously selected) of the photo. Again, when you have a selection active, a layer mask tells Elements that you want to keep the selected area visible and hide everything that isn't selected. In our case, a portion of the layer with the players on it was selected, so that stays visible. But part of their heads was hidden (again, not deleted—just hidden for now).

Step Six:

Now take a look at the layer itself. Notice it has a black-and-white thumbnail next to the image thumbnail? That's the layer mask. The layer mask is the same size as the layer. The white part of the thumbnail corresponds to the rectangular portion of the photo (the players) that we see. The black part corresponds to the area we don't see. In other words, white shows you whatever is on the layer that the layer mask is attached to and black hides that part of the layer and shows you whatever is below it in the layer stack (in this case, the laptop).

Step Seven:
The biggest advantage of layer masks is that nothing is permanent. Even though it looks like we've deleted the top of the image, it's still there. Go ahead and look at the layer thumbnail (circled here) and you'll see it looks exactly the same. Nothing was deleted—just hidden. Layer masks are non-destructive and always give you a way out. Just to demonstrate really quickly, click once on the layer mask thumbnail (not the layer thumbnail) to select it. Then go under the Edit menu and choose **Fill Layer**. Set the Use pop-up menu to **White** and click OK to fill the whole mask with white again. Things are back to normal, as if nothing ever happened.

Step Eight:
Press **Ctrl-Z (Mac: Command-Z)** to undo that last step, so the black-and-white layer mask is back again. Let's take a look at the other main way to work with layer masks: adjusting them after the fact with brushes. In our example, the players' helmets are cut off. We can fine-tune the mask to show them, though. Remember, layer masks just care about one thing: black and white. It doesn't matter how black and white get there. Earlier, we did it with a selection, but you can also use a brush to get the ultimate flexibility and control over the mask. Click on the mask thumbnail, then get the Brush tool **(B)**, click on the Brush thumbnail in the Tool Options Bar and choose a small, soft-edged brush from the Brush Picker. Press **D** to set your Foreground color to white (remember, white allows us to keep whatever is on this layer visible) and paint over the tops of their helmets. You'll see them reappear, because they weren't permanently gone in the first place.

(Continued)

Step Nine:

Why all the trouble? If you're asking yourself, why not just erase away the unwanted areas instead of adding a layer mask, then read on. If not, skip to the next step. So, what would happen if we erased away the top of the image with the Eraser tool, and then we erased some more background? At some point, maybe we'd erase away part of a player's helmet. But then we'd continue to erase away the background until we got to the point where we were done, and we'd realize we'd erased some of the helmet. Well, each one of those clicks of the mouse when we erase is a history state. They build up, so we'd have to undo all the work we did to get back to the point where we inadvertently erased his head. Needless to say, that'd be a big pain in the neck. Plus, since layer masks are part of the layer, we can save our image as a PSD file and open it again tomorrow (or at some later date) and change it. Layer masks allow us to be non-destructive in our editing, so we can always come back and change something later if we need to.

Step 10:

You can see in Step Eight that I went a little overboard with the white brush and brought back parts of the background, too. No sweat. Remember that black and white thing? We were painting with white to bring areas back into view, so if we switch to black, the opposite will happen. Press the letter **X** on your keyboard to switch your Foreground color to black. Then, press **Ctrl-+ (Mac: Command-+)** to zoom in if you need to, and paint on the mask again to hide those areas and reveal the laptop and white background behind their helmets.

Final

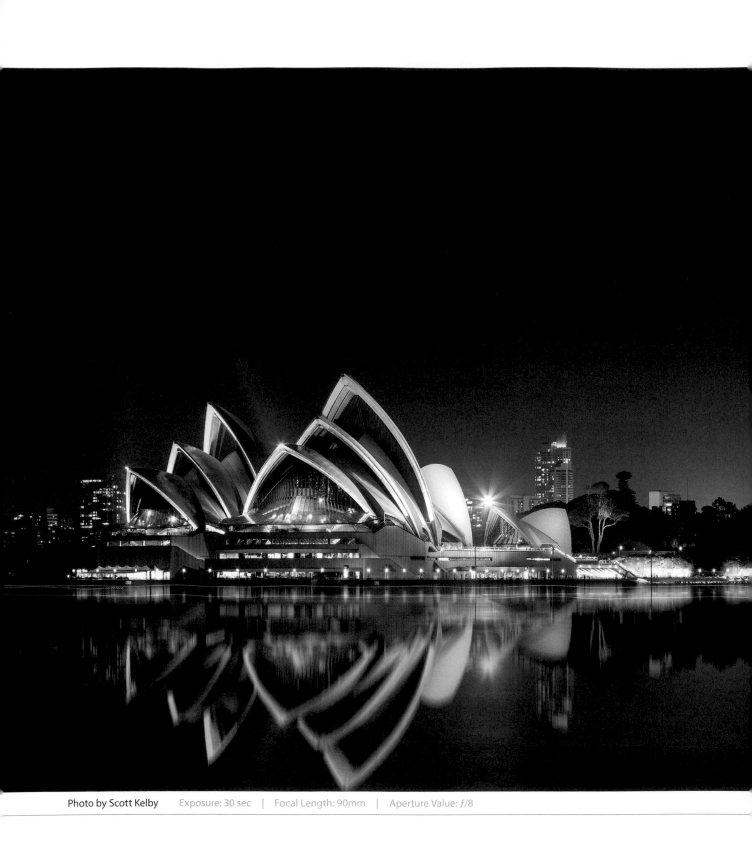

Photo by Scott Kelby Exposure: 30 sec | Focal Length: 90mm | Aperture Value: ƒ/8

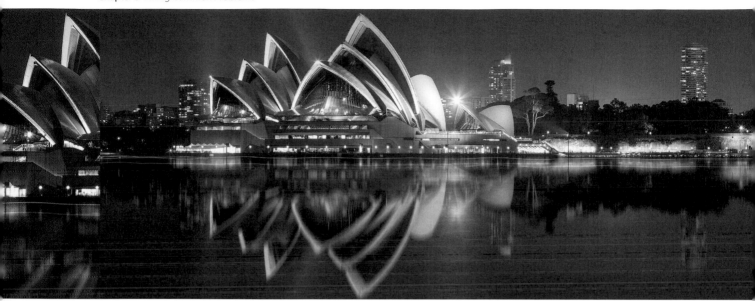

LITTLE PROBLEMS
fixing common problems

The title for this chapter comes from the 2009 movie *Little Problems* (written and directed by Matt Pearson), but I could have just as easily gone with the 2008 short *Little Problems* (written and directed by Michael Lewen), but there was one big thing that made the choice easy: the first movie was about zombies. You just can't make a bad movie about zombies. It's a lock. Throw a couple of hapless teens (or in this case "an unlikely couple") into some desolate location with a couple hundred flesh-starved undead, and you've got gold baby, gold! Now, has anyone ever wondered, even for a second, why every zombie in the rich and colorful history of zombies, has an insatiable hunger for human flesh and only human flesh? Why can't there be zombies that have an insatiable hunger for broccoli? Then, in their bombed-out shell of a desolate vacant city, on every corner there would be other zombies selling broccoli the size of azalea

bushes. Anyway, it's just a little too coincidental that every zombie wants to eat you, but they don't want to eat something that might actually keep them alive, and is in ample and easily reproducible supply, like broccoli, or spring rolls, or chowder. Nope, it has to be human flesh, even though you know and I know (say it with me) it tastes like chicken (well, that's what I've been told, anyway). Another thing that drew me to the first *Little Problems* was the director's last name, seeing as all my books are published by subsidiaries of Pearson Education, a company who somehow chose to hire Nikki McDonald as my editor, despite the fact that they were forewarned by the DCBGC (the Desolate City Broccoli Growers' Consortium) that Nikki might not actually be the strict vegetarian she claimed to be in her resume. I probably shouldn't say anything bad about Nikki, though. I don't want to bite the hand that feeds me.

Adjusting Flesh Tones

So what do you do if someone in your photo has a red face? This is one of the most common people-photo problems out there. You can try this quick trick for getting your flesh tones in line by removing the excess red. This one small adjustment can make a world of difference.

Step One:

Open a photo that needs red removed from the flesh tones. If the whole image appears too red, skip this step and move on to Step Three. However, if just the flesh-tone areas appear too red, get the Quick Selection tool **(A)** and click on all the flesh-tone areas in your photo (press-and-hold the **Alt [Mac: Option] key** to remove any areas that were selected that shouldn't have been). Here, only her face and shoulders are visible.

Step Two:

Go under the Select menu and choose **Feather**. Enter a Feather Radius of about 3 pixels, then click OK. By adding this feather, you're softening the edges of your selection, preventing a hard, visible edge from appearing around your adjustments.

Step Three:

Click on the Create New Adjustment Layer icon at the top of the Layers palette, and choose **Hue/Saturation** from the pop-up menu. Then, in the Hue/Saturation adjustments palette, click on the Channel pop-up menu near the top and choose **Reds**, so you're only adjusting the reds in your photo (or in your selected areas if you put a selection around the flesh tones).

Step Four:
The rest is easy—you're simply going to reduce the amount of saturation, so the flesh tones appear more natural. Drag the Saturation slider to the left to reduce the amount of red (I moved mine to –16, but you may have to go farther to the left, or not as far, depending on how red your skin color is). The changes are live, so you'll be able to see the effect of reducing the red as you lower the Saturation slider. Also, if you made a selection of the flesh tone areas, once you create the adjustment layer, it will hide the selection border from view and create a layer mask with your selection. When the flesh tones look right, you're done.

Before

After

Using the Smart Brush Tool to Select and Enhance Skies at the Same Time

Photoshop Elements includes a brush tool that lets you fix problem areas (as well as create some pretty cool effects) with just a brush stroke. It's called the Smart Brush tool, and it helps keep you from making complicated selections and then having to fix them in a separate step. Instead, you choose which effect you want to apply and just brush away. Let's check it out.

Step One:

Open a photo that has an area you want to enhance or fix. There's actually a huge list of things you can do with this brush, but let's concentrate on one area for now—the sky. A big digital image problem is that the sky never seems to look as vibrant and dramatic as it does when we're there photographing it. Well, the Smart Brush tool has an option to help fix this, so go ahead and select it from the Toolbox (it's the large paint brush icon in the Enhance section) or just press the **F key**.

Step Two:

Once you select the tool, click on the thumbnail near the left side of the Tool Options Bar to open the Preset Picker. As you change the Presets pop-up menu and scroll through the Preset Picker, you'll see what I meant in Step One— there are indeed a bunch of things you can do here. Let's go ahead and choose **Nature** from the pop-up menu, though, to narrow it down. Then click on the thumbnail in the top left, which makes dull skies bluer.

Step Three:
Now the main thing to remember about this tool is that it is still a brush, which means it has settings just like all other brushes (size, hardness, spacing, etc.). So, using the Size slider in the Tool Options Bar, choose a size that'll help you paint over the area fairly quickly. In this example, I'm using a 200-pixel brush for the sky.

Step Four:
The rest is pretty simple—just click-and-drag on the sky to paint the effect on the photo. By the way, notice how Elements automatically started adding the Blue Skies effect to parts of the sky that you haven't even painted over yet? That's where the "smart" part of this brush comes into play. It automatically examines your photo for areas similar to what you have painted on and adds them to the selection.

Step Five:
Now, keep brushing on the sky to get the rest of it. Each time you click, you're adding to the selection, so there's no need to press-and-hold any keys or change tools to widen the effect to other parts of the photo.

(Continued)

Step Six:

Okay, this brush is pretty cool, right? But it's not perfect. There will inevitably come a time (probably sooner than later) where the "smartness" of the brush isn't as smart as it thinks it is, and it bleeds into a part of the photo you didn't want it to (like the trees at the edge of the stadium on the right side of the photo, as seen in Step Five). When that happens, press-and-hold the **Alt (Mac: Option) key** to put the brush into subtract mode. Then paint over the areas you didn't want to apply the effect to (as shown here). Again, Elements will do a lot of the work for you and wipe away the areas, even if you don't paint directly on them. *Note:* Decrease the size of your brush and zoom in on the area, if needed, to help remove it from the selection.

Step Seven:

Here's another really cool thing about the Smart Brush tool: it's non-destructive to your photo. This means you can always go back and change (or even delete) the effects. You'll see this in two ways: First, you'll notice that the Smart Brush tool automatically adds a new adjustment layer to the Layers palette. If you ever find the effect is too harsh, you can always reduce the opacity of the layer to reduce the effect.

Step Eight:

Also, you may have noticed a tiny red box on your photo where you started to paint with the Smart Brush tool. This is the adjustment marker, letting you know you've applied a Smart Brush adjustment to the photo. If you Right-click on it, you'll see you can delete it if you want or you can change the adjustment settings. Choosing Delete Adjustment does just what you think it does—the adjustment will be removed totally. But try choosing **Change Adjustment Settings** instead. It brings up the Adjustments palette or dialog with the controls for whatever adjustment Elements used to achieve your effect. If you're familiar with that Adjustments palette or dialog, you can always try tweaking the settings. In this case, Gradient was used, so the Gradient Fill dialog appeared.

Step Nine:

You can also add multiple Smart Brush adjustments to different parts of the photo. If you notice, the sky looks a lot better, but now the stadium looks a little flat in comparison. Press **Ctrl-D (Mac: Command-D)** to Deselect the current Smart Brush adjustment in the sky. Then, go to the Preset Picker in the Tool Options Bar and, under the Lighting presets in the pop-up menu, click on the second thumbnail in the top row, which intensifies contrast. Now, paint on the foreground to add some contrast to the stadium. To bring some more color out in it, I Right-clicked on the adjustment marker for the stadium and chose Change Adjustment Settings to get to the Adjustments palette options that were used for the effect. It brought up the Brightness/Contrast controls, where I decreased the Brightness to –6 and increased the Contrast to 64.

(Continued)

Step 10:

One more thing: the Smart Brush tool is so smart that you can not only change the adjustment settings, but you can also totally change the Smart Brush adjustment you've applied. For example, let's say we want to see what the Cloud Contrast adjustment looks like. Just click back on your Blue Skies layer in the Layers palette, then in the Preset Picker, click on the second thumbnail in the top row of the Nature presets and Elements will swap out the Blue Skies adjustment with the Cloud Contrast one. If you like it, then keep it; if not, then just click back on the first preset you chose or try a new one altogether. Once you're finished, just choose **Flatten Image** from the Layers palette's flyout menu.

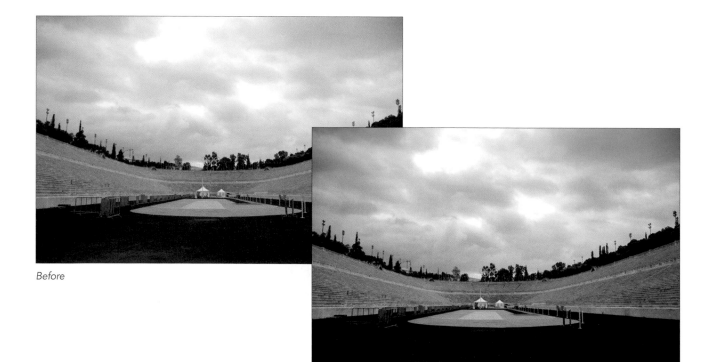

Before

After (with the Blue Skies and Increase Contrast presets)

Sometimes we don't get to shoot in perfect weather. Especially when you're traveling—you don't get to pick the day, time, or weather forecast. It has happened to me a hundred times. I get somewhere cool and I've got gray skies. Well, there's a sweet little adjustment in Elements that can take those gray skies and make them look pretty darn cool and dramatic. And more often than not, when you apply this and show it to people, they'll comment on how good the sky looks.

Adding Contrast and Drama to Cloudy Skies

Step One:
Open a photo where you've got some cloudy gray skies. Then, select the Smart Brush tool from the Toolbox (it's the large paint brush icon in the Enhance section) or just press the **F key**. (*Note:* For more on the Smart Brush tool, see the previous tutorial.)

Step Two:
Once you have the tool selected, click on the thumbnail on the left side of the Tool Options Bar to open the Preset Picker. From the Presets pop-up menu, choose **Nature**, and then click on the second thumbnail in the top row, which adds contrast to cloudy skies.

(Continued)

Step Three:

Now, choose a brush size using the Size slider (also in the Tool Options Bar), paint over the sky, and you'll start to see all the details that you knew were there when you took the photo start to come out.

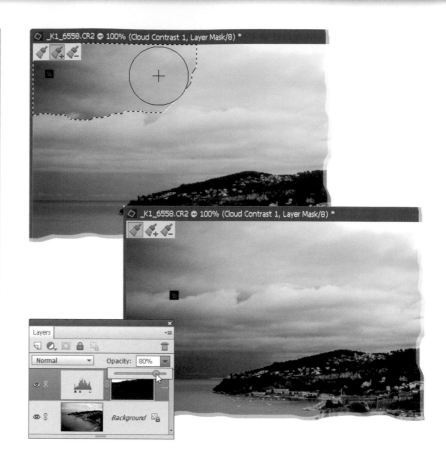

Step Four:

Like most of the Smart Brush tool adjustments, sometimes the default adjustment is too strong. If that's the case, just go to the Layers palette and reduce the Opacity setting, depending on how strong you want it to look. Not bad, eh? It does a great job of taking an ordinary photo and turning it into something way more dramatic.

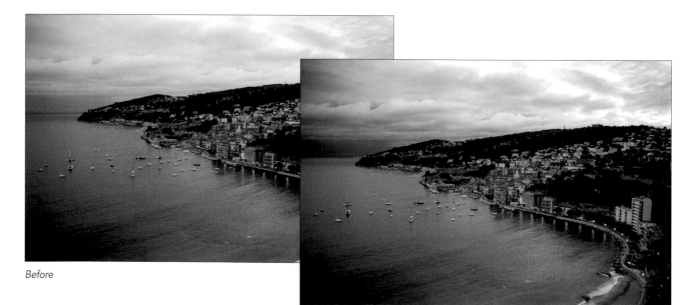

Before

After

Before you go any further, this is one of those circumstances mentioned in the beginning of the book, in the introduction on page xvi. Remember the whole topic about how Elements has changed over the years, and the way we work on our photos is very different today than it was say, five years ago? This is a perfect example. Elements 14 includes the hands-down best way to remove noise in your photos, but it's in Camera Raw (see Chapter 2). So, if you're thinking about using this filter, just know that there's a much better way to remove noise in Camera Raw. If you already have the photo open in the Editor and you're not in the mood to reopen it in Camera Raw, then this filter is an alternative (but not really a good one).

Removing Digital Noise

Step One:
Open the photo that was taken in low lighting (or using a high ISO setting) and has visible digital noise. This noise will be most obvious when viewed at a magnification of 100% or higher (noise appears throughout this photo, but is most visible in the steps and lamppost, although it's hard to see at the small size of the image here). *Note:* If you view your photos at smaller sizes, you may not notice the noise until you make your prints.

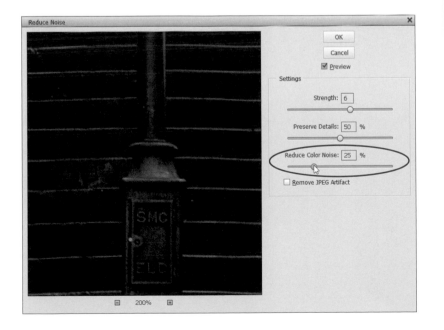

Step Two:
Go under the Filter menu, under Noise, and choose **Reduce Noise**. The default settings usually aren't too bad, but if you're having a lot of color aliasing (dots or splotchy areas of red, green, and blue), like we have here, drag the Reduce Color Noise slider to the right. If it still looks splotchy, try dragging the Preserve Details slider to the left.

(Continued)

Step Three:

One thing to watch out for when using this filter is that, although it can reduce noise, it can also make your photo a bit blurry, and the higher the Strength setting and amount of Reduce Color Noise, the blurrier your photo will become. If the noise is really bad, you may prefer a bit of blur to an incredibly noisy photo, so you'll have to make the call as to how much blurring is acceptable, but to reduce the amount of blur a bit, drag the Preserve Details slider to the right. Here, I thought it looked best set to 60%.

TIP: See a Before/After

To see an instant before/after of the Reduce Noise filter's effect on your photo without clicking the OK button, click your cursor within the Reduce Noise dialog's preview window. When you click-and-hold within that window, you'll see the before version without the filter (zoom in if you need to). When you release the mouse button, you'll see how the photo will look if you click the OK button.

Before (although it's difficult to see, look for the digital noise in the steps and lamppost)

After (noise removed using a slight blur from the Reduce Noise filter)

I've got some bad news and some good news (don't you hate it when people start a conversation like that?). The bad news first (yeah, I like it that way, too): Elements' Dodge and Burn tools are kind of lame. The pros don't use them and, after you read this tutorial, I hope you won't either. The good news...there is a great method the pros do use to dodge and burn and it's totally non-destructive. It's flexible and really quite easy to use. See, isn't it better to end on a good note (with the good news, that is)?

Focusing Light with Digital Dodging and Burning

Step One:
In this tutorial, we're going to dodge areas to add some highlights, then we're going to burn in some areas a bit to darken them. Start by opening the photo you want to dodge and burn.

Step Two:
Go to the Layers palette, click on the down-facing arrow at the top right, and from the flyout menu, choose **New Layer** (or just **Alt-click [Mac: Option-click]** on the Create a New Layer icon at the top of the palette). This accesses the New Layer dialog, which is needed for this technique to work.

(Continued)

Step Three:

In the New Layer dialog, change the Mode to **Overlay**, then right below that, turn on the checkbox for Fill with Overlay-Neutral Color (50% Gray). This is normally grayed out, but when you switch to Overlay mode, this choice becomes available. Click the checkbox to turn it on, then click OK.

Step Four:

This creates a new layer, filled with 50% gray, above your Background layer. (When you fill a layer with 50% gray and change the Mode to Overlay, Elements ignores the color. You'll see a gray thumbnail in the Layers palette, but the layer will appear transparent in your image window.)

Step Five:

Press **B** to switch to the Brush tool, and choose a medium, soft-edged brush from the Brush Picker (which opens when you click on the Brush thumbnail in the Tool Options Bar). While in the Tool Options Bar, lower the Opacity to approximately 30%.

Step Six:
Press **D**, then **X** to set your Foreground color to white and begin painting over the areas that you want to highlight (dodge). As you paint, you'll see light gray strokes appear in the thumbnail of your gray transparent layer, and in the image window, you'll see soft highlights.

Step Seven:
If your first stab at dodging isn't as intense as you'd like, just release the mouse button, click again, and paint over the same area. Since you're dodging at a low opacity, the highlights will "build up" as you paint over previous strokes. If the highlights appear too intense, just go to the Layers palette and lower the Opacity setting of your gray layer until they blend in.

(Continued)

Step Eight:

If there are areas you want to darken (burn) so they're less prominent (such as the mountains or any shadow areas on the ground), just press **D** to switch your Foreground color to black and begin painting in those areas. Okay, ready for another dodging-and-burning method? Good, 'cause I've got a great one.

Alternate Technique:

Open the photo that you want to dodge and burn, then just click on the Create a New Layer icon in the Layers palette and change the blend mode to **Soft Light**. Now, set white as your Foreground color and you can dodge right on this layer using the Brush tool set to 30% Opacity. To burn, just as before, switch to black. The dodging and burning using this Soft Light layer appears a bit softer and milder than the previous technique, so you should definitely try both to see which one you prefer.

Before

After

Removing Haze from Your Photos

Adobe sneak-peeked this one, and it's actually pretty darn slick. Anyone who shoots underwater photography, or takes a shot at an aquarium, or just shoots on foggy or hazy days will so love this. It cuts through haze amazingly well (and it doesn't just add the same ol' contrast, it's its own brand of contrast that works particularly well for this type of stuff).

Step One:

There are two ways to remove haze from your photos: automatically and manually. We'll start with the automatic way. Here, I've opened a photo I took in China on a hazy day. Instead of trying to add contrast ourselves to remove the haze, go under the Enhance menu and choose Auto Haze Removal.

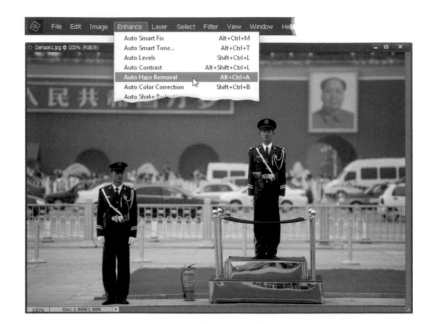

Step Two:

Elements then analyzes your photo and applies the amount of haze removal it thinks your photo needs. In this case, it did a pretty good job, but if you think it is not enough or is too much, press Ctrl-Z (Mac: Command-Z) to Undo and try it manually (we'll cover that next).

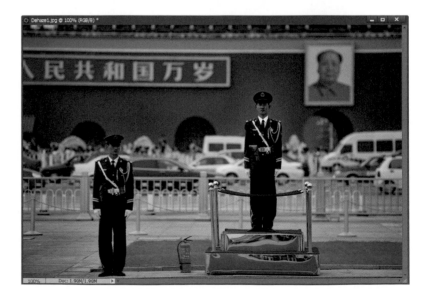

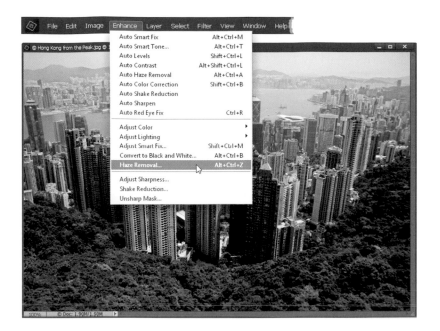

Step Three:
Open another hazy photo, like this one of a city skyline, where you want to manually apply haze removal. This time, go under the Enhance menu and choose **Haze Removal** (or press **Ctrl-Alt-Z [Mac: Command-Alt-Z]**).

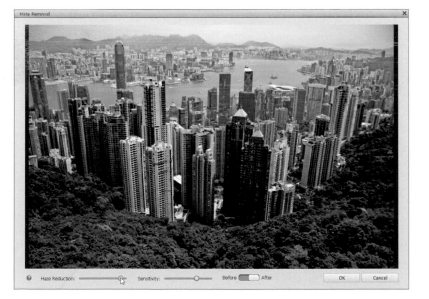

Step Four:
This opens the Haze Removal dialog. Elements will try to remove the haze, but you can click-and-drag the Haze Reduction and Sensitivity sliders back and forth until it looks good to you (it removed the haze from the top of the image here). To see the difference, simply click on the Before/After button at the bottom center of the dialog Click OK when you're done.

Opening Up Shadow Areas That Are Too Dark

One of the most common problems you'll run into with your digital photos is that the shadow areas are too dark. Fortunately for you, since it is the most common problem, digital photo software like Elements has gotten really good at fixing this problem. Here's how it's done:

Step One:
Open the photo that needs to have its shadow areas opened up to reveal detail that was "lost in the shadows."

Step Two:
Go under the Enhance menu, under Adjust Lighting, and choose **Shadows/Highlights**.

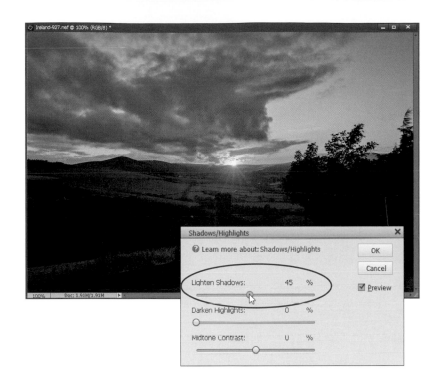

Step Three:
When the dialog appears, it already assumes you have a shadow problem (sadly, most people do but never admit it), so it automatically opens up the shadow areas in your document by 35% (you'll see that the Lighten Shadows slider is at 35% by default [0% is no lightening of the shadows]). If you want to open up the shadow areas even more, drag the Lighten Shadows slider to the right. If the shadows appear to be opened too much with the default 35% increase, drag the slider to the left to a setting below 35%. When the shadows look right, click OK. Your repair is complete. Here, I dragged the slider to 45%.

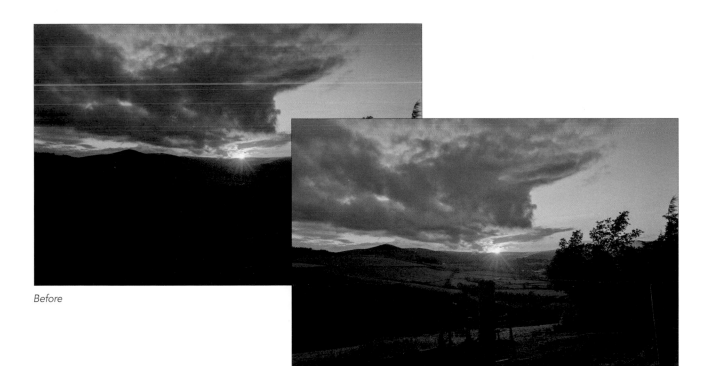

Before

After

Fixing Areas That Are Too Bright

Although most of the lighting problems you'll encounter are in the shadow areas of your photos, you'll be surprised how many times there's an area that is too bright (perhaps an area that's lit with harsh, direct sunlight, or you exposed for the foreground but the background is now overexposed). Luckily, this is now an easy fix, too!

Step One:

Open the photo that has highlights that you want to tone down a bit. *Note:* If it's an individual area (like the sun shining directly on your subject's hair), you'll want to press the **L key** to switch to the Lasso tool and put a loose selection around that area. Then go under the Select menu and choose **Feather**. For low-res, 72-ppi images, enter 2 pixels and click OK. For high-res, 300-ppi images, try 8 pixels.

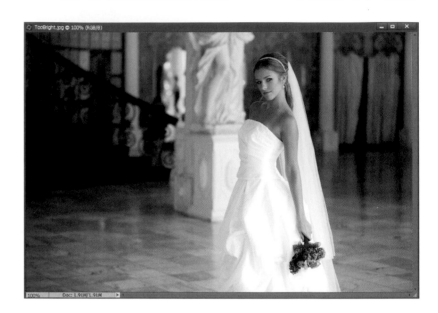

Step Two:

Now go under the Enhance menu, under Adjust Lighting, and choose **Shadows/Highlights**.

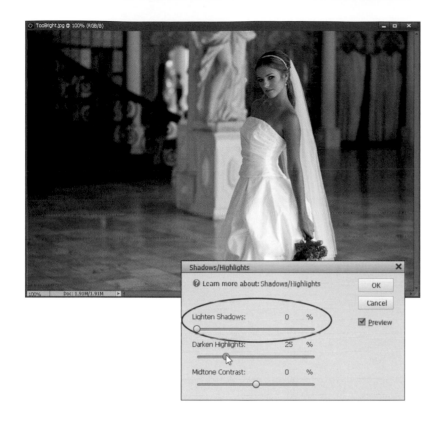

Step Three:

When the dialog appears, drag the Lighten Shadows slider to 0% and drag the Darken Highlights slider to the right, and as you do, the highlights will decrease, bringing back detail and balancing the overall tone of your (selected) highlights with the rest of your photo. (You'll mainly see it in the dress, skin tones, and some of the background here. They have lots more detail now.) Sometimes, when you make adjustments to the highlights (or shadows), you can lose some of the contrast in the midtone areas (they can become muddy or flat looking, or they can become oversaturated). If that happens, drag the Midtone Contrast slider (at the bottom of the dialog) to the right to increase the amount of midtone contrast, or drag to the left to reduce it. Then click OK. *Note:* If you made a selection, you'll need to press **Ctrl-D (Mac: Command-D)** to Deselect when you're finished.

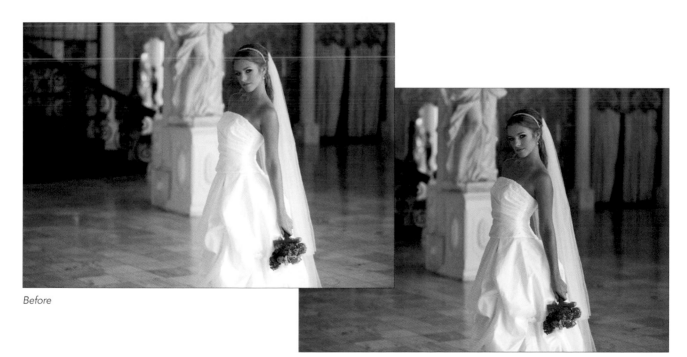

Before

After

When Your Subject Is Too Dark

Sometimes your subject is too dark and blends into the background: maybe there just wasn't enough light, or you forgot to use fill flash, or a host of other reasons that could have caused this. You could go and retake the photo if you realize it right away. However, you don't always realize it immediately, so you'll need to get Elements to help out. For those times, there's a really clever way in Elements to essentially paint your light onto the subject after the fact.

Step One:
Open a photo where the subject(s) of the image appears too dark.

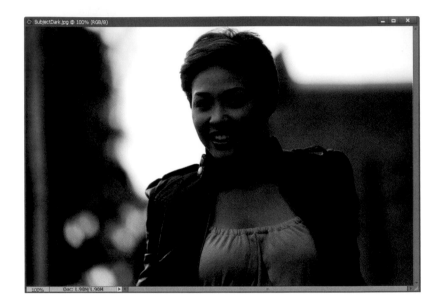

Step Two:
Click on the Create New Adjustment Layer icon at the top of the Layers palette (shown circled here), and choose **Levels**. This will add a Levels adjustment layer above your Background layer, and open the Levels adjustments palette.

Step Three:

Drag the middle gray Input Levels slider (under the histogram) to the left until your subject(s) looks properly exposed. (*Note:* Don't worry about how the background looks—it will probably become completely blown out, but you'll fix that next—for now, just focus on making your subject look right.) If the midtones slider doesn't bring out the subject enough, you may have to increase the highlights as well, so drag the far-right (white) Input Levels slider to the left to increase the highlights.

Step Four:

When your subject looks properly exposed, press **D** to set your Foreground color to white and your Background color to black. Then press **Ctrl-Backspace (Mac: Command-Delete)** to fill the layer mask with black and remove the brightening of the photo. Press **B** to switch to the Brush tool and click on the Brush thumbnail in the Tool Options Bar to open the Brush Picker, where you'll choose a soft-edged brush. Now, you'll paint (on the layer mask) over the areas of the image that need a fill flash with your newly created "Fill Flash" brush. The areas you paint over will appear lighter, because you're "painting in" the lightening of your image on this layer.

(Continued)

Step Five:

Continue painting until it looks as if you had used a fill flash. If the effect appears too intense, just lower the opacity of the adjustment layer by dragging the Opacity slider to the left in the Layers palette (as shown here).

TIP: Try the Smart Brush Tool Instead

The Smart Brush tool (covered earlier in this chapter) has a Portrait preset called Lighten Skin Tones that also works pretty well in cases like this.

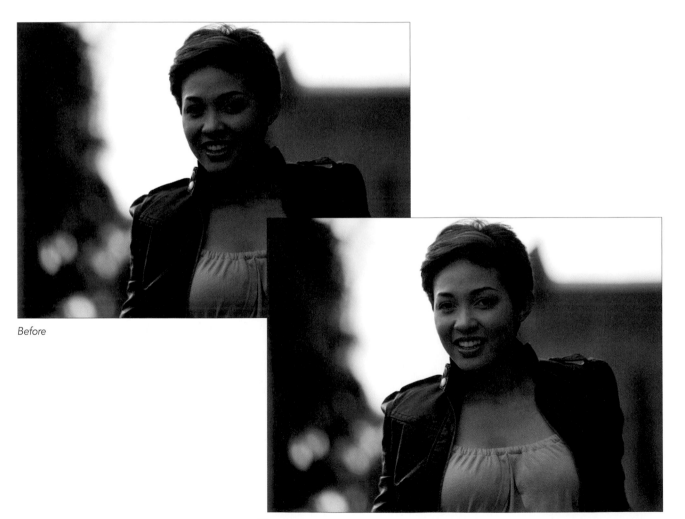

Before

After

Automatic Red-Eye Removal

If you just finished shooting an indoor event with lots of flash and low light, chances are you're going to have a ton of photos with red eyes. If you know this ahead of time, then the feature you're about to see comes in very handy. You can set up Elements to automatically remove red eye as your photos are being imported into the Organizer. No interaction by you is needed. Just let Elements do its work and by the time you see your photos onscreen, you'll never even know red eye existed.

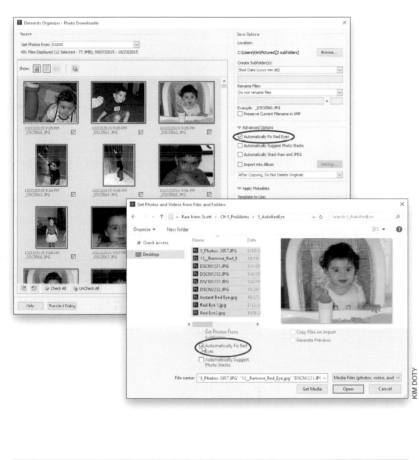

KIM DOTY

Step One:
First, we'll start with the fully automatic version, which you can use when you're importing photos into the Organizer. Here's how it works: When importing photos from your camera, the Elements Organizer – Photo Downloader dialog appears. On the right side of the dialog, in the Advanced Options section, there's a checkbox for Automatically Fix Red Eyes (if your dialog doesn't look like this, click on the Advanced Dialog button at the bottom). If you think some of the photos you're about to import will have red eye, just turn on this checkbox (shown circled here), and then click the Get Media button to start the importing and the red-eye correction. If you're importing photos already on your computer, you'll have the same option in the Get Photos and Videos from Files and Folders dialog.

Step Two:
Once you click the Get Media button, the Elements Organizer dialog will appear. In this dialog, there's a status bar indicating how many photos are being fixed. It also shows you a preview of each photo it's importing.

(Continued)

Step Three:

Once the process is complete, it auto-
matically groups the original with the
fixed version in a Version Set (you'll see
an icon at the top right of the image
thumbnail), so if you don't like the fix
(for whatever reason), you still have the
original. You can see both versions of
the file by Right-clicking on the photo
(in the Organizer) and in the pop-up
menu, under Version Set, choosing
Expand Items in Version Set (or by
just clicking on the right-facing arrow
to the right of the image thumbnail).
Note: To expand your version sets,
your thumbnail view must be set to
Details (found on the View menu).

Step Four:

Here is one of the photos with red eye
and with it automatically removed.

Step Five:

This really isn't a step; it's another way
to get an auto red eye fix, and that's
by opening an image in the Editor,
in Expert mode or Quick mode, and
then going under the Enhance menu
and choosing **Auto Red Eye Fix**. You
can also use the keyboard shortcut
Ctrl-R (Mac: Command-R). Either way,
it senses where the red eye(s) is, re-
moves it automatically, and life is good.

Instant Red-Eye Removal

When you use the flash on your digital point-and-shoot camera (or even the on-camera flash on a digital SLR), do you know what you're holding? It's called an A.R.E.M. (short for automated red-eye machine). Yep, that produces red eye like it's going out of style. Studios typically don't have this problem because of the equipment and positioning of the flashes, but sometimes you don't have a choice—it's either an on-camera flash or a really dark and blurry photo. In those cases, just accept the red eye. Become one with it and know that you can painlessly remove it with a couple of clicks in Elements.

KIM DOTY

Step One:
Open a photo where the subject has red eye.

Step Two:
Press **Z** to switch to the Zoom tool (it looks like a magnifying glass in the Toolbox) and drag out a selection around the eyes (this zooms you in on the eyes). Now, press the letter **Y** to switch to the Red Eye Removal tool (its Toolbox icon looks like an eye with a tiny crosshair cursor in the left corner). There are two different ways to use this tool: click or click-and-drag. We'll start with the most precise, which is click. Take the Red Eye Removal tool and click it once directly on the red area of the pupil. It will isolate the red in the pupil and replace it with a neutral color. Instead, now you have "gray" eye, which doesn't look spectacular, but it's a heck of a lot better than red eye.

(Continued)

Step Three:

If the gray color that replaces the red seems too "gray," you can adjust the darkness of the replacement color by going to the Tool Options Bar and adjusting the Darken amount. To get better results, you may have to adjust the Pupil Radius setting so that the area affected by the tool matches the size of the pupil. This is also done in the Tool Options Bar when you have the Red Eye Removal tool selected. Now, on to the other way to use this tool (for really quick red-eye fixes).

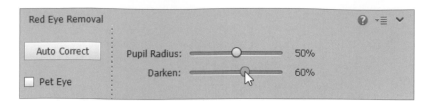

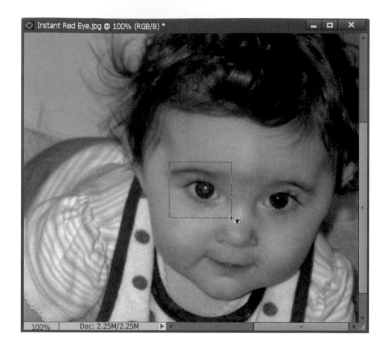

Step Four:

If you have a lot of photos to fix, you may opt for this quicker red-eye fix—just click-and-drag the Red Eye Removal tool over the eye area (putting a square selection around the entire eye). The tool will determine where the red eye is within your selected area (your cursor will change to a timer), and it removes the red. Use this "drag" method on one eye at a time for the best results.

Before

After

Elements has a feature called Correct Camera Distortion that's made for problems that happen when we shoot with wide-angle lenses. We've all probably seen those super-wide photos that make it look like the buildings in a city are leaning over, or architecture where those perfect lines don't look like they do in real life. Well, that's exactly what this filter is for.

Fixing Problems Caused by Your Camera's Lens

Step One:
Open your photo, and then go under the Filter menu and choose **Correct Camera Distortion**. There are a few problems that this filter fixes, like distortion if you have curved surfaces in the photo. It's not quite as common as some of the other lens problems, and usually only rears its head if you're shooting with a fisheye lens or a lens that is really wide. But if you do have any distortion, like maybe a curved horizon line, you can use the Remove Distortion slider to fix it (as shown here). The little icons at either end of the slider show you which way you need to drag.

TIP: Use the Grid as Your Guide
If you need extra help lining things up, there is a Show Grid checkbox at the bottom of the dialog, as seen in the image above. It really helps you see whether or not crooked lines exist in your photo. It does get kind of annoying, though, so you'll probably want to turn it off if you don't need it.

Step Two:
The two sliders in the Vignette section, remove any edge darkening in the photo. Again, this doesn't always happen and a lot of people actually like edge vignetting (it's an effect we often add to a photo). But, if it bugs you, you can remove it here by dragging the Amount slider toward the right (toward Lighten), and then adjusting the Midpoint slider so it is removed farther toward the middle or closer to the edges.

(Continued)

Step Three:

The next section is really where you'll probably spend most of your time—Perspective Control. And, usually, it will be Vertical Perspective issues, like we have in this image. See how the buildings are leaning?

Step Four:

Just drag the Vertical Perspective slider to the left to help straighten them. Depending on what lens you used, you may have to drag pretty far. Keep in mind, though, that when you do this, you're actually cropping away areas on the sides of your photo (Elements does this automatically). So if you go too far, you may cut out a key part of the photo. Personally, I always back off a little. If you're not an architectural photographer selling your images to clients, then nobody who sees your photos will care about the slightly leaning buildings. Why? Because the same problem happens to the rest of the world and they're used to it :-)

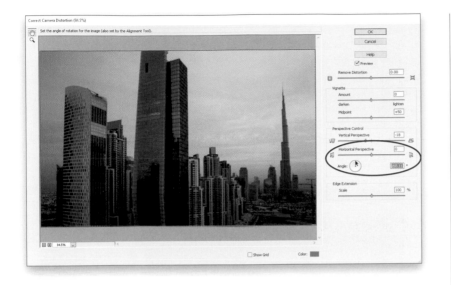

Step Five:

If you see any horizontal lines that aren't straight, then you can tweak a couple more settings. First, there is a Horizontal Perspective slider that may work. Usually, though, I try to get the vertical lines straight, and then I go to the Angle setting and rotate the image slightly to fix things (you can turn the Show Grid checkbox back on to help line things up). Also, if the Angle control moves in too large increments, then click-and-drag directly on the word Angle. Keep in mind that when you do this, you may have to go back and fix the vertical setting a little, too. You'll find it's a constant push-and-pull here, but I don't mind a little bit of a tilt to the buildings in the front so I'll leave it. When you're done, just click OK. You can see the before/after below.

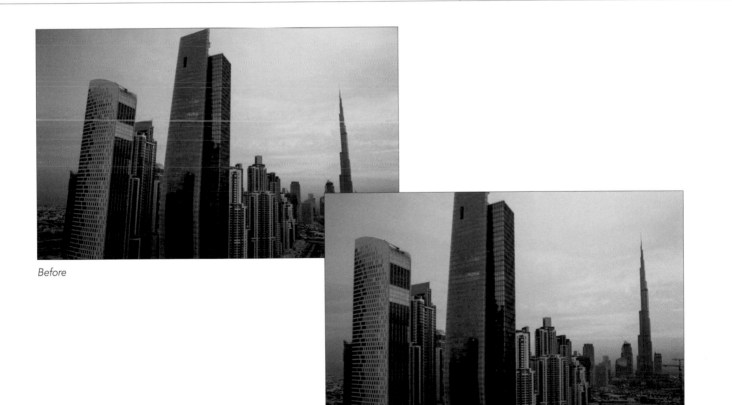

Before

After

Saving Blurry Photos Using the Shake Reduction Filter

If you have a shot you took handheld in low light (so the blurriness was caused by shooting with a slow shutter speed), or if your blurry shot came from a long lens, you may be in luck using a filter called Shake Reduction. It can greatly reduce the blur caused by shots where your camera moved a bit (it's not for shots where your subject is moving). This filter works best on images that don't have a lot of noise, have a pretty decent overall exposure, and where you didn't use flash. It doesn't work on every image, but when it does, it's pretty jaw-dropping.

Step One:

Here's a shot I took handheld in low light; it's a blurry mess, and this is exactly when you'd reach for the Shake Reduction filter (it's found under the Enhance menu). When the filter opens, it immediately starts analyzing the image, starting in the middle of that box (called a Shake Region) in the bottom-center of the preview area, and searching outward from there. You'll see a little progress bar appear (as it's thinking) inside that Shake Region. If you want to cancel the analyzing process, just click the little X in the top right of it.

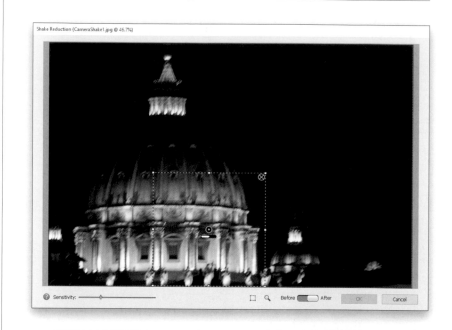

Step Two:

Once it's done doing the math, it shows you its automated blur correction (seen here), where I have to say, on this image, it did a pretty good job. It's not perfectly sharp and there is some ghosting, but the original was completely unusable. At least now, if I wanted to put it on Facebook or Twitter at web resolution, it would be totally passable, which I think is saying a lot. For most users, this is all you'll need to do: open the filter, let it do its thing, and you're done. However, if you're a "tweaker," then read on.

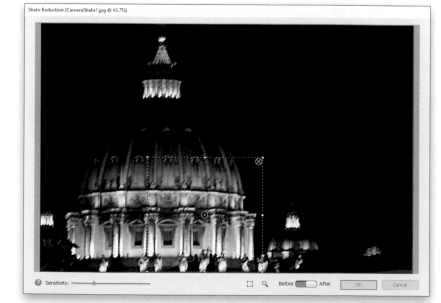

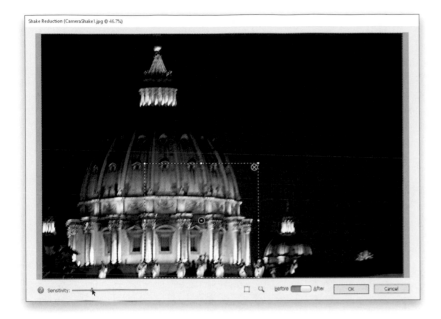

Step Three:
The filter automatically calculates what it thinks is the amount of camera shake based on how many pixels it thinks have moved, but if the auto method doesn't look good, it may be that it either needs to affect more or fewer pixels. That's what the Sensitivity slider is for. This slider controls how many pixels the filter affects (kind of like how the Tolerance slider for the Magic Wand tool determines how far out the tool selects). Dragging the slider to the left affects fewer pixels (so, if there's just a little blurring, it may need to affect fewer pixels) and dragging to the right affects more pixels. Its own estimation is pretty darn good but, again, you can override it (in this case, I only moved it a little).

Step Four:
Now, what if you don't like the where it placed the Shake Region, and think there's a better area for it to base its fix on, just click on the dot in the center of the Shake Region and drag it where you want it. You can also click on one of the corner or side handles and resize the Shake Region (just like you would a Free Transform bounding box). Here, I made it into a long rectangle and dragged it to the left a little.

(Continued)

Step Five:

So far, we've only used one area for Shake Reduction's calculations, but what if there's more than one place where you want the emphasis on camera shake reduction placed? Well, luckily, you can have multiple Shake Regions. To add a new Shake Region, either click-and-drag over the area you also want to emphasize, or click on the Add Another Shake Region button below the center of the preview area, then move and resize it. Here, I added another Shake Region above the original one.

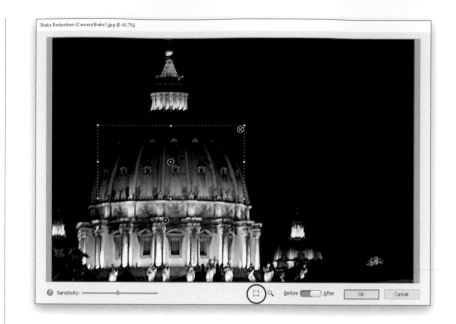

Step Six:

To see a zoomed-in view of your image (if you want a better idea of how well Elements is fixing an area), click on Show Magnifier Window button (it looks like a magnifying glass) below the preview area or press the letter **Q** on your keyboard. A floating magnifier window appears on your image that you can click-and-drag wherever you like. You can zoom in tighter by clicking the zoom amount buttons at the top right of the window. Press Q again to close it. If you click-and-hold inside the magnifier window, it gives you a quick "before" view of your image (before you removed the camera shake). When you release the button, it brings you back to the edited "after" image. Here, I added another Shake Region at the top of the dome and opened the magnifier window to see how it looks.

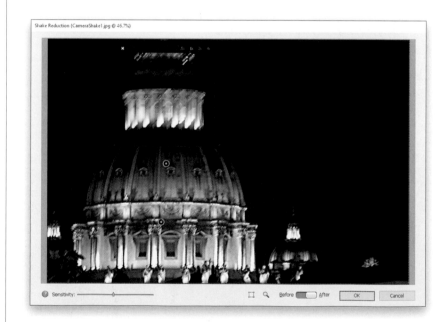

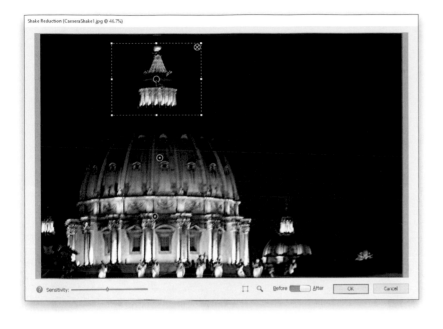

Step Seven:

If you've added a Shake Region and don't like the effect or want to see how the image would look without it, just click on the dot in the center of the Shake Region and it will turn a solid gray. This means you've turned off that Shake Region. If you decide you want to keep it, click on the dot again. If you want to delete the Shake Region, click the X in the top-right corner. You can see the changes to the entire image by clicking on the Before/After toggle button to the left of the OK button.

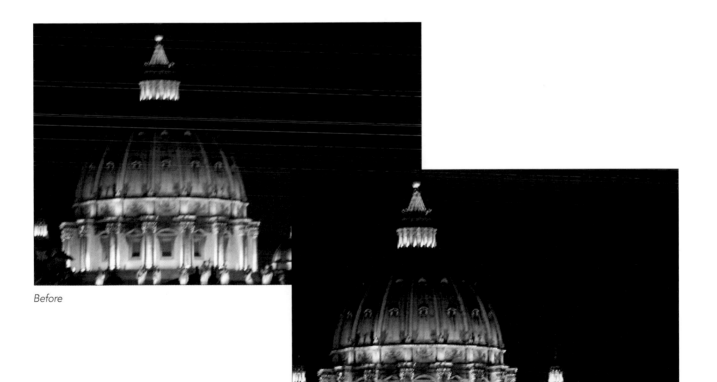

Before

After

The Elements Secret to Fixing Group Shots

Group shots can be a challenge. Everyone has to be looking and smiling at the right time. If one person isn't, then you have to shoot it again. The real problem comes from the fact that you really can't tell if everyone has their eyes open or is looking the right way from the small LCD on the back of your camera. So you get back and upload your photos only to find out that not one of them has everyone looking and smiling the way that they need to be. No sweat, with Elements' Group Shot feature. As long as you have a few photos to choose from, you can create the perfect group photo afterward.

Step One:
Here's a group shot where one of the subjects (the boy on the right) wasn't looking at the camera.

Step Two:
If you've ever taken group shots before, you're guilty of photographing until your group threatens to riot or otherwise destroy your gear. Chances are, you took more photos of the same group before such threats ensued. So here's another shot where the boy on the right looks better. But, we can't use this shot, because now the man on the left isn't smiling and one of the other men has his eyes closed. No problem. We're going to use the Group Shot feature to give us the best of both worlds and combine these photos.

Step Three:

At this point, you should have both photos open in the Editor. So, click on Guided at the top, then click on Photomerge®, and choose Photomerge® Group Shot.

Note: A quick rule of thumb when using the Group Shot feature is to pick the best photo of the group as the final photo. See, Elements uses the final photo as the bottommost layer in the Layers palette. You'll see in a few steps, that makes it easier for us to go back later and restore the best parts of the photo with the Eraser tool.

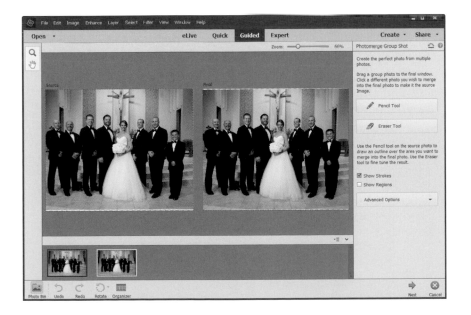

Step Four:

The first thing you need to do here is set up the photos as a source and a final. In the example here, I wanted the photo where the boy on the right was looking at the camera (but the guy on the left wasn't smiling) on the Source side (if it wasn't, I would've just clicked on its thumbnail down in the Project Bin). Then, I went to the Project Bin and clicked-and-dragged the thumbnail of the photo where the guy on the left was smiling (but the boy on the right was looking to the side) to the Final side. So basically, what I want to do is take the boy on the right from the Source side (the one where he's looking at the camera) and use it to replace the boy on the Final side (where he's looking to the side).

(Continued)

Step Five:

The rest is pretty easy: Use the Zoom tool (Z) to zoom in on the area you want to replace, then click on the Pencil Tool button on the right-hand side and paint on the area in the Source image that you want to appear in the Final image. In this example, I painted over the Source image where the boy's face is. Elements will think for a moment, and magically replace the boy's face in the Final photo with the one from the Source photo.

TIP: Change Your Brush Size

Sometimes the default brush size is way too small and it takes you a while to paint in your source image. If that happens, then increase the Size setting in the Pencil Tool section to something larger.

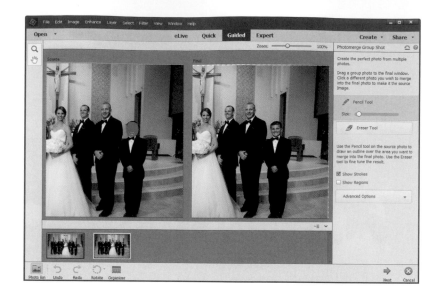

Step Six:

At this point, if things look good (and trust me, things don't always look good here, although it may work on the first try), then click the Next button at the bottom right of the window, and then either save it, share it, or choose to continue editing if it still needs a little work. I clicked the In Expert button here. Now, your merged photo is in a new document with two layers (the original on the bottom and new merged photo on the top) in the Layers palette (use the Crop tool [C] to crop away any excess canvas).

TIP: Use the Eraser Tool to Fix It

If the Group Shot merge doesn't work perfectly, you can finesse it by painting with the Eraser tool (E) on the top layer to reveal the layer below. You'll want to zoom in really close, but it's a good trick to fix any flaws that remain.

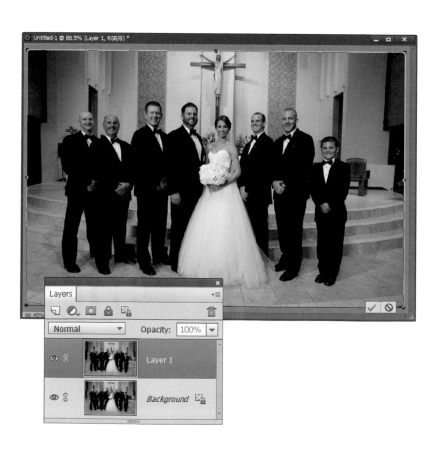

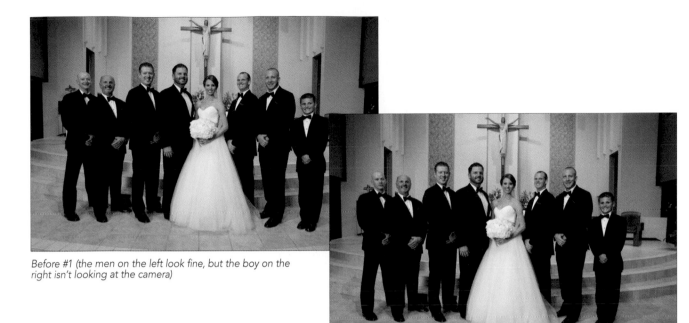

Before #1 (the men on the left look fine, but the boy on the right isn't looking at the camera)

Before #2 (the boy on the right now looks fine, but the man on the left isn't smiling and one of the other men has his eyes closed)

After (we've got the best of both worlds—everyone in the shot is smiling and looking at the camera without squinting or blinking)

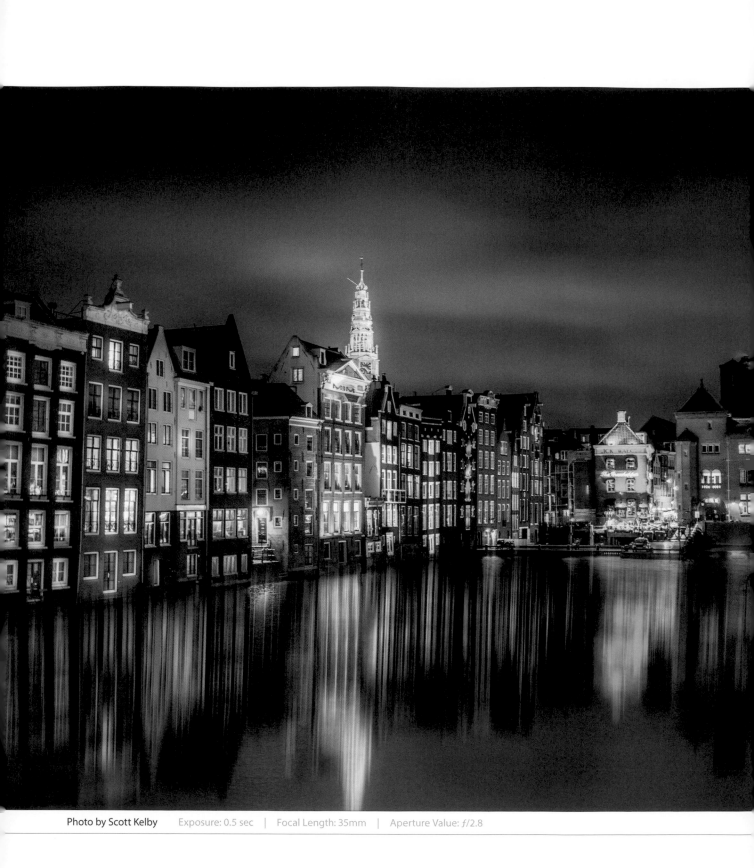

Photo by Scott Kelby | Exposure: 0.5 sec | Focal Length: 35mm | Aperture Value: ƒ/2.8

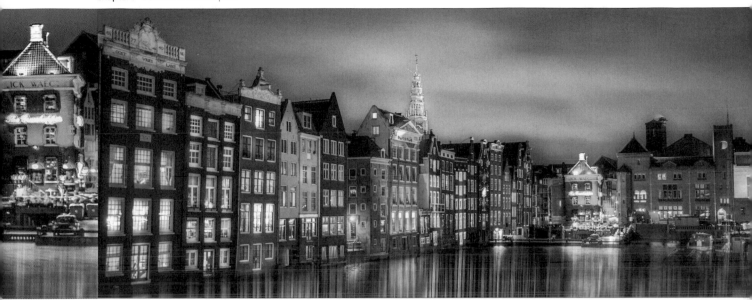

SELECT START
selection techniques

This chapter is actually named after the band Select Start, because the name of the song that came up when I searched in the iTunes Store for the word "Select" was their song, titled "She's Not a Hottie Hotty," but I thought that "She's Not a Hottie Hotty" would make a weird name for a chapter on how to make selections. I listened to "She's Not a Hottie Hotty" and it actually wasn't bad, but I really thought the song could use more references to making selections and fewer references to b-double-o-t-y. Okay, I have to be honest, I only listened to the free 90-second preview of the song, and I didn't actually hear the word "booty" per se, but seriously, what song that includes the word "hottie" doesn't have the word "booty" in there somewhere? I mean, how many words are there that rhyme with hottie that aren't used regularly by a toddler (made ya stop and think for a moment, didn't I?). Anyway, Select Start (the band's name) is really a pretty good name for the chapter, because we start with teaching you how to make simple selections, and then take you through Elements' most important selection techniques, because being able to easily select and adjust just one particular area of your photo is really important. Once you've mastered selections, the next logical step is to learn how to break down people's names rap-style, like Fergie (F to the E-R-G-I-E), but if you just wondered, "Why would the Duchess of York talk like that?" we have an entirely different problem.

Selecting Square, Rectangular, or Round Areas

Selections are an incredibly important feature in Elements. They're how you tell Elements to affect only specific areas of your photos. Whether it's moving part of one photo into another or simply trying to draw more attention to or enhance part of a photo, you'll have so much more control if you know how to select things better. For starters, Elements includes quick and easy ways to make basic selections (square, round, rectangular). These are probably the ones you'll use most, so let's start here.

Step One:

To make a rectangular selection, choose (big surprise) the Rectangular Marquee tool by pressing the **M key**. Adobe's word for selection is "marquee." (Why? Because calling it a marquee makes it more complicated than calling it what it really is—a selection tool—and giving tools complicated names is what Adobe does for fun.)

Step Two:

We're going to start by selecting a rectangle shape, so click your cursor in the upper-left corner of the door and drag down and to the right until your selection covers the entire left side of the door, then release the mouse button. That's it! You've got a selection and anything you do now will affect only the selected rectangle (in other words, it will only affect the left side of the door).

Step Three:

To add another area to your current selection, just press-and-hold the Shift key, and then draw another rectangular selection. In our example here, let's go ahead and select the other side of the door, too. So press-and-hold the Shift key, drag out a rectangle around the other side of the door, and release the mouse button. Now the entire door is selected.

Step Four:

Now let's make an adjustment and you'll see that your adjustment will only affect your selected area. Click on the Create New Adjustment Layer icon at the top of the Layers palette, and choose **Hue/Saturation** from the pop-up menu. In the Hue/Saturation adjustments palette, drag the Hue slider all the way to the left to change the color of the door to a green color. Notice how just the color of the door is changing and nothing else in the image? This is why selections are so important—they are how you tell Elements you only want to adjust a specific area. You can also drag the Saturation or Lightness sliders, too, but I'm just going to move the Saturation to the right a little, here. Also, you'll notice your selection goes away when you add the adjustment layer, but if you ever want to deselect something, just press **Ctrl-D (Mac: Command-D)**.

(Continued)

Step Five:

Okay, you've got rectangles, but what if you want to make a perfectly square selection? It's easy—the tool works the same way, but before you drag out your selection, you'll want to press-and-hold the Shift key. Let's try it: open another image, get the Rectangular Marquee tool, press-and-hold the Shift key, and then draw a perfectly square selection (around the center area inside of this fake instant photo, in this case).

©DOLLAR PHOTO CLUB/YOSSARIAN6

Step Six:

While your selection is still in place, open a photo that you'd like to appear inside your selected area and press **Ctrl-A (Mac: Command-A)**; this is the shortcut for Select All, which puts a selection around your entire photo at once. Then press **Ctrl-C (Mac: Command-C)** to copy that photo into Elements' memory.

Step Seven:

Switch back to the instant photo image, and you'll notice that your selection is still in place. Go under the Edit menu and choose **Paste Into Selection**. The image held in memory will appear pasted inside your square selection. If the photo is larger than the square you pasted it into, you can reposition the photo by just clicking-and-dragging it around inside your selected opening.

Step Eight:
You can also use Free Transform (press **Ctrl-T [Mac: Command-T]**) to scale the pasted photo in size. Just grab a corner point (press **Ctrl-0** [zero; **Mac: Command-0**] if you don't see them), press-and-hold the Shift key (or turn on the Constrain Proportions checkbox in the Tool Options Bar), and drag inward or outward. When the size looks right, press the **Enter (Mac: Return) key** and you're done. (Well, sort of—you'll need to press **Ctrl-D [Mac: Command-D]** to Deselect, but only do this once you're satisfied with your image, because once you deselect, Elements flattens your new image into your Background layer, meaning there's no easy way to adjust this image.) Now, on to oval and circular selections…

©DOLLAR PHOTO CLUB/MASSON

Step Nine:
Open an image with a circle shape you want to select (a bowl here), and then press **M** to switch to the Elliptical Marquee tool (pressing M toggles you between the Rectangular and Elliptical Marquee tools by default). Now, just click-and-drag a selection around your circle. Press-and-hold the Shift key as you drag to make your selection perfectly round. If your round selection doesn't fit exactly, you can reposition it by moving your cursor inside the border of your round selection and clicking-and-dragging to move it into position. You can also press-and-hold the Spacebar to move the selection as you're creating it. If you want to start over, just deselect, and then drag out a new selection. *Hint:* With circles, it helps if you start dragging before you reach the circle, so try starting about ¼" to the top left of the circle.

(Continued)

Step 10:

While we're at it, let's check out an-
other little tip with selections. In our
example, we've selected the bowl be-
cause it's simple and easy to select.
But really, the background is the area
we'd like to fix here. It's just a little
bright and I think it'll look better if it's
a bit darker. No sweat. Just go under
the Select menu and choose **Inverse**,
and Elements will select everything
else *but* what you put a selection
around in the previous step.

Step 11:

Now let's adjust the area around the
bowl. Click on the Create New Adjust-
ment Layer icon and choose **Levels**.
In the Levels adjustment palette, drag
the black (shadows) slider beneath the
histogram to the right to around 24,
then drag the gray (midtones) slider to
the right to around 0.89 to add more
contrast to the background. That's it.
Remember, to simply make ovals or
rectangles just start dragging. However,
if you need a perfect circle (or square)
then hold down the Shift key.

If you've spent 15 or 20 minutes (or even longer) putting together an intricate selection, once you deselect it, it's gone. (Well, you might be able to get it back by choosing Reselect from the Select menu, as long as you haven't made any other selections in the meantime, but don't count on it. Ever.) Here's how to save your finely-honed selections and bring them back into place anytime you need them.

Saving Your Selections

Step One:
Open an image and then put a selection around an object in your photo using the tool of your choice. Here I used the Quick Selection tool **(A)** to select the sky and the water, then went under the Select menu and chose **Inverse** to select the buildings. Then, I clicked on the tops of the buildings to add them to the selection. If you select too much, just press-and-hold the **Alt (Mac: Option) key** and click in the areas you want to deselect. To save your selection once it's in place (so you can use it again later), go under the Select menu and choose **Save Selection**. This brings up the Save Selection dialog. Enter a name in the Name field and click OK to save your selection.

Step Two:
Now you can get that selection back (known as "reloading" by Elements wizards) at any time by going to the Select menu and choosing **Load Selection**. If you've saved more than one selection, they'll be listed in the Selection pop-up menu—just choose which one you want to "load" and click OK. The saved selection will appear in your image.

Softening Those Harsh Edges

When you make an adjustment to a selected area in a photo, your adjustment stays completely inside the selected area. That's great in many cases, but when you deselect, you'll see a hard edge around the area you adjusted, making the change look fairly obvious. However, softening those hard edges (thereby "hiding your tracks") is easy—here's how:

Step One:

Let's say you want to darken the area around the flowers and vase, so it looks almost like you shined a soft spotlight on them. Start by drawing an oval selection around them using the Elliptical Marquee tool (press **M** until you have it). Make the selection big enough so the flowers, vase, and the surrounding area appear inside your selection. Now we're going to darken the area around them, so go under the Select menu and choose **Inverse**. This inverses the selection so you'll have everything but the flowers and vase selected (you'll use this trick often).

Step Two:

Click on the Create New Adjustment Layer icon at the top of the Layers palette, and choose **Levels**. In the Levels adjustments palette, drag the gray (midtones) slider beneath the histogram to the right to about 0.54. You can see the harsh edges around the oval, and it looks nothing like a soft spotlight— it looks like a bright oval. That's why we need to soften the edges, so there's a smooth blend between the bright oval and the dark surroundings.

Step Three:

Press **Ctrl-Z (Mac: Command-Z)** three times so your photo looks like it did when you drew your selection in Step One (your selection should be in place—if not, drag out another oval). With your selection in place, go under the Select menu and choose **Feather**. When the Feather Selection dialog appears, enter 150 pixels (the higher the number, the more softening effect on the edges) and click OK. That's it—you've softened the edges. Now, let's see what a difference that makes.

Step Four:

Go under the Select menu and choose Inverse again. Add a Levels adjustment layer again, drag the midtones Input Levels slider to around 0.54, and you can see that the edges of the area you adjusted are soft and blending smoothly, so it looks more like a spotlight. Now, this comes in really handy when you're doing things like adjusting somebody with a face that's too red. Without feathering the edges, you'd see a hard line around the person's face where you made your adjustments, and it would be a dead giveaway that the photo had been adjusted. But add a little bit of feather (with a face, it might only take a Feather Radius of 2 or 3 pixels), and it will blend right in, hiding the fact that you made an adjustment at all.

Easier Selections with the Quick Selection Tool

This is another one of those tools in Photoshop Elements that makes you think, "What kind of math must be going on behind the scenes?" because this is some pretty potent mojo for selecting an object (or objects) within your photo. What makes this even more amazing is that I was able to inject the word "mojo" into this introduction, and you didn't blink an eye. You're one of "us" now….

Step One:
Open the photo that has an object you want to select (in this example, we want to select one of the squares of soap). Go to the Toolbox and choose the Quick Selection tool (or just press the **A**, for Awesome, **key**).

Step Two:
The Quick Selection tool has an Auto-Enhance checkbox down in the Tool Options Bar. By default, it's turned off. My line of thinking is this: when would I ever not want an enhanced (which in my book means better) selection from the Quick Selection tool? Seriously, would you ever make a selection and say, "Gosh, I wish this selection looked worse?" Probably not. So go ahead and turn on the Auto-Enhance checkbox, and leave it that way from now on.

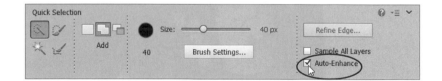

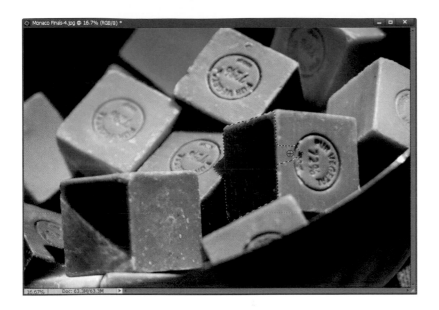

Step Three:

Take the Quick Selection tool and simply paint squiggly brush strokes inside of what you want to select. You don't have to be precise, and that is what's so great about this tool—it digs squiggles. It longs for the squiggles. It needs the squiggles. So squiggle.

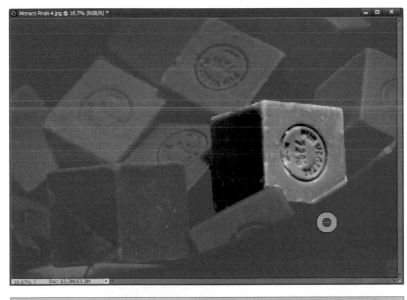

Step Four:

If the selection includes areas you don't want (like part of the soap on the left and part of the bowl, in this example), then try switching to the Refine Selection Brush (press **A** until you have it). Some new features have been added to this brush in Elements 14, making it similar to the Refine Edge feature (which we'll look at in the next tutorial). One new feature is the View option. When you click on this brush an overlay mask appears to help you refine your selection. You can change the color of the overlay, change it to a black or white mask, or reduce its opacity in the Tool Options Bar. The way the brush works is it automatically adds or subtracts from the selection based on where you place it. Go ahead and try it. Place the brush in the actual boundary of the selection and you'll see the center of the brush has a plus in it. That means it's in Add mode. Then try placing it outside of the selection and it automatically has a minus sign in it, meaning it's in subtract mode.

(Continued)

Step Five:

In this example, we want to subtract areas from the outside, so leave the brush on the outside of the selection. Take a look at the brush's three sliders in the Tool Options Bar. First, there's Size, which is the overall size of the brush. Brush size is important because it affects how closely the brush will work with the edges around it. Think of this brush as having two parts to it: the middle (dark gray) circle is what you put over the area you want to add to or subtract from your selection (the soap on the left and the edge of the bowl, in this case), and the outer (light gray) circle is what you place over the area you want the edges of the selection to snap to (the soap). Make sure the correct sign (plus or minus) is showing in the dark gray circle, and that it doesn't overlap anything you want in your selection (the soap, here). Next, you have Snap Strength, which I usually keep high. That means that Elements will tend to snap to edges more consistently than if the setting was lower. Finally, there's Selection Edge, new in Elements 14, which sets the selection edge radius. This slider moves when you set the Size of your brush, but you can also adjust it manually, making it a harder or softer edge radius. Click-and-nudge your selection edges inward until only that one square of soap is selected.

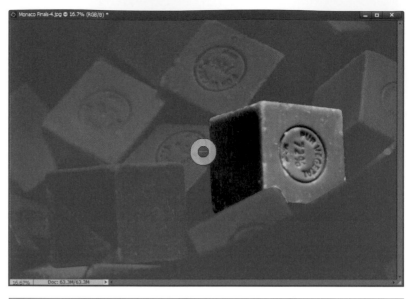

Step Six:

Now that we've got it selected, we might as well do something to it, eh? How about this: let's change its color. Start by clicking back on the Quick Selection tool (so you see your image again without a mask). Then, click on the Create New Adjustment Layer icon at the top of the Layers palette and choose **Hue/Saturation**. In the Hue/Saturation adjustment palette, drag the Hue slider to the right to around +130 and the Saturation slider to around +35 to choose a nice pinkish-red color.

Making Really Tricky Selections, Like Hair (and Some Cool Compositing Tricks, Too!)

Most of the selecting jobs you'll ever have to do in Elements are pretty easy, but the one that has always kicked our butts is when we have to select hair. Over the years we've come up with all sorts of tricks, but all these techniques kind of went right out the window when Adobe supercharged the Quick Selection tool in Elements with the Refine Edge feature. This is, hands down, one of the most useful, and most powerful, tools in all of Photoshop—and now we've got it in Elements.

Step One:
Start by opening an image that has a challenging area to select (like our subject's hair here). Then, get the Quick Selection tool **(A)** from the Toolbox (as shown here).

Step Two:
Here's how it works: you just take the tool and paint loosely over the areas you want to select, and it expands to select the area. One thing I've learned about this tool is it actually seems to work best when you use it quickly—really zoom over your subject with the tool and it does a pretty decent job. Here, I selected the subject, and while you can see some problems with the selection (the area around her hair and the arm holding the bag), it's not that bad overall. If it selects too much, press-and-hold the **Alt (Mac: Option) key** and paint over that accidentally selected area to remove it from your selection. Don't worry—it's not going to look perfect at this point.

(Continued)

Step Three:

Now, here's something else I've learned about the Quick Selection tool: while it's pretty good at selecting, it's not nearly as good at deselecting areas that you don't want selected (like the area near her arm). I've found that when it misses areas like that, you're honestly better off switching to the Magic Wand tool (keep pressing **A**), pressing-and-holding the Alt (Mac: Option) key, and clicking once in that area to instantly deselect it. So, let's go ahead and do that near her arm, and you'll see that in just one click with the Magic Wand tool, that area is deselected (as shown here).

Step Four:

Okay, here comes a very important part of this stage of the process, and that is making sure that when you select her hair, you don't select any background area with it. In other words, don't let there be any hair selected with white background showing through. In fact, I basically follow the rule that I don't get too close to the outside edges of my subject's hair unless an area is pretty flat (in other words, no flyaway, tough-to-select hair in that area). You can see what I mean in the close-up here, where I avoided the thinner edges of her hair (we'll let Elements select those hard parts—we'll just get close to the edge then stop). Also, you can see where I stopped before some areas where the hair is finer. Again, we'll let Elements grab those parts later, but for now we're most concerned with avoiding selecting areas where you can see white background through her hair. If you accidentally select an area with gaps, then just press-and-hold the Alt (Mac: Option) key, and paint over those gap areas to deselect them.

Step Five:

Once your selection looks pretty decent, it's time to unlock the real selection power (the Quick Selection tool is just the warm-up act). Go down to the Tool Options Bar and click on the Refine Edge button (shown circled here). This is where the magic happens. In the Refine Edge dialog, you have a number of choices for how you can view your selected image (including the standard old marching ants), but for now, as part of our learning process, go ahead and choose **Black & White** from the View pop-up menu. This shows your selection as a standard layer mask. As you can see, the Quick Selection tool, by itself, isn't gettin' the job done (the edges are jaggy and harsh, and there's no wispy hair selected at all). That's okay, though, because we're just gettin' started.

Step Six:

Next, turn on the Smart Radius checkbox (you won't see anything happen yet, but turn it on anyway). Smart Radius is the edge technology that knows the difference between a soft edge and a hard edge, so it can make a mask that includes both. This checkbox is so important that I leave it on all the time (if you want it always on, as well, just turn it on and then turn on the Remember Settings checkbox at the bottom of the dialog). Now, again, just for learning purposes, drag the Radius slider all the way over to the right (to 250), and all of her hair gets selected instantly (pretty amazing isn't it?). While it did a great job on her hair, there are parts of her (like her glasses, dress, hands, and bag) that are being "over-selected." Those areas will wind up being transparent, and you don't want that, so we always have to back it way down. But, I just wanted you to see the incredible math at work.

(Continued)

Step Seven:

Okay, let's drag that Radius slider back down until those areas look more solid white. Here's how this works: We want our subject to be solid white and we want the background to be solid black. Anything that appears in gray will be semi-transparent. That's okay if this happens in her hair in wispy areas, but it's not good on her arms or clothes or anything that's supposed to have a well-defined hard edge. Otherwise, we'd leave the Radius up at 250 and be done with it. But, there's more to most portraits than just hair, so we have to keep those other areas pretty much intact, too. Here, I rolled back the Radius to around 47, but you might be able to bring it down a bit more, to 20, 30, or 40. It just depends on the complexity of the selection and the details around the person. For simple selections, leave the Radius amount down low. When you have a tricky selection, like fine hair, you'll have to increase it. So, just remember: trickier selections mean higher Radius amounts.

Step Eight:

Now, let's change the View to **Overlay** to see if there are any areas we missed. The parts that are selected appear in full-color, and the parts that aren't appear in red. If you see the background color showing through (in our case, white), you've got a problem (and we do here quite a bit). You need to tell Elements exactly where the problem areas are, so it can better define those areas. You do that with the Refine Radius tool (**E**; shown circled here). It's active by default, so just take your cursor and simply paint over the areas where you see the background peeking through (as shown here), and it redefines those areas. This is what picks up that fine hair detail.

Step Nine:

As you look around her hair, if you see parts of it that are tinted red, those parts aren't selected. So, just paint a stroke or two over those areas (like I'm doing here), and they become full-color (letting you know they're added to your selection) as Elements refines those edge areas where you're painting. It'll look like it's painting in white sometimes, but when you're done, it just redefines the area and tells Elements that this area needs some work, and it "redoes" its thing. Here, I've gone over some areas that were tinted red on her hair, and you can see those areas are now appearing in color. I also increased the Radius amount a bit.

Step 10:

I recommend avoiding the Adjust Edge section sliders in the center of the dialog altogether, because you'll spend too much time fussing with them, trying to make them work. (I figure you want me to tell you when to avoid stuff, too.) Down at the bottom of the dialog, there's a Decontaminate Colors checkbox, which basically desaturates the edge pixels a bit. So, when you place this image on a different background, the edge color doesn't give you away. Just below that, you get to choose what the result of all this will be: will your selected subject be sent over to a new blank document, or just a new layer in this document, or a new layer with a layer mask already attached, etc.? I always choose to make a new layer with a layer mask in the same document. That way, I can just grab the Brush tool and fix any areas that might have dropped out, which we're probably going to have to do next, so choose **New Layer with Layer Mask** and click OK.

(Continued)

Step 11:

When you click OK, your image will now appear on a transparent layer (as seen here) and if you look in the Layers palette, you'll see a new layer with a layer mask attached (just what you asked for). You can also see it does a pretty amazing job. It won't get every little thin, wispy hair strand, but it gets most of the important ones. Also, I've got a trick or two coming up that will help a bit more, but first, let's do a quick check of that mask and fine-tune it just a bit before we put her over a different background (that's right, baby, we're doing some compositing!). Press-and-hold the Alt (Mac: Option) key and click directly on that layer mask thumbnail in the Layers palette to see just the mask (you can see it in the next step).

Step 12:

Now, as you move around the mask, you can see some areas that aren't solid white (which means these areas will be semi-transparent and that's not what you want). So, get the Brush tool (B) and, with your Foreground color set to white, choose a small, hard-edged brush from the Brush Picker in the Tool Options Bar, and then paint along the grayish areas, to make them solid white. You can see some areas here on her hands, glasses, and ears that need a cleanup, as well. Next, press X to switch your Foreground color to black to clean up any places where the white has spilled over onto the black. It should be solid black in the background areas. For a little help cleaning up tricky areas, switch your Brush's blend mode to **Overlay**. That way, when you're painting with white, it automatically avoids painting over the color black (and vice versa).

©DOLLAR PHOTO CLUB/ZHU ZHU DIFENG

Step 13:

At this point, we're done with our mask, so you can apply it permanently to your image by clicking directly on the layer mask thumbnail (in the Layers palette) and dragging it onto the Trash icon at the top of the palette (as shown here) to delete it. When you do this, a warning dialog pops up asking if you want to "Apply mask to layer before removing?" You want to click Apply, and the masking you did is now applied to the layer (and the layer mask thumbnail is deleted). This just makes things a little easier from here on out.

Step 14:

Next, open the background image you want to use in your composite. Get the Move tool **(V)**, then drag-and-drop your subject right onto this background image (as shown here). (*Note:* This is easier if you have all images on-screen. To float both images, press **Ctrl-K [Mac: Command-K]** to open the General Preferences, and turn on the Allow Floating Documents in Expert Mode checkbox. Then, you can go under the Window menu, under Images, and choose Float All In Windows. If all else fails, copy-and-paste it onto this background like we did in the chapter on layers; it will appear on its own layer.) If your subject is too big, press **Ctrl-T (Mac: Command-T)** to open Free Transform. Then, turn on the Constrain Proportions checkbox in the Tool Options Bar, grab a corner handle, and drag inward until she is the right size for the background. Press **Enter (Mac: Return)** to lock in your changes.

(Continued)

Step 15:

Depending on the background and your selection, you may see a white fringe around your selected object. To remove the fringe, go under the Enhance menu, under Adjust Color, and choose **Defringe Layer**. When the Defringe dialog appears (shown here), enter 1 pixel (use 2 pixels for a higher-megapixel image), click OK, and that fringe is gone! (Elements basically replaces the outside edge pixels with a new set of pixels that is a combination of the background it's sitting on and your subject's edge, so the fringe goes away.)

Step 16:

Here's a trick that gives you more detail and brings back some of those lost wisps of hair by building up some pixels. It's going to sound really simple and it is. Just press **Ctrl-J (Mac: Command-J)** to duplicate your layer (the one with your subject). That's it. Just duplicate your subject layer, and it has a "building up" effect around the edges of her. Suddenly, it looks more defined, and it fills in some of the weaker wispy areas. If for any reason it looks like too much, at the top of the Layers palette, just lower the Opacity of this duplicate layer until it looks right (here, I lowered it to 50% and it looks about right). Next, merge this duplicate layer with your original subject layer by pressing **Ctrl-E (Mac: Command-E)**.

Step 17:

Now, she looks a little warm for the background, so let's desaturate her a little. Start by Ctrl-clicking (Mac: Command-clicking) on the layer thumbnail for her layer to put a selection around her again. Then, click on the Create New Adjustment Layer icon at the top of the Layers palette and choose **Hue/Saturation** from the pop-up menu. This adds a Hue/Saturation adjustment layer, but with your selection (our subject) already masked on the layer mask, so the adjustment will only affect what is inside the selection. In the Hue/Saturation adjustment palette, set the Channel pop-up menu to **Yellows** and drag the Saturation slider to the left a bit, until she blends with the background better (here, I dragged to –48). That's it.

Final

Photo by Scott Kelby Exposure: 1/25 sec | Focal Length: 11mm | Aperture Value: f/4

CLONE WARS
removing unwanted objects

Have you ever taken a photo of some majestic landscape and when you open the photo in Elements, only then do you notice a crushed beer can just off to the side of the image? Or you see some really ugly power lines you didn't see when you took the shot. Or, maybe it's a crushed beer can balanced on top of some really ugly power lines (okay, that last one was a stretch, but you get the idea). At this point, you have to make an ethical and moral decision. Now, this is an easy decision if you're a photojournalist—you have to maintain the total integrity of the image, so that beer can and those power lines stay. But what if you're not a photojournalist? You're an artist, which means your job is to create the most beautiful, pleasing image you can. In that case, as an artist, you have full license to remove those unwanted, distracting elements from the scene, and then clone in a stock photo of a Ferrari in the background that you downloaded from the web. Errr…I mean, perhaps you should consider using Elements' tools, like the Spot Healing Brush and the Clone Stamp tool, to remove those unwanted objects in order to return the scene to how it looked when you were actually there. Now, there is a third alternative: when you're taking the photo, pick up the crushed beer can and put it in the trash. However, this is actually frowned upon in the photo community because it breaks the sacred rule of all photographers, which is to expend as little physical energy as possible, so we're fully rested when called upon to gently press the shutter button on the top of our cameras. Hey, I'm sorry I had to be the one to tell you, but that's how we roll.

Removing Spots and Other Artifacts

Elements has a tool, the Spot Healing Brush tool, which is just about perfect for getting rid of those tiny little spots and other artifacts. (By the way, the term "artifacts" is a fancy "ten-dollar" word for spots and other junk that wind up in your photos.)

Step One:

Open a photo that has spots (whether they're in the scene itself or are courtesy of specks or dust on either your lens or your camera's sensors). In the photo shown here, there are all sorts of distracting little spots in the sky (yes, I need to get my camera sensor cleaned). :-)

Step Two:

Press **Z** to get the Zoom tool and zoom in on an area with lots of spots (here, I zoomed in on the sky, which is typically where you'll see them the most). Now get the Spot Healing Brush tool from the Toolbox (or just press the letter **J** until you have it).

Step Three:

Position the Spot Healing Brush directly over the spot you want to remove and click once. That's it. You don't have to sample an area or Alt-click anywhere first—you just move it over the spot and click, and the spot is gone. (*Note:* If the fix doesn't look quite right, make sure Content Aware is chosen for Type in the Tool Options Bar.)

Step Four:

You remove other spots the same way—just position the Spot Healing Brush over them and click. I know it sounds too easy, but that's the way it works. So, just move around and start clicking away on the spots. Now you can "de-spot" any photo, getting a "spotless" version in about 30 seconds, thanks to the Spot Healing Brush.

Before

After

The Amazing (and Easiest) Way to Remove Distracting Stuff from Your Photos

When people talk about "Photoshop magic," the Clone Stamp Tool and Content-Aware options are some of those things they're talking about. Even after using them for years now to get rid of distracting things in my images, they still amaze me with the remarkable job they do. The fact that they're incredibly easy to use at the same time really makes them a powerful, and indispensable, tool for photographers. While the Spot Healing Brush in Elements has had a Content-Aware feature for a while now, back in Elements 13 they added Content-Aware Fill, which works a little differently. Most of the time, you'll end up using a combination of the two.

Step One:
Here, we have a couple people sitting on some rocks, and they distract from our subject (the lighthouse), so ideally we'd like them out of the shot.

Step Two:
First, to have Content-Aware Fill remove the people, get the Lasso tool **(L)**, or whichever selection tool you're most comfortable with (like maybe the Quick Selection tool), and draw a selection around them. Once your selection is in place, you can help Content-Aware Fill do its thing by expanding that selection outward by 4 or so pixels. So, go under the Select menu, under Modify, and choose **Expand**. When the Expand Selection dialog appears (shown here), enter 4 pixels, click OK, and your selection grows outward by that much.

Step Three:

Next, go under the Edit menu and choose **Fill Selection**. When the Fill Layer dialog appears, choose **Content-Aware** from the Use pop-up menu (as seen here). Now, just click OK, sit back, and prepare to be amazed (I know—it's freaky). Not only are the people gone, but it also patched the rocks pretty darn perfectly beneath them (that's why it's called "Content-Aware" Fill. It's aware of what is around the object you're removing, and it does an intelligent filling in of what would normally just be a big white hole in your image). Go ahead and deselect by pressing **Ctrl-D (Mac: Command-D)**.

Step Four:

One area it didn't fill perfectly is the bar coming down from the solar panel, so we'll have to fix that manually using the Clone Stamp tool. Get the Clone Stamp tool **(S)** from the Toolbox, Alt-click (Mac: Option-click) on what it left of the bar and paint down (as seen here at the top. I also went around and cleaned up a bit of the rocks, as well). Now, you will fall deeply in love with Content-Aware Fill if you can come to peace with the fact that it won't work perfectly every time. But, if it does 70% or 80% of the work for me (in removing something I don't want), that means I only have to do the other 20% (or maybe 3%, like in this case), and that makes it worth its weight in gold. If it does the entire job for me, and sometimes it surely does, then it's even better, right? Right. Also, it helps to know that the more random the background is behind the object you want to remove, the better job Content-Aware Fill generally does for you.

(Continued)

Step Five:

Content-Aware Fill is pretty amazing when it works, but like any other tool in Elements, it doesn't work 100% of the time on every single type of photo and every situation. When I use Content-Aware Fill, I usually wind up using the Spot Healing Brush along with it, because it has Content-Aware healing built in. Let's open another image (the shot here) and use these tools together to remove the grate, the white object below it, and the pipe next to the window.

Step Six:

A lot of times, you don't have to do as accurate a selection as we just did when removing the people in the previous project. For the white object, take the regular ol' Lasso tool (L), draw a loose selection around it (as seen here), then go under the Edit menu and choose Fill Selection. When the Fill Layer dialog comes up, make sure Content-Aware is selected in the Use pop-up menu, then click OK, and press Ctrl-D (Mac: Command-D) to Deselect (you'll see in the next step that it's gone, and it did a great job of filling in the bricks). If part of its fix doesn't look great, simply select that area and try again.

Step Seven:
Take a look at where the white object used to be. It's outtathere! Let's switch to the Spot Healing Brush tool **(J)** for the pipe next to the window (make sure Type is set to Content Aware in the Tool Options Bar). You literally just make your brush size a little bigger than the pipe, paint over it, and Elements uses the Content-Aware technology to remove it (when I release the mouse button, a second later that will be gone, too!). *Note:* The regular Healing Brush tool (the one where you have to choose the area to sample from by Option-clicking [PC: Alt-clicking]) does not have the Content-Aware technology. Only the Spot Healing Brush tool has it.

Step Eight:
As you use the tools more, you'll start to get a feel for which one works better when it comes to the Content-Aware stuff. I usually use the Lasso tool and Content-Aware Fill for larger areas, like for the grate here, and the Spot Healing Brush with Content Aware turned on for smaller things. While sometimes they work the same, sometimes they also work differently, so it's always good to try both ways if you don't see the result you like right off the bat.

(Continued)

Step Nine:

Let's take care of one last thing: Switch back to the Spot Healing Brush, then paint over the shadow area in the top right (as shown here). The Spot Healing Brush did a great job here—it filled it in almost perfectly, as if it were never there. You can see this all in the Before and After images shown on the next page.

Before

After

Moving Things Without Leaving a Hole Using Content-Aware Move

This is another one of those tools that makes you just scratch your head at the math that must be going on to perform the mini-miracle of letting you select something, then move it someplace else in your image, and Photoshop automatically repairs the area where it used to be. This doesn't work for every image, every time, and it's one of those tools you won't be reaching for every day, but when you need it, and it does its thing perfectly, your jaw hits the floor. It can be finicky sometimes, but I'll show you a few things to help it help you.

Step One:
Here's the image we're going to work on, and in this one, we want to move the light fixture closer to the door.

Step Two:
From the Toolbox, get the Content-Aware Move tool (or just press the letter **Q**). Now, draw a selection around the objects you want to move (in this case, the light, the bracket holding it, and the plug and socket). It doesn't have to be a perfect selection, but get fairly close.

TIP: Use Any Selection Tool
The Content-Aware Move tool works a lot like the Lasso tool. However, you could draw your selection with any selection tool you'd like, and then simply use the Content-Aware Move tool to move it just like we're about to do.

Step Three:
Next, click in your selection and drag it over to the part of the image you want to move it to. When you release the mouse button, the original will still be there in the same position for a few seconds while Elements is freaking out (kidding—while Elements is doing its crazy math thing).

Step Four:
When you release your mouse button, it's going to take a few moments for the magic to happen (depending on how large your file size is), but then you'll see that not only are your subjects moved, but the hole that would normally have been left behind is instead totally patched and filled. However, don't deselect quite yet. Two things can happen after using this tool. First, the area that was filled in as you moved the selection away may not be perfect. Second, the selected area you moved may not fit nicely into its new background. If either happens, then leave your selection in place—especially if it didn't work well. While it's still selected, you can change how Elements creates the background texture that blends with your move. You do this using the Healing slider in the bottom Tool Options Bar. You can choose a different healing amount and it will re-render your move. So, all you have to do is move the slider until you find a place that looks the best (again, I do this only if there's a problem). If you keep it to the left, it uses a strict healing amount that doesn't do as much healing between the two areas. This looks more realistic in some cases, but it can make the move look weird in others. You can also move it to the right (more healing) which forces Elements to really look around the selected-and-moved area and find other places to heal those holes with.

(Continued)

Step Five:

I'm not gonna lie to you here. As with many of the auto-fix tools in Elements, Content-Aware Move is not always perfect. Here, it did a pretty good job, but most of the time you're going to need to do some cleanup after. If that happens, try taking the Spot Healing Brush or the Clone Stamp tool and fixing it. Finally, just press **Ctrl-D (Mac: Command-D)** to Deselect.

Automatically Cleaning Up Your Scenes (a.k.a. The Tourist Remover)

If you've ever tried to photograph a popular landmark or national monument, you'll know that it's pretty unlikely you'll be there alone. Unless you're willing to get up really early in the morning (when most people are still sleeping), you're bound to get a tourist or two (or 20) in your photos. In this tutorial, you'll learn a few tricks to help clean up those scenes and remove the tourists with just a few brush strokes.

Step One:
The first step starts in the camera. You'll need to take at least two shots of the same scene (but you can use up to 10 if you'd like). So, if you're in one of those situations where you just can't get a photo with no people in it, then take a few photos in the hope that the people move around a little (even if they don't ever exit the area completely).

Step Two:
Here, there was a woman walking around when I was shooting at the Paris Opera House. I waited for her to leave, but she wasn't going anywhere. Since we have this feature, though, it's an easy fix.

TIP: Keep Your Camera Steady
I wasn't on a tripod when I shot this, but Elements does a great job of auto-aligning photos. If you can't shoot on a tripod, the key is to try to be as steady as possible, so the actual photo doesn't change too much.

(Continued)

Step Three:

Go ahead and open the photos you've taken (remember, you'll need at least two but can use up to 10. In this example, I'm only using two) in the Elements Editor. Then select them down in the Photo Bin by clicking on the first one and Shift-clicking on the last one. Now, click on Guided at the top of the window. Click on Photomerge® at the top right of the Guided window, and then click on **Photomerge® Scene Cleaner**. This will take you into Photomerge.

ADVANCED TIP: Try the Advanced Options

Here's a follow-up to the previous tip. In fact, just file this tip away, because you may or may not need it. If you didn't shoot on a tripod, and you're not getting good results from Photomerge, then click on the Advanced Options button at the bottom of the Photomerge palette. Use the Alignment tool to place three markers in the Source window and three in the Final window, on similar places in the photos. Then click Align Photos, and Elements will do its best to align the photos based on those markers. This helps the Scene Cleaner give more predictable results. Again, give Step Three through Step Seven a try first and see how things work out. If everything looks good, then you don't need the Advanced Options.

Step Four:
The Source window on the left will automatically be populated with the first photo you chose. You'll need to create a Final photo though, so drag the other photo from the Photo Bin into the Final window on the right.

Step Five:
Now look over at the Source window and find the clean areas from this photo that you'd like copied over to the Final photo. In this example, we'll paint over the railing and wall, to the left of where the woman is standing. You can use the Zoom tool (the one that looks like a magnifying glass in the Toolbox on the left) to zoom in to the area if you need to.

(Continued)

Step Six:

All right, let's get rid of the woman walking through the photo. Click on the Pencil tool on the right side of the window because we're going to use this to paint on the Source image (left side). The way this works is you want to paint on an area from the Source image that you want copied over to the Final image. So, again, I'm going to paint to the left of the woman, right near the railing (as shown here). Remember, we're painting on a clean area that we want copied over to our Final image. Elements will only copy over the areas we paint over with the Pencil tool.

Step Seven:

When you release your mouse button, you'll see Scene Cleaner automatically remove her from the Final image. In this example, our tourist goes away pretty quickly. If we had more people, we'd do the same thing—just paint over the area we want copied into the Final image. When you're done cleaning up the image, click the Next button and then choose what you'd like to do with the image. Here, we're going to continue editing it back in the Editor, so I'll click on the In Expert button.

TIP: Getting Rid of the Pencil Marks

If you move your mouse over the Final image, you'll see the blue pencil marks on it, too. If you want to see your Final image without the blue pencil marks over it, just move your mouse away from it and they'll disappear. If you want to see the Source image without the blue marks, then turn off the Show Strokes checkbox in the Photomerge palette on the right.

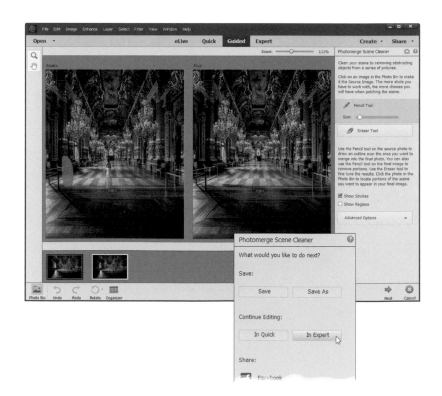

Step Eight:
If Photomerge left some extra white canvas around your final image, first flatten your image by choosing **Flatten Image** from the Layers palette's flyout menu, then just use the Crop tool **(C)** to remove the extra white canvas.

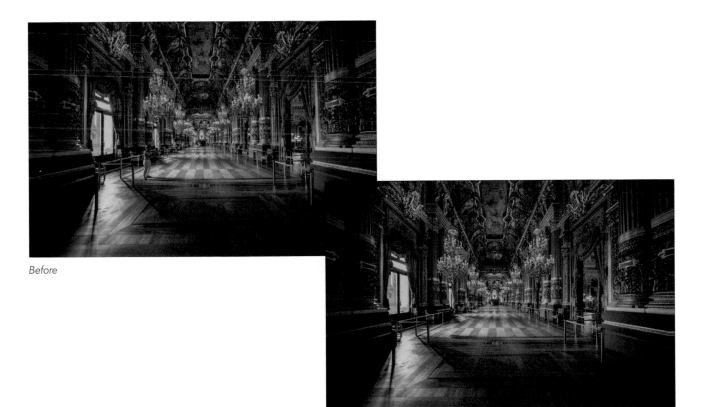

Before

After

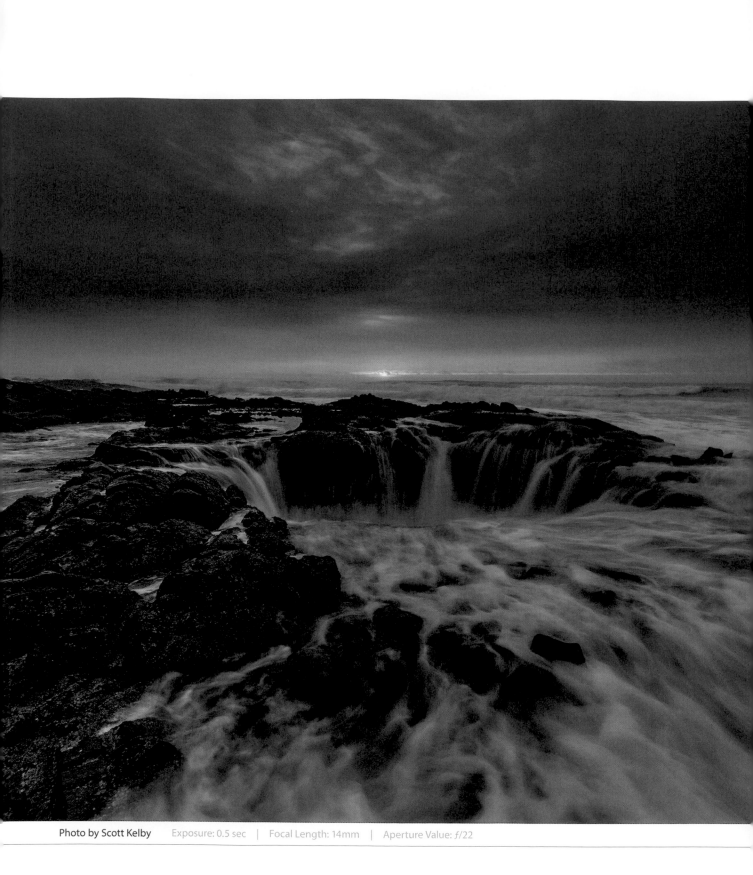

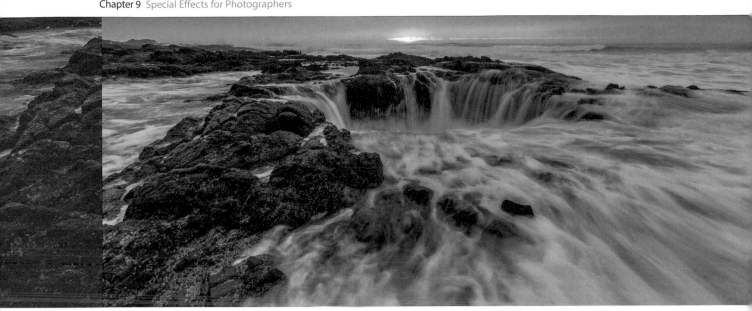

SIDE EFFECTS
special effects for photographers

The name of this chapter comes from the 2009 movie short *Side Effects* (it's less than 20 minutes long, which is probably why you can buy it for only $1.99 in the iTunes Store. It's either that, or it's so cheap because of its lack of zombies). Anyway, here's how they describe *Side Effects* (say this in your best movie voice-over guy voice): "An ordinary guy becomes a human guinea pig in an experimental drug test and meets the girl of his dreams…" Sounds like a pretty typical everyday story. At least the human guinea pig in an experimental drug test part. Anyway, I looked at the movie poster, and the guys in the poster all have this creepy-looking bluish/green color cast that makes them look kind of sickly, but then the female lead's photo looks fine, with regular-looking flesh tones, and that's when I realized why this guy thinks he's found the woman of his dreams. She doesn't have a creepy bluish/green color cast. I mean,

think about it. If all the girls around you had a serious white balance problem, and then all of a sudden you meet a girl carrying around her own 18% gray card, so she looks correctly color balanced in any lighting situation, wouldn't you fall in love with her, too? Exactly. I'll bet in the last 10 minutes of the movie, you find out that this guy actually starts an online business for people using dating sites like eHarmony, or Match.com, or HandsomeStalker.com, where he offers to remove bluish/green color casts from your profile photo for a price. Things are going pretty well for him for a while, but then in about the eighteenth minute, the experimental drug wears off, and he finds himself trapped in a dank, dimly-lit room, forced to write nonsensical chapter intros late into the night, until his wife comes in and says, "Honey, come to bed," but right then, he notices she has a bluish/green color cast, and….

Effects and Presets Galore in Quick Edit Mode

People love one-click effects. They're quick and simple to use, and they can help give your photos a new look that maybe you hadn't thought of. In Elements 14, they've really taken the Quick edit mode effects up a notch by adding a new auto feature, and now you've got a great group of presets that are really just a click away.

Step One:
Open a photo in the Editor, click on Quick at the top of the window, and then click on the Effects button at the bottom right. You'll see all of the possible effects listed in the panel on the right side of the screen.

Step Two:
Now, it couldn't be easier—just click on an effect, and it applies that effect to the photo you have open (here, I clicked on the second effect: Tint).

Step Three:
When you click on an effect, you'll see four other variations of the effect right below the main one. Some are just different levels of intensity of the main effect and some look way different. But it's easy to experiment by just clicking on them to see if you like what they do to your image. You can always click on another one to reverse the effect and see something else. Here, at the top, I clicked on the Vintage effect, and then at the bottom, I clicked on Sepia Glow (the third variation).

Step Four:
As I mentioned, in Elements 14, they added a new auto feature to Quick edit mode effects. Click on Smart Looks, at the top of the panel, and Elements will automatically apply five different effects to the image based on its color and lighting. Just click on the four other auto variations that appear to see what it came up with. Here, I clicked on the third variation, which applied a high-contrast effect to the image.

Creating a Picture Stack Effect

Picture Stack is one of my favorite Guided edits, because this one would seriously take a ton of time if you tried to do it manually. The idea is to take one photo and make it look like it was cut up into smaller photos with white borders stacked on top of each other. The effect looks pretty cool and is a fun way to show off your photos. Plus, it even goes so far as to add shadows under each photo, so it really looks like they're lying on top of each other.

Step One:
In the Editor, open the photo that you want to use for the Picture Stack effect. I usually find landscape and travel photos look good here. You can use photos of people, too, but sometimes Elements will cut the photo right in the middle of someone's face, so you have to watch out when using these. Click on Guided at the top of the window and then, in the Guided window, under Fun Edits, click on Picture Stack (it's third in the top row).

Step Two:
First, you'll choose how many pictures you want your photo to be chopped up into. My favorite is 8 Pictures. To me, 4 Pictures doesn't look like enough and 12 Pictures makes the photo look too busy. The good thing is that you don't really have to commit to too much at this point. So, click on the 8 Pictures button on the right and Elements will go to work. It takes a minute, but you'll eventually see your photo cut into smaller square/rectangular pieces.

Step Three:
If you want to see what it looks like using four or 12 pictures, then just click on one of those buttons and Elements will redo the stack. It's pretty easy to figure out which one looks best for your photo by just trying out each option.

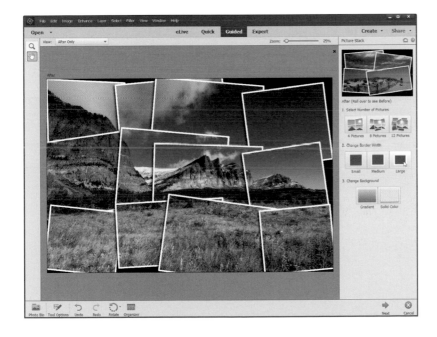

Step Four:
You'll notice that each photo has a white border around it and, in section 2, you can control the width of that border. I usually go with the Medium setting here—the Small setting is too thin, so I barely ever use it, but the Large setting isn't bad (sometimes it's a little overpowering, but sometimes it looks cool). Just like with selecting the number of pictures, this one is easy to experiment with, so click on the three border buttons to see which one you like better.

(Continued)

Step Five:

Lastly, you can change the background color and style (I switched back to eight photos with a medium border here). You have a choice between a gradient or just a simple solid-color background— I usually stick with a solid color. While the default black looks pretty cool, let's try a white background. Click on the Solid Color button and when the New Layer dialog appears, click OK. In the Color Picker, choose white and then click OK. I kinda like white, because it lets you see the shadows under the photos. It gives the image a little more depth, so each picture in the stack really looks like it's lying on the background.

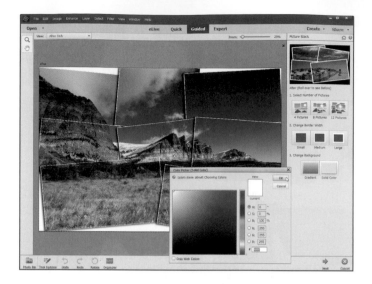

Step Six:

When you've settled on your background color, just click the Next button at the bottom of the Palette Bin, and then choose what you want to do next with the photo—save it, continue editing it, or share it.

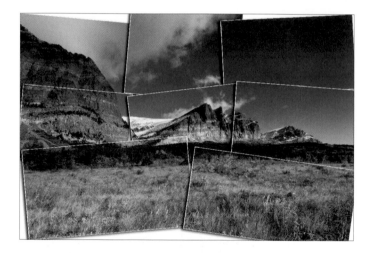

TIP: Edit the Layers

If you choose to continue editing it in Expert mode and look in the Layers palette, you'll see the behind-the-scenes work that went on. Elements adds quite a few layers to your document. If you're brave enough, you can go into the separate layers and adjust them. The drop shadows, the outline around each photo—they each have their own layer, so if there's something you want to change, you can do so right on the layer.

Depth of field is a great way to really make your subjects stand out from the background by blurring it. Sure, we can do a lot of this work in-camera with our lens and f-stop choice, but sometimes the creative idea doesn't strike until the photo hits the computer. The Depth Of Field lens effect in Elements will help you fix that, though.

Enhancing Depth of Field (or Faking That 85mm f/1.4 Look)

Step One:

In the Editor, open a photo that has a busier background than you'd care for, or just one where you'd like to draw attention to a specific part of the image. Click on Guided at the top of the window, then click on Special Effects at the top, and then click on Depth Of Field.

Step Two:

In this example, we'll keep the woman in focus and blur the background. You'll see this effect has two modes: Simple and Custom. Let's start by clicking on the Simple button. Elements pretty much walks you through what to do in Simple mode. First, click the Add Blur button at the top to simply add some blur to the entire photo. At this point, you haven't defined the subject yet, so Elements will blur everything in the photo.

(Continued)

Step Three:

Next, you need to tell Elements what parts of the photo you want in focus. So, start by clicking on the Add Focus Area button in section 2, then click in the middle of whatever you want to be in focus and drag outward. The farther out from the center you drag, the smoother your sharp-to-blur transition will be. You can also click-and-drag more than once, as I did here, where I dragged once to get her head in focus, and once to get her body in focus.

Step Four:

Once you've defined the part of the photo you want sharp, you can use the Blur slider to add more blur if you want. I dragged my slider to 6 to make the background even blurrier. Now, if you haven't realized yet, the simple method is, well, simple, but it's limited because of the way it fades the blur away. Like most things in Elements, however, this effect gives you a simple way and a more custom way to do things. We'll take a look at the custom method next.

Step Five:

I've got another photo open here in the Editor. In this example, the bride, and the column and statue to her right are all in focus, but I'd like to make it so the bride seems like the center of attention. So, once again, in the Guided options, go to the Special Effects, and click on Depth Of Field. This time, though, click on Custom.

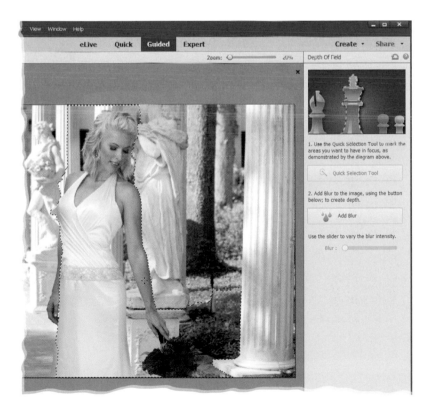

Step Six:

The first thing we'll do here is define our subject (the part of the photo that we don't want to blur). We did it before using a gradient tool, which didn't give us too much control, but in the Custom options, we get to make a selection. So, click on the Quick Selection Tool button (by the way, we covered this tool in greater detail back in Chapter 7), and then just start painting over the bride in the photo. Don't worry if you select part of the background, though, because we'll take care of that in the next step.

(Continued)

Step Seven:

Chances are that you've probably selected something you didn't want to during your first pass with the Quick Selection tool. No sweat. Just press-and-hold the **Alt (Mac: Option) key** to put the tool into Subtract mode and click on any areas you didn't want selected.

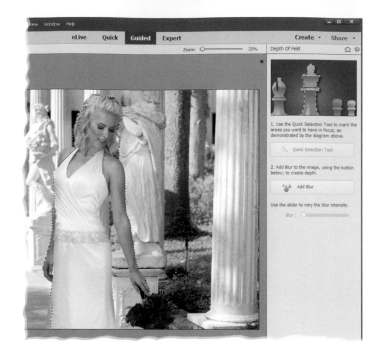

Step Eight:

The rest is a piece of cake. Just click on the Add Blur button in section 2 to blur everything that wasn't selected in the photo. Now the bride should really stand out from the background behind her. Just like before, if you want to add more blur to the background, just drag the Blur slider to the right some. If you find the blur is too intense (when using either the Simple or Custom method), click the Next button at the bottom right, then click the In Expert button to bring the photo back to Expert mode, and lower the blurred layer's opacity.

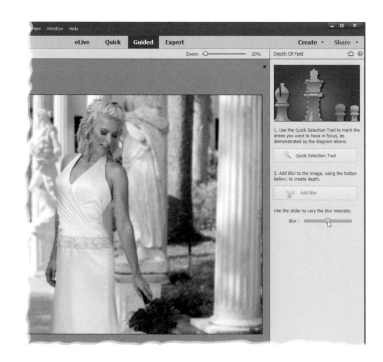

This is just about the hottest Photoshop portrait technique out there right now, and you see it popping up everywhere, from covers of magazines to CD covers, from print ads to Hollywood movie posters, and from editorial images to billboards. It seems right now everybody wants this effect (and you're about to be able to deliver it in roughly 60 seconds flat using the simplified method shown here!).

Trendy Desaturated Skin Look

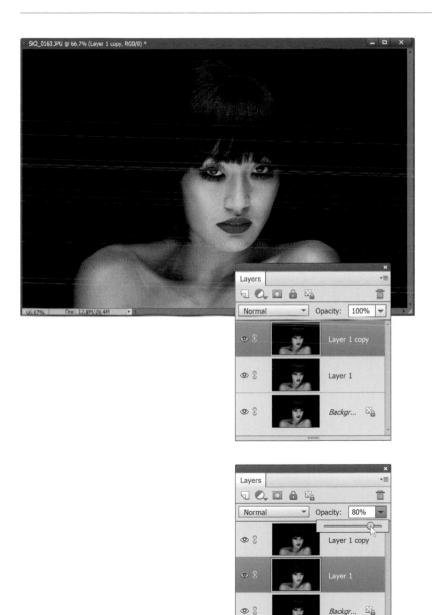

Step One:
Open the photo you want to apply this trendy desaturated skin look to. Duplicate the Background layer by pressing **Ctrl-J (Mac: Command-J)**. Then duplicate this layer using the same shortcut (so you have three layers in all, which all look the same, as shown here).

Step Two:
In the Layers palette, click on the middle layer (Layer 1) to make it the active layer, then press **Ctrl-Shift-U (Mac: Command-Shift-U)** to desaturate and remove all the color from that layer. Now, lower the Opacity of this layer to 80%, so just a little color shows through. Of course, there's still a color photo on the top of the layer stack, so you won't see anything change onscreen (you'll still see your color photo), but if you look in the Layers palette, you'll see the thumbnail for the center layer is in black and white (as seen here).

(Continued)

Step Three:

In the Layers palette, click on the top layer in the stack (Layer 1 copy), then switch its layer blend mode from Normal to **Soft Light** (as shown here), which brings the effect into play. Now, Soft Light brings a very nice, subtle version of the effect, but if you want something a bit edgier with even more contrast, try using Overlay mode instead. If the Overlay version is a bit too intense, try lowering the Opacity of the layer a bit until it looks good to you, but honestly, I usually just go with Soft Light myself.

Step Four:

Our last step is to limit the effect to just our subject's skin (of course, you can leave it over the entire image if it looks good, but normally I just use this as a skin effect. So, if it looks good to you as is, you can skip this step). To limit it to just the skin, press **Ctrl-Alt-Shift-E (Mac: Command-Option-Shift-E)** to create a merged layer on top of the layer stack (a merged layer is a new layer that looks like you flattened the image). You don't need the two layers below it any longer, so you can hide them from view by clicking on the Eye icon to the left of each layer's thumbnail (like I did here), or you can just delete them altogether. Now, press-and-hold the Alt (Mac: Option) key and click on the Add Layer Mask icon at the top of the Layers palette to hide our desaturated layer behind a black mask. Press **D** to set your Foreground color to white, get the Brush tool **(B)**, choose a medium-sized, soft-edged brush from the Brush Picker in the Tool Options Bar, and just paint over her face, neck, and shoulders (any visible skin) to complete the effect. If you think the effect is too intense, just lower the Opacity of this layer until it looks right to you. That's it!

High-Contrast Portrait Look

The super-high-contrast look is incredibly popular right now, and while there are a number of plug-ins that can give you this look, I wanted to include this version, which I learned from German retoucher Calvin Hollywood, who shared this technique during a stint as my special guest blogger at my daily blog (www.scottkelby.com). The great thing about his version is you don't need to buy a third-party plug-in to get this look. My thanks to Calvin for sharing this technique with me, and now you.

Step One:
Open the image you want to apply a high-contrast look to.

Step Two:
Make a copy of your Background layer by pressing **Ctrl-J (Mac: Command-J)**. Then, change the blend mode of this duplicate layer to **Vivid Light** (I know it doesn't look pretty now, but it'll get better in a few more moves).

(Continued)

Step Three:

Now press **Ctrl-I (Mac: Command-I)** to Invert the layer (it should look pretty gray at this point). Next, go under the Filter menu, under Blur, and choose **Surface Blur**. When the dialog appears, enter 40 for the Radius and 40 for the Threshold, and click OK (it takes a while for this particular filter to do its thing, so be patient. If you're running this on a 16-bit version of your photo, this wouldn't be a bad time to grab a cup of coffee. Maybe a sandwich, too).

Step Four:

We need to change the layer's blend mode again, but we can't change this one from Vivid Light or it will mess up the effect, so instead we're going to create a new layer, on top of the stack, that looks like a flattened version of the image. That way, we can change its blend mode to get a different look. This is called "creating a merged layer," and you get this layer by pressing **Ctrl-Alt-Shift-E (Mac: Command-Option-Shift-E)**.

Step Five:
Now that you have this new merged layer, you need to delete the middle layer (the one you ran the Surface Blur upon), so drag it onto the Trash icon at the top of the Layers palette. Next, we have to deal with all the funky neon colors on this layer, and we do that by simply removing all the color. Click on your merged layer (Layer 2) to make it active again, then go under the Enhance menu, under Adjust Color, and choose **Remove Color**, so the layer only looks gray. Then, change the blend mode to **Overlay**, and now you can start to see the effect taking shape. You can stop right there (I usually do), but if you think you need an even stronger high-contrast effect (hey, it's possible. It just depends on the image, and how much texture and contrast you want it to have), you can continue on and crank your amp up to 11 (sorry for the lame *This Is Spinal Tap* movie reference).

Step Six:
Go under the Enhance menu again, under Adjust Lighting, and choose **Shadows/Highlights**. When the dialog appears, drag the Lighten Shadows slider down to 0. Then, you're going to add what amounts to Camera Raw's Clarity by increasing the amount of Midtone Contrast on this Overlay layer. Go to the bottom of the dialog and drag the Midtone Contrast slider to the right, and watch how your image starts to get that crispy look (crispy, in a good way). Of course, the farther to the right you drag, the crispier it gets, so don't go too far, because you're still going to sharpen this image. Here, I dragged to +20%. Click OK. The next step is optional, so if you don't need it, go to the Layers palette's flyout menu and choose **Flatten Image**.

(Continued)

Step Seven:

Okay, this high-contrast look looks great on a lot of stuff, but one area where it doesn't look that good (and makes your image look obviously post-processed) is when you apply this to blurry, out-of-focus backgrounds, or ones that already have texture. So, I would only apply it to our subject and not the background. Here's how: Alt-click (Mac: Option-click) on the Add Layer Mask icon at the top of the Layers palette to hide the contrast layer behind a black mask (so the effect is hidden from view). With your Foreground color set to white, get the Brush tool **(B)**, choose a medium-sized, soft-edged brush from the Brush Picker in the Tool Options Bar, and paint over his face, neck, and hair to add the high-contrast effect there. Lower the brush's Opacity in the Tool Options Bar to 70% (so the effect isn't as intense), then paint over his shirt. This way, you avoid adding the contrast to the blurry, textured background altogether. Lastly, go to the Layers palette and lower the Opacity of this layer until it looks more natural, as shown here at 60%. Now, you can flatten the layers and sharpen it using Unsharp Mask (see Chapter 10. Here, I used Amount: 120, Radius: 1, Threshold: 3) to finish off the effect.

Before

After

There are a few different ways to convert to black and white in Elements. You could simply use the Remove Color enhancement, but that leaves you with kind of a blah result. That's because Elements simply removes the color from the photo and leaves a very bland looking black-and-white image. Plus, there are no settings, so you can't customize your black-and-white image in any way. Here are two great techniques that create a better looking black-and-white and give you plenty of control to really customize the way it looks:

Converting to Black and White

Step One:
The first technique is simple—pretty much one or two clicks and that's it. So, open the color photo you want to convert to black and white (yes, you need to start with a color photo), and then go under the Enhance menu and choose **Convert to Black and White** (as shown here).

Step Two:
When you choose Convert to Black and White, a dialog appears and your photo (behind the dialog) is converted to black and white on the spot (in other words, you get a live preview of your changes). At the top of the dialog is a before and after, showing your color photo on the left, and your black-and-white conversion on the right. Your first step is to choose which style of photo you're converting from the list of styles on the lower-left side of the dialog. These styles are really just preset starting points that are fairly well-suited to each type of photo. The default setting is Scenic Landscape, which is a fairly non-exciting setting. Since I'm generally looking to create high-contrast, black-and-white photos with lots of depth, I recommend the Vivid Landscapes style, which is much punchier. Go ahead and choose that now, just so you can see the difference.

(Continued)

Step Three:

Whether you stay with the default Scenic Landscape, or try my suggested Vivid Landscapes (or any of the other styles to match the subject of your photo), these are just starting places—you'll need to tweak the settings to really match your photo, and that's done by dragging the four Adjust Intensity sliders that appear on the bottom-right side of the dialog. The top three (Red, Green, and Blue) let you tweak ranges of color in your photo. So, for example, if you'd like the grass darker, you'd drag the Green slider to the left. If you want the mountains and sky, which are mostly blue, brighter you'd drag the Blue slider to the right, as shown here.

Step Four:

So, basically, you use those three sliders to come up with a mix that looks good to you. You don't have to use these sliders, but if you can't find one of the presets that looks good to you, find one that gets you close, and then use the Red, Green, and Blue sliders to tweak the settings. The fourth slider, Contrast, does just what you'd expect it would—if you drag to the right, it adds contrast (and to the left removes it). I'm very big on high-contrast black-and-white prints, so I wouldn't hesitate to drag this a little to the right just to create even more contrast (so, personally, I'm more likely to start with a preset, like Vivid Landscapes, and then use the Contrast slider, as shown here, than I am to spend much time fooling with the Red, Green, and Blue sliders. But hey, that's just me).

Step Five:

So, that technique isn't too bad and it's quick and easy. But, if you really want some control over creating a killer black-and-white, and have an extra minute or two, then give this second one a try: Start by opening the color photo you want to convert to black and white, then press **D** to set your Foreground and Background colors to their defaults of black and white.

Step Six:

To really appreciate this technique, it wouldn't hurt if you went ahead and did a regular conversion to black and white, just so you can see how lame it is. So, go under the Image menu, under Mode, and choose **Grayscale**. When the Discard Color Information dialog appears, click OK, and behold the somewhat lame conversion. Now that we agree it looks pretty bland, press **Ctrl-Z (Mac: Command-Z)** to undo the conversion, so you can try something better.

(Continued)

Step Seven:

Go to the top of the Layers palette and choose **Levels** from the Create New Adjustment Layer pop-up menu (it's the half-blue/half-white circle icon). The Levels options will appear in the Adjustments palette and a new layer will be added to your Layers palette named "Levels 1." Press **X** to set your Foreground color to black, then go back to the top of the Layers palette and choose **Gradient Map** from the Create New Adjustment Layer pop-up menu. This brings up the Gradient Map options in the Adjustments palette and adds another layer to the Layers palette (above your Levels 1 layer) named "Gradient Map 1."

Step Eight:

Just choosing Gradient Map gives you a black-and-white image (and doing just this, this one little step alone, usually gives you a better black-and-white conversion than just choosing Grayscale from the Mode submenu. Freaky, I know). Now, if you don't get a black-to-white gradient, it's probably because your Foreground and Background colors were not set at their defaults of black and white. In that case, click-and-drag the Gradient Map and Levels adjustment layers onto the Trash icon at the top of the palette, press **D**, and then add both adjustment layers again.

Step Nine:
Now, in the Layers palette, click on the Levels 1 layer to bring up the Levels options again. From the Channel pop-up menu at the top of the palette, you can choose to edit individual color channels. So, choose the **Red** color channel.

Step 10:
You can now adjust the Red channel, and you'll see the adjustments live onscreen as you tweak your black-and-white photo. (It appears as a black-and-white photo because of the Gradient Map adjustment layer above the Levels 1 layer. Pretty sneaky, eh?) You can drag the middle gray midtone Input Levels slider to the right to darken the shadowy areas, as shown here. You can also try dragging the white highlight Input Levels slider to the left a little if you need to lighten things.

(Continued)

Step 11:

Now, switch to the **Green** channel in the Channel pop-up menu. You can make adjustments here, as well. Try increasing the midtones in the Green channel by dragging the same slider to the right, as shown here.

Step 12:

Next, choose the **Blue** channel from the pop-up menu, and try increasing the highlights and midtones quite a bit by dragging the Input Levels sliders (the ones that we've been using below the histogram). These adjustments are not standards or suggested settings for every photo; I just experimented by dragging the sliders, and when the photo looked better, I stopped dragging. When the black-and-white photo looks good to you (good contrast, and good shadow and highlight details), just stop dragging.

Step 13:

To complete your conversion, go to the Layers palette, click on the flyout menu at the top right, then choose **Flatten Image** to flatten the adjustment layers into the Background layer. Although your photo looks like a black-and-white photo, technically, it's still in RGB mode, so if you want a grayscale file, go under the Image menu, under Mode, and choose **Grayscale**.

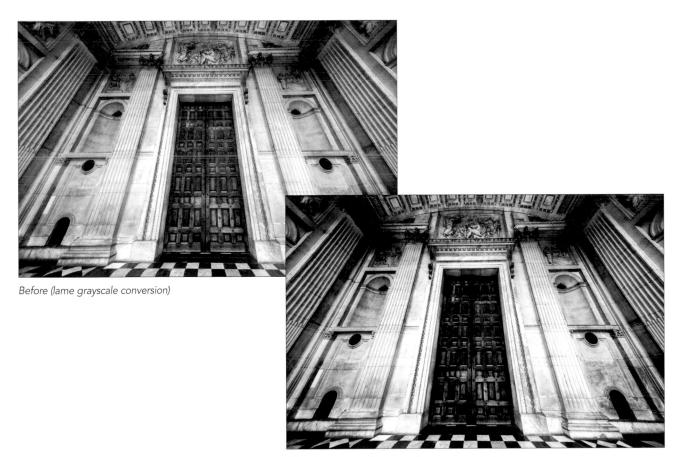

Before (lame grayscale conversion)

After (awesome adjustment layers conversion)

Panoramas Made Crazy Easy

Elements has had a feature to help you stitch multiple photos into a single panoramic photo for years now. As long as you did everything right in the camera (shooting on a tripod with just about every auto feature turned off), Photomerge worked pretty well. However, Photomerge is now so vastly improved that you can pretty much hand-hold your camera without regard to the auto settings, and Photomerge will not only perfectly align the photos, but now it will also seamlessly blend the pieces together, even if the exposure or white balance isn't "on the money." And, in Elements 14, it was added to Guided mode, which makes it even easier to use. This is very cool stuff.

Step One:

Before you create your pano, choose whether you want to edit it (stuff like exposure, highlights, etc.) now, in Camera Raw, while the individual images are still in 16-bit RAW format, or once it's a single 8-bit pano. Your call, but I recommend tweaking them now in Camera Raw before you make your pano, so you get the advantages of working with RAW-quality images (if they're JPEGs, it doesn't matter when you edit them—I'd just wait until they're a pano). So, if you shot in RAW, Command-click (PC: Ctrl-click) to select all the pano images in the Organizer, and then click on the Editor button beneath the Media Browser (as shown here).

Step Two:

Since these are RAW files, they open in Camera Raw. Click the Select All button at the top of the filmstrip on the left to select all the images, so any changes you make are automatically applied to all the frames. Let's decrease the Exposure (to –0.50) and increase the Contrast (to +23), pull back the Highlights to –93 to bring back some color in the sky, and bump the Shadows up to +95 to see more detail. Set the white and black points by pressing-and-holding the Shift key and double-clicking on the Whites and Blacks slider knobs. Then, let's crank the Clarity to +41 to accentuate the texture, and the Vibrance to +38. When you're done, click the Open Images button.

Step Three:
This opens your images in the Editor. Now, in Elements 14, the Photomerge® options where moved to Guided mode, so click on Guided at the top of the window, then click on the Photomerge® tab up top. Since your images were already opened, you'll see them in the Photo Bin at the bottom of the window. (*Note:* You can also open your images here right from the Organizer by going under the Edit menu, under Photomerge®, and choosing Photomerge® Panorama. Each will get you to the same place, but I prefer going directly from the RAW images.) Select your images down in the Photo Bin, and then click on Photomerge® Panorama.

Step Four:
Now that this is a Guided edit, the process is simple. On the right, click on Settings, and you'll see a few options: Leave the Blend Images Together checkbox turned on. If you have lens vignetting (the edges of your images appear darkened), turn on Vignette Removal (as I did here; it will take longer to render your pano, but will try to remove the vignetting during the process). And, if you used a Nikon, Sigma, or Canon fisheye lens, turn on the Geometric Distortion Correction checkbox to correct the fisheye distortion. Click on the graphic above Settings and a pop-up menu appears (seen here). The default setting is Auto Panorama, and I recommend leaving it set to that to get the standard wide pano we're looking for. The five other choices all give you…well…funky looking panos (that's the best description I can give you)—they don't give you that nice wide pano most of us are looking for. So, let's stick with Auto Panorama.

(Continued)

Step Five:
Click the Create Panorama button at the bottom right, and within a few minutes (depending on how many photos you're using), your pano is seamlessly stitched together (as seen here). You'll see status bars that let you know Elements is aligning and blending your layers to make this mini-miracle happen, and in the Layers palette, you'll see all the masks it created.

Step Six:
To make your pano fit perfectly together, Photomerge has to move and rearrange things in a way that will cause you to have extra canvas around your final pano. That's why the Clean Edges dialog will pop up. With it, you can have Elements try to fill in the blank space based on the image—it does an amazingly good job, although you may have to continue editing in Expert mode and use the Clone Stamp tool **(S)** to finish it off. Or, you can click No, then click the Next button in the bottom right of the Guided window. Click In Expert to go back to Expert mode, then get the Crop tool **(C)**, and drag out your cropping border (encompassing as much of the pano as possible without leaving any gaps).

Step Seven:

Now to finish it up. First, choose **Flatten Image** from the Layers palette's flyout menu, then sharpen it by going under the Enhance menu, and choosing **Unsharp Mask**. Pick some nice strong settings (here, I chose Amount: 120, Radius: 1.0, Threshold: 3), and click OK to finish the image (seen below).

Burned-In Edge Effect (Vignetting)

If you want to focus attention on something within your image, applying a wide vignette that acts like a soft light is a great way to do this (which is really just an alternative to the Vignette Effect in Guided mode). What you're doing is creating a dark border that will burn in the edges of your image. Here's how to do just that:

Step One:
Open the photo to which you want to apply a burned-in edge effect. Just so you know, what we're doing here is focusing attention through the use of light—we're burning in all the edges of the photo (not just the corners, like lens vignetting, which we learned how to fix in Chapter 6 and I usually try to avoid), leaving the visual focus in the center of the image.

Step Two:
Go under the Filter menu, and choose **Correct Camera Distortion**. When your image opens in the Correct Camera Distortion dialog, if it has an annoying grid over it, start by turning off the Show Grid checkbox beneath the bottom right of the preview area. In the Vignette section near the top, you're going to drag the Amount slider to the left, and as you drag left, you'll start to see vignetting appear in the corners of your photo. But since it's just in the corners, it looks like the bad kind of vignetting, not the good kind. You'll need to make the vignetting look more like a soft spotlight falling on your subject.

Step Three:
To do just that, drag the Midpoint slider quite a bit to the left, which increases the size of the vignetting and creates a soft, pleasing effect that is very popular in portraiture, or anywhere you want to draw attention to your subject. That's it!

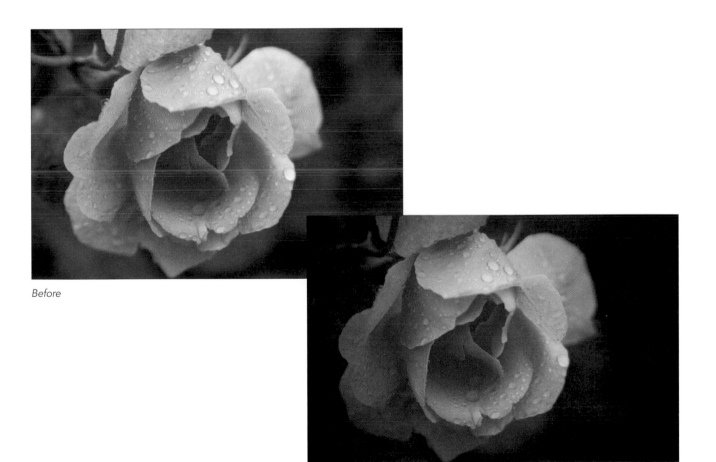

Before

After

Creating the Selective Color Effect

Nothing says 1985 like selective color! I say that semi-jokingly in that it's one of those effects that some photographers are tired of. But, the rest of the world still loves it. It's basically a way to make part of a photo pop out by leaving it in color, while everything else is black and white. You'll find it in the Guided mode, along with lots of other special effects. They all work pretty much the same, but we'll just go over the selective color one here.

Step One:

In the Editor, open a photo you'd like to apply the effect to, then click on Guided at the top of the window. At the top of the Guided window, click on Black & White, then click on B&W Selection.

Step Two:

In the Palette Bin, you'll see all of the settings you have control over for the effect. The way Guided edits usually work is you start from the top and work your way down, but you don't always have to use all of the settings there. For this one, click on the B&W Selection Brush button. Playing off the "Guided" name, you'll see that Elements pretty much guides you along the way.

Step Three:
Here, you'll start off in Add mode. This means that wherever you paint on the photo, it'll be turned to black and white (as shown here). You even have a Brush Size option if you need a larger or smaller brush to paint with. Whatever you don't paint on remains in color. You'll also notice that it tends to snap to parts of your image. That's the Elements "smart" brush technology that helps make selections for you.

Step Four:
If you happen to paint over too much of the photo, or Elements doesn't automatically pick up an edge and turn it to black and white, then just click on the Subtract button and paint the color back in. Here, we want the bouquet to stay in color, so I'm painting the color back in there.

(Continued)

Step Five:

You can also click on the Refine Edge button (you can find out more about how Refine Edge works in Chapter 7), and Elements will help make the edges look more realistic and not so jaggy.

Step Six:

Finally, if you need to get really detailed, then click on the B&W Detail Brush option. This brush doesn't use any of Elements' selection technology, though. Instead, it works just like a regular brush and paints in the effect in only the exact areas you paint on. Oh, and one last thing: if you want to see the reverse of everything you've done, then turn on the Invert Effect checkbox in the third section, and whatever was in color will now become black and white and whatever was black and white will be in color.

One of the most popular lens filters for outdoor photographers is the neutral density gradient filter, because often (especially when shooting scenery, like sunsets) you wind up with a bright sky and a dark foreground. A neutral density gradient lens filter reduces the exposure in the sky by a stop or two, while leaving the ground unchanged (the top of the filter is gray, and it graduates down to transparent at the bottom). Well, if you forgot to use your ND gradient filter when you took the shot, you can create your own ND gradient effect in Photoshop Elements.

Neutral Density Gradient Filter

Step One:
Open the photo where you exposed for the ground, which left the sky too light. Press the letter **D** to set your Foreground color to black. Then, go to the Layers palette and choose **Gradient** from the Create New Adjustment Layer pop-up menu (it's the half-white/half-blue circle icon) at the top of the palette. When the Gradient Fill dialog appears, click on the little, black, downward-facing arrow to the right of the Gradient thumbnail to bring up the Gradient Picker. Double-click on the second gradient in the list, which is the gradient that goes from Foreground to Transparent. Don't click OK yet.

Step Two:
By default, this puts a dark area on the ground (rather than the sky), so turn on the Reverse checkbox to reverse the gradient, putting the dark area of your gradient over the sky and the transparent part over the land. Your image will look pretty awful at this point, but you'll fix that in the next step, so just click OK.

(Continued)

Step Three:

To make this gradient blend in with your photo, go to the Layers palette and change the blend mode of this adjustment layer from Normal to **Overlay**. This darkens the sky, but it gradually lightens until it reaches land, and then it slowly disappears. So, how does it know where the ground is? It doesn't. It puts a gradient across your entire photo, so in the next step, you'll basically show it where the ground is.

Step Four:

In the Layers palette, double-click on the thumbnail for the Gradient adjustment layer to bring up the Gradient Fill dialog again. To control how far down the darkening will extend from the top of your photo, just click once on the Gradient thumbnail at the top of the dialog. This brings up the Gradient Editor. Grab the top-right transparent Opacity stop above the gradient ramp near the center of the dialog and drag it to the left. The darkening will "roll up" from the bottom of your photo, so keep dragging to the left until only the sky is affected, and then click OK in the Gradient Editor.

Step Five:

By default, the gradient you choose fills the entire image area, smoothly transitioning from a dark gray at the top center to transparent at the very bottom. It's a smooth, "soft-step" gradient. However, if you want a quicker change from black to transparent (a hard step between the two), you can lower the Scale amount in the Gradient Fill dialog.

Step Six:

Also, if the photo you're working on doesn't have a perfectly straight horizon line, you might have to use the Angle control by clicking on the line in the center of the Angle circle and dragging slowly in the direction that your horizon is tilted. This literally rotates your gradient, which enables you to have it easily match the angle of your horizon. When it looks good to you, click OK to complete the effect.

Before (exposing for the ground makes the sky too light)

After (the ground is the same, but the sky is now bluer)

Getting the Instagram Look

Here's a quick and easy way to get the wildly popular Instagram app look. Of course, there isn't just one "look," because Instagram has like 15 different ones, but this will at least take you in the right direction. One more thing: I know you're thinking, "Do people really want to learn how to do phone app looks in Elements?" Yup. It's one of the most-requested effects people ask to learn (don't get me started). Luckily, it's easy, and the looks are actually based on classic darkroom effects, so that can't be a bad thing.

Step One:
Start by opening an image in Camera Raw. One of the trademark looks of the Instagram app is its square cropping ratio, so let's start there. Click-and-hold on the Crop tool in the toolbar at the top and a list of cropping ratios appears. Choose the 1 to 1 ratio (as shown here), which gives you a square crop.

Step Two:
Drag your cropping border out over the part of the image you want to have the effect (in this case, it's pretty obvious which part of the image we should keep). Once the crop is where you want it, just press the **Enter (Mac: Return) key** to lock in your square crop. From here on out, it's pretty darn easy—I'll give you some sliders to set, a couple of minor little moves, and you're there. Let's do it.

Step Three:

Another trademark part of the Instagram look is that the images have very flat contrast (after all, these are imitating some vintage camera looks), so start by dragging the Contrast slider all the way to the left to –100. Then, go ahead and crank up the Vibrance a bunch to +100. Now, we'll add a little contrast back in by dragging the Whites to the right to increase the very brightest highlights (here, I dragged over to +55), and bring some color back to the darkest shadow areas by dragging the Blacks slider to the left (here, I dragged it over to –70). At this point, the photo looks kind of yellowish. Not for long, though. Click Open Image to open the image in the Editor.

Step Four:

Next, go under the Enhance menu, under Adjust Lighting, and choose **Levels**. We're going to use some different settings in Levels than you may be used to. Under the Channel pop-up menu, you'll see you have the choice of adjusting the Red, Green, or Blue channels. Don't worry, though, even if you've never used Levels this way before, you'll absolutely be able to do this, since we pretty much use the same settings all the time. So, first, from the Channel pop-up menu, choose **Green**. Then, grab the gray Input Levels slider beneath the histogram and drag it to the left to 1.51 (as shown here) to bump up the greens. See, that was easy, eh?

(Continued)

Step Five:

Now that you've got the hang of adjusting the Levels this way, choose **Blue** from the Channel pop-up menu. Grab the same gray middle slider, but this time drag it to the right to 0.53. Then, go to the bottom of the dialog and drag the black Output Levels slider on the left to the right to around 130 (as shown here). This gives the image more of a teal-and-yellowish feel. When you're done, click OK to close the Levels dialog.

TIP: Add Grain for a Film-Like Look

One of the trademarks of the Instagram effect is a grainy look, and you can always hop into Guided mode and apply the Old Fashioned Photo effect to the image. But, instead of using all of the settings, just click on the Add Texture button.

Step Six:

Now, we're going to add a fake border. Press **Ctrl-A (Mac: Command-A)** to select the entire photo, then go under the Select menu, under Modify, and choose **Border**. For a low-resolution photo, enter a Width setting of 10 pixels in the Border Selection dialog, or enter around 20 pixels for a higher resolution photo like this one, and click OK. This creates a selected border around the edge of your image. Now, we just need to fill it with a color. Instagram gives you the choice between black or white. I usually like black, so just press the letter **D** to set your Foreground color to black, then press **Alt-Backspace (Mac: Option-Delete)** to fill the selected area with black. Continue pressing Alt-Backspace and the border will get darker and thicker (I pressed it four times here). When you're done, press **Ctrl-D (Mac: Command-D)** to Deselect.

Step Seven:

That's it. If you want a variation on the look we've created, in Step Four, after choosing the Green channel, try dragging the gray Input Levels slider to the right instead of to the left to add a red tint to the photo instead. Then, in Step Five, after choosing the Blue channel, drag only the black Output Levels slider to around 118 (as seen here) and you'll have a whole different style, but one that still has that old look to it.

Fake Duotone

The duotone tinting look is all the rage right now, but creating a real two-color duotone that will separate in just two colors on press is a bit of a chore. However, if you're outputting to an inkjet printer, or to a printing press as a full-color job, then you don't need all that complicated stuff—you can create a fake duotone that looks at least as good (if not better).

Step One:

Open the color RGB photo that you want to convert into a duotone (again, I'm calling it a duotone, but we're going to stay in RGB mode the whole time). Now, the hard part of this is choosing which color to make your duotone. I always see other people's duotones, and think, "Yeah, that's the color I want!" but when I click on the Foreground color swatch and try to create a similar color in the Color Picker, it's always hit or miss (usually miss). That's why you'll want to know this next trick.

Step Two:

If you can find another duotone photo that has a color you like, you're set. So, I usually go to a stock photo website (like DollarPhotoClub.com) and search for "duotones." When I find one I like, I return to Elements, press I to get the Color Picker tool, click-and-hold anywhere within my image area, and then (while keeping the mouse button held down) I drag my cursor outside Elements and onto the photo in my web browser to sample the color I want. Now, mind you, I did not and would not take a single pixel from someone else's photo—I'm just sampling a color.

Step Three:
Return to your image in Elements. Go to the Layers palette and click on the Create a New Layer icon at the top of the palette. Then, press **Alt-Backspace (Mac: Option-Delete)** to fill this new blank layer with your sampled color. The color will fill your image area, hiding your photo, but we'll fix that.

Step Four:
While still in the Layers palette, change the blend mode of this sampled color layer to **Color**.

Step Five:
If your duotone seems too dark, you can lessen the effect by clicking on the Background layer, and then going under the Enhance menu, under Adjust Color, and choosing **Remove Color**. This removes the color from your RGB photo without changing its color mode, while lightening the overall image. Pretty sneaky, eh?

Photo by Scott Kelby Exposure: 1/800 sec | Focal Length: 19mm | Aperture Value: *f*/4

SHARPEN YOUR TEETH
sharpening techniques

I had two really good song titles to choose from for this chapter: "Sharpen Your Teeth" by Ugly Casanova or "Sharpen Your Sticks" by The Bags. Is it just me, or at this point in time, have they totally run out of cool band names? Back when I was a kid (just a few years ago, mind you), band names made sense. There were The Beatles, and The Turtles, and The Animals, and The Monkees, and The Flesh Eating Mutant Zombies, and The Carnivorous Flesh Eating Vegetarians, and The Bulimic Fresh Salad Bar Restockers, and names that really made sense. But, "The Bags"? Unless this is a group whose members are made up of elderly women from Yonkers, I think it's totally misnamed. You see, when I was a kid, when a band was named The Turtles, its members looked and acted like turtles. That's what made it great (remember their hit single "Peeking Out of My Shell," or who could forget "Slowly Crossing a Busy Highway" or my favorite "I Got Hit Crossing a Busy Highway"?). But today, you don't have to look ugly to be in a band named Ugly Casanova, and I think that's just wrong. It's a classic bait-and-switch. If I were in a band (and I am), I would name it something that reflects the real makeup of the group, and how we act. An ideal name for our band would be The Devastatingly Handsome Super Hunky Guys with Six-Pack Abs (though our fans would probably just call us TDHSHGWSPA for short). I could picture us playing at large 24-hour health clubs and Gold's Gyms, and other places where beautiful people (like ourselves) gather to high-five one another on being beautiful. Then, as we grew in popularity, we'd have to hire a manager. Before long, he would sit us down and tell us that we're living a lie, and that TDHSHGWSPA is not really the right name for our band, and he'd propose something along the lines of Muscle Bound Studs Who Are Loose With Money, or more likely, The Bags.

297

Basic Sharpening

After you've color corrected your photos and right before you save your files, you'll definitely want to sharpen them. I sharpen every digital camera photo I take, either to help bring back some of the original crispness that gets lost during the correction process, or to help fix a photo that's slightly out of focus. Either way, I haven't met a digital camera (or scanned) photo that didn't need a little sharpening. Here's a basic technique for sharpening the entire photo:

Step One:
Open the photo that you want to sharpen. Because Elements displays your photo in different ways at different magnifications, choosing the right magnification (also called the zoom amount) for sharpening is critical. Today's digital cameras produce such large-sized files that it's now pretty much generally accepted that the proper magnification to view your photos during sharpening is 50%. If you look up in your image window's title bar, or down in the bottom-left corner of the window, it displays the current percentage of zoom (shown circled here in red). The quickest way to get to a 50% magnification is to press **Ctrl-+** (plus sign; **Mac: Command-+**) or **Ctrl--** (minus sign; **Mac: Command--**) to zoom the magnification in or out.

Step Two:
Once you're viewing your photo at 50% size, go under the Enhance menu and choose **Unsharp Mask**. (If you're familiar with traditional darkroom techniques, you probably recognize the term "unsharp mask" from when you would make a blurred copy of the original photo and an "unsharp" version to use as a mask to create a new photo whose edges appeared sharper.)

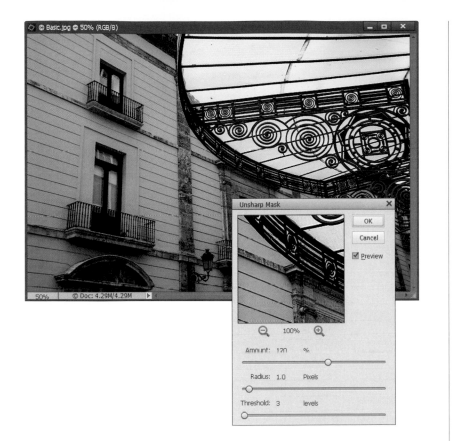

Step Three:

When the Unsharp Mask dialog appears, you'll see three sliders. The Amount slider determines the amount of sharpening applied to the photo; the Radius slider determines how many pixels out from the edge that the sharpening will affect; and the Threshold slider determines how different a pixel must be from the surrounding area before it's considered an edge pixel and sharpened by the filter. Threshold works the opposite of what you might think—the lower the number, the more intense the sharpening effect. So, what numbers do you enter? I'll give you some great starting points on the following pages, but for now, we'll just use these settings: Amount: 120%, Radius: 1, and Threshold: 3. Click OK and the sharpening is applied to the photo.

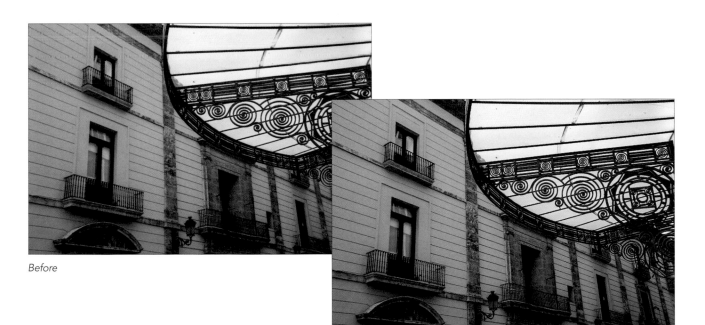

Before

After

(Continued)

Sharpening Soft Subjects:

Here are the Unsharp Mask settings—Amount: 120%, Radius: 1, Threshold: 10—that work well for images where the subject is of a softer nature (e.g., flowers, puppies, people, rainbows, etc.). It's a subtle application of sharpening that is very well suited to these types of subjects.

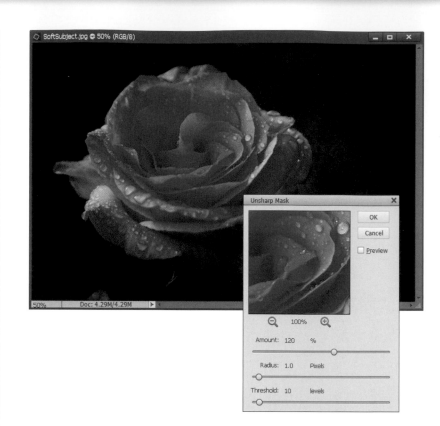

Sharpening Portraits:

If you're sharpening a close-up portrait (head-and-shoulders type of thing), try these settings—Amount: 75%, Radius: 2, Threshold: 3—which applies another form of subtle sharpening, but with enough punch to make eyes sparkle a little bit, and bring out highlights in your subject's hair.

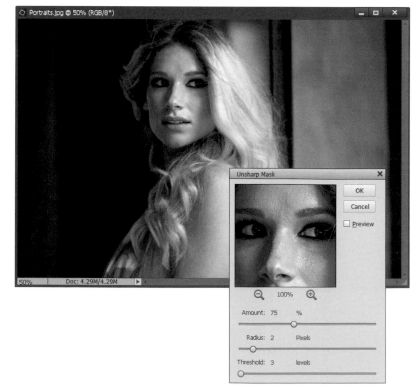

Moderate Sharpening:

This is a moderate amount of sharpening that works nicely on everything from product shots, to photos of home interiors and exteriors, to landscapes (and in this case, some chairs on a porch). If you're shooting along these lines, try applying these settings—Amount: 120%, Radius: 1, Threshold: 3—and see how you like it (my guess is you will). Take a look at how it added snap and detail to the chairs and porch rail.

Maximum Sharpening:

I use these settings—Amount: 65%, Radius: 4, Threshold: 3—in only two situations: (1) The photo is visibly out of focus and it needs a heavy application of sharpening to try to bring it back into focus; or (2) the photo contains lots of well-defined edges (e.g., buildings, coins, cars, machinery, etc.). In this photo, the heavy amount of sharpening really brings out the detail in the edges of this car.

(Continued)

All-Purpose Sharpening:

These are probably my all-around favorite sharpening settings—Amount: 85%, Radius: 1, Threshold: 4—and I use these most of the time. It's not a "knock-you-over the-head" type of sharpening—maybe that's why I like it. It's subtle enough that you can apply it twice if your photo doesn't seem sharp enough after the first application (just press **Ctrl-F [Mac: Command-F]**), but once will usually do the trick.

Web Sharpening:

I use these settings—Amount: 200%, Radius: 0.3, Threshold: 0—for web graphics that look blurry. (When you drop the resolution from a high-res, 300-ppi photo down to 72 ppi for the web, the photo often gets a bit blurry and soft.) If the sharpening doesn't seem sharp enough, try increasing the Amount to 400%. I also use this same setting (Amount: 400%) on out-of-focus photos. It adds some noise, but I've seen it rescue photos that I would have otherwise thrown away.

Coming Up with Your Own Settings:

If you want to experiment and come up with your own custom blend of sharpening settings, I'll give you some typical ranges for each adjustment so you can find your own sharpening "sweet spot."

Amount

Typical ranges go anywhere from 50% to 150%. This isn't a rule that can't be broken. It's just a typical range for adjusting the Amount, where going below 50% won't have enough effect, and going above 150% might get you into sharpening trouble (depending on how you set the Radius and Threshold). You're fairly safe staying under 150%. (In the example here, I reset my Radius and Threshold to 1 and 2, respectively.)

Radius

Most of the time, you'll use just 1 pixel, but you can go as high as (get ready)—2. I gave you one setting earlier for extreme situations, where you can take the Radius as high as 4, but I wouldn't recommend it very often. I once heard a tale of a man in Cincinnati who used 5, but I'm not sure I believe it. (Incidentally, Adobe allows you to raise the Radius amount to [get this] 250! If you ask me, anyone caught using 250 as their Radius setting should be incarcerated for a period not to exceed one year and a penalty not to exceed $2,500.)

(Continued)

Threshold

A pretty safe range for the Threshold setting is anywhere from 3 to around 20 (3 being the most intense, 20 being much more subtle. I know, shouldn't 3 be more subtle and 20 more intense? Don't get me started). If you really need to increase the intensity of your sharpening, you can lower the Threshold to 0, but keep a good eye on what you're doing (watch for noise appearing in your photo).

The Final Image

For the final sharpened image you see here, I used the Moderate sharpening settings I gave earlier (Amount: 120%, Radius: 1, Threshold: 3). If you're uncomfortable with creating your own custom Unsharp Mask settings, then start with this: pick a starting point (one of the set of settings I gave on the previous pages), and then just move the Amount slider and nothing else (so, don't touch the Radius and Threshold sliders). Try that for a while, and it won't be long before you'll find a situation where you ask yourself, "I wonder if lowering the Threshold would help?" and by then, you'll be perfectly comfortable with it.

Before

After

One of the problems we face when trying to make things really sharp is that things tend to look oversharpened, or worse yet, our photos get halos (tiny glowing lines around edges in our images). So, how do we get our images to appear really sharp without damaging them? With a trick, of course. Here's the one I use to make my photos look extraordinarily sharp without damaging the image:

Creating Extraordinary Sharpening

Step One:
Open your image, and then apply the Unsharp Mask filter (found under the Enhance menu) to your image, just as we've been doing all along. For this example, let's try these settings—Amount: 65%, Radius: 4, and Threshold: 3—which will provide a nice, solid amount of sharpening.

Step Two:
Press **Ctrl-J (Mac: Command-J)** to duplicate the Background layer. Because we're duplicating the Background layer, the layer will be already sharpened, but we're going to sharpen this duplicate layer even more in the next step.

(Continued)

Step Three:

Now apply the Unsharp Mask filter again, using the same settings, by pressing **Ctrl-F (Mac: Command-F)**. If you're really lucky, the second application of the filter will still look okay, but it's doubtful. Chances are that this second application of the filter will make your photo appear too sharp—you'll start to see halos or noise, or the photo will start looking artificial in a lot of areas. So, what we're going to do is hide this oversharpened layer, then selectively reveal this über-sharpening only in areas that can handle the extra sharpening (this will make sense in just a minute).

Step Four:

Go to the Layers palette, press-and-hold the Alt (Mac: Option) key, and click on the Add Layer Mask icon at the top of the palette (shown circled here in red). This hides your oversharpened layer behind a black layer mask (as seen here). *Note:* To learn more about layer masks, see Chapter 5.

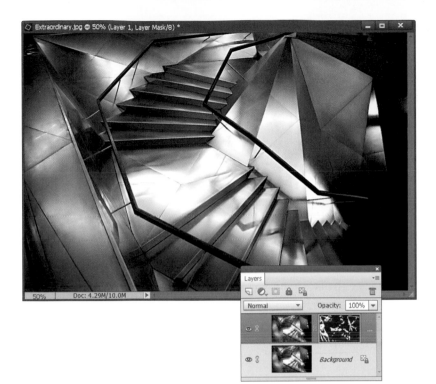

Step Five:
Here's the fun part—the trick is to paint over just a few key areas, which fool the eye into thinking the entire photo is sharper than it is. Here's how: Press **B** to get the Brush tool, and in the Tool Options Bar, click on the Brush thumbnail to open the Brush Picker and choose a soft-edged brush. With your Foreground color set to white, and with the layer mask active in the Layers palette (you'll see a little blue frame around it), start painting on your image to reveal your sharpening. (*Note:* If you make a mistake, press **X** to switch your Foreground color to black and paint over the mistake.) Here, I painted over the seams in the middle, dents, and reflections. Revealing these few sharper areas, which immediately draw the eye, makes the whole photo look sharper.

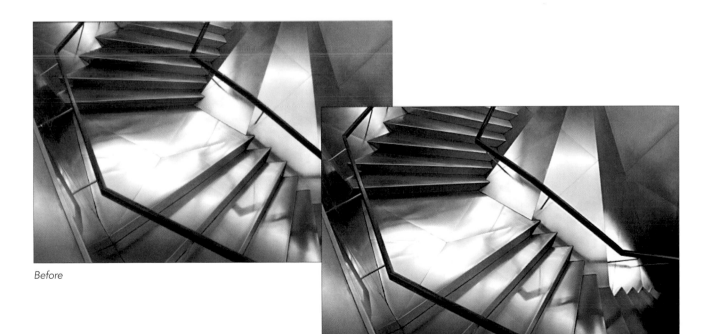

Before

After

Edge Sharpening
Technique

This is a sharpening technique that doesn't use the Unsharp Mask filter, but still leaves you with a lot of control over the sharpening, even after it's applied. It's ideal to use when you have an image that can really hold a lot of sharpening (a photo with a lot of edges) or one that really needs a lot of sharpening.

Step One:
Open a photo that needs edge sharpening.

Step Two:
Duplicate the Background layer by going under the Layer menu, under New, and choosing Layer via Copy (or pressing **Ctrl-J [Mac: Command-J]**). This will duplicate the Background layer onto a new layer (Layer 1).

Step Three:

Go under the Filter menu, under Stylize, and choose **Emboss**. You're going to use the Emboss filter to accentuate the edges in the photo. You can leave the Angle and Amount settings at their defaults (135° and 100%), but if you want more intense sharpening, raise the Height amount from its default setting of 3 pixels to 5 or more pixels (in the example here, I raised it to 6). Click OK to apply the filter, and your photo will turn gray, with neon-colored highlights along the edges.

Step Four:

In the Layers palette, change the layer blend mode of this layer from Normal to **Hard Light**. This removes the gray color from the layer, but leaves the edges accentuated, making the entire photo appear much sharper.

(Continued)

Step Five:

If the sharpening seems too intense, you can control the amount of the effect by simply lowering the Opacity of this top layer in the Layers palette.

Before

After

The Most Advanced Sharpening in Elements

We never used to use the Sharpen tool, until Adobe rewrote its underlying logic, taking it from its previous role as a "noise generator/pixel destroyer" to what Adobe Product Manager Bryan O'Neil Hughes has called "...the most advanced sharpening in any of our products." Here's how it works:

Step One:

Start by applying your regular sharpening to the overall image using Unsharp Mask or Smart Sharpen (more on this coming up next)—your choice. In this case, since this is a portrait of a woman, I'd use the portrait sharpening settings I gave you earlier in this chapter. Now, get the Sharpen tool (**R**; it's found nested beneath the Blur tool). Once you've got the tool, go to the Tool Options Bar and make sure the Protect Detail checkbox (shown circled here in red) is turned on (this is the checkbox that makes all the difference, as it turns on the advanced sharpening algorithm for this tool).

Step Two:

I recommend duplicating the Background layer at this point (by pressing **Ctrl-J [Mac: Command-J]**) and applying this extra level of sharpening to the duplicate layer. That way, if you think the sharpening looks too intense, you can just lower the amount of it by lowering the opacity of this layer. I also usually zoom in (by pressing **Ctrl-+** [plus sign; **Mac: Command-+**]) on a detail area (like her eyes), so I can really see the effects of the sharpening clearly (another benefit of applying the sharpening to a duplicate layer is that you can quickly see a before/after of all the sharpening by showing/hiding the layer).

(Continued)

Step Three:

Now, click on the Brush thumbnail in the Tool Options Bar, choose a medium-sized, soft-edged brush from the Brush Picker, and then simply take the Sharpen tool and paint over just the areas you want to appear sharp (this is really handy for portraits like this, because you can avoid areas you want to remain soft, like skin, but then super-sharpen areas you want to be really nice and crisp, like her irises and lips, like I'm doing here). Below is a before/after, after painting over other areas that you'd normally sharpen, like her eyes, eyebrows, eyelashes, and lips, while avoiding all areas of flesh tone. One more thing: This technique is definitely not just for portraits. The Sharpen tool does a great job on anything metal or chrome, and it's wonderful on jewelry, or anything that needs that extra level of sharpening.

Before

After

Sometimes, I'll turn to the Adjust Sharpness control, instead of the Unsharp Mask filter, to sharpen my photos. Here's why: (1) it does a better job of avoiding those nasty color halos, so you can apply more sharpening without damaging your photo; (2) it lets you choose different styles of sharpening; (3) it has a much larger preview window, so you can see your sharpening more accurately; (4) it has a More Refined feature that applies multiple iterations of sharpening; and (5) it's just flat out easier to use.

Advanced Sharpening Using Adjust Sharpness

Step One:
Open the photo you want to sharpen using the Adjust Sharpness control. (By the way, although most of this chapter focuses on using the Unsharp Mask filter, I only do that because it's the current industry standard. If you find you prefer the Adjust Sharpness control, from here on out, when I say to apply the Unsharp Mask filter, you can substitute the Adjust Sharpness control instead. Don't worry, I won't tell anybody.) Go under the Enhance menu and choose **Adjust Sharpness**.

Step Two:
When the dialog opens, you'll notice there are only two sliders: Amount (which controls the amount of sharpening—sorry, my editors made me say that) and Radius (which determines how many pixels the sharpening will affect). I generally leave the Radius setting at 1 pixel, but if a photo is visibly blurry, I'll pump it up to 2. (Very rarely do I ever try to rescue an image that's so blurry that I have to use a 3- or 4-pixel setting.) Here, I increased the Amount to 200% and left the Radius set to 1 px.

(Continued)

Step Three:

Next is the Remove pop-up menu, which has three types of blurs you can reduce using Adjust Sharpness. Gaussian Blur (the default) applies a brand of sharpening that's pretty much like what you get using the regular Unsharp Mask filter. Motion Blur requires you to know the angle of blur that appears in your image, so it's tough to get really good results with this one. So, I recommend Lens Blur. It's better at detecting edges, so it creates fewer color halos than you'd get with the other choices, and overall I think it just gives you better sharpening for most images. The downside? Choosing Lens Blur causes the filter to take a little longer to "do its thing." A small price to pay for better-quality sharpening.

Step Four:

Below that is Shadows/Highlights. Just click on the little right-facing arrow to the left of it and these options appear. The Shadows sliders are for reducing sharpening in the shadow areas (I occasionally use these, but just on *really* noisy images—it allows you to reduce or turn off sharpening in the shadow areas where noise is usually most visible), and the Highlights sliders are used for reducing the amount of sharpening in the highlight areas (I never use those).

Before

After

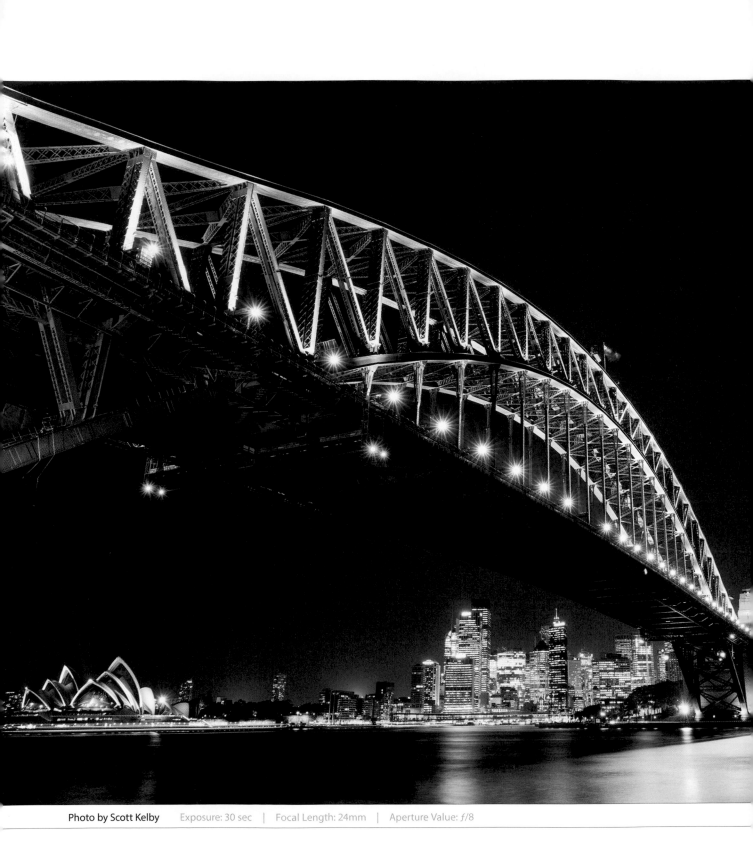

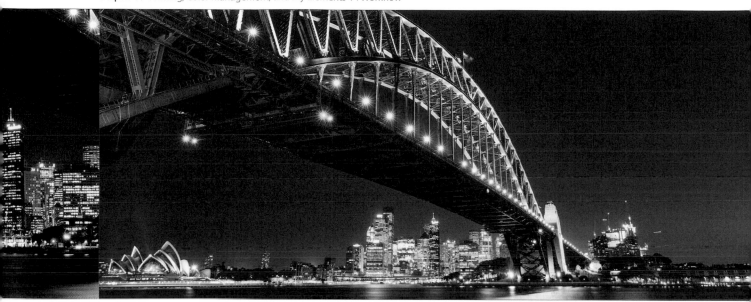

FINE PRINT
printing, color management, and my Elements 14 workflow

There is nothing like a photographic print. It's the moment when your digitally captured image, edited on a computer, moves from a bunch of 1s and 0s (computer code) into something real you can hold in your hand. If you've never made a print (and sadly, in this digital age, I meet people every day who have never made a single print—everything just stays on their computer, or on Facebook, or someplace else where you can "look, but don't touch"), today, all that changes, because you're going to learn, step by step, how to make your own prints. Now, if you don't already own a printer, this chapter becomes something else. Expensive. Actually, in all fairness, it's not the printer, it's the paper and ink, which is precisely why the printers aren't too expensive. But once you've bought a printer—they've got you. You'll be buying paper and ink for the rest of your natural life, and it seems like you go through ink cartridges faster than a gallon of milk.

This is precisely why I've come up with a workflow that literally pays for itself: I use my color inkjet printer to print out counterfeit U.S. bills. Now, I'm not stupid about it—I did some research and found that new ink cartridges for my particular printer run about $13.92 each, so I just make $15 bills (so it also covers the sales tax). Now—again, not stupid here—I don't go around using these $15 bills to buy groceries or lunch at Chili's, I only use them for ink cartridges, and so far, it has worked pretty well. I must admit, I had a couple of close calls, though, mainly because I put Dave Cross's face on all the bills, which seemed like a good idea at the time, until a sales clerk looked closely at the bill and said, "Isn't Dave Canadian?" (By the way, this chapter title comes from the song "Fine Print" by Nadia Ali. According to her website, she was born in the Mediterranean, which is precisely why you don't see her on my newly minted $18.60 bills.)

Setting Up Your Color Management

Most of the color management decisions in Elements come in the printing process (well, if you actually print your photos), but even if you're not printing, there is one color management decision you need to make now. Luckily, it's a really easy one.

Step One:
In the Elements Editor, go under the Edit menu and choose **Color Settings** (or just press **Ctrl-Shift-K** [Mac: **Command-Shift-K**]).

Step Two:
This brings up the Color Settings dialog. By default, Elements is set to Always Optimize Colors for Computer Screens, which uses the sRGB color space. However, if you're going to be printing to your own color inkjet printer (like an Epson, HP, Canon, etc.), you'll want to choose Always Optimize for Printing, which sets your color space to the Adobe RGB color space (the most popular color space for photographers), and gives you the best printed results. Now just click OK, and you've done it—you've configured Elements' color space for the best results for printing. *Note:* You only want to make this change if your final prints will be output to your own color inkjet printer. If you're sending your images out to an outside lab for prints (or your final images will only be viewed onscreen), you should probably stay in sRGB, because most labs are set up to handle sRGB files. Your best bet: ask your lab which color space they prefer.

You Have to Calibrate Your Monitor Before You Go Any Further

To get what comes out of your color inkjet printer to match what you see onscreen, you have to calibrate your monitor in one of two ways: (1) buy a hardware calibration sensor that calibrates your monitor precisely; or (2) use free software calibration, which is better than nothing, but not by much since you're just "eyeing" it. Hardware calibration is definitely the preferred method of monitor calibration (in fact, I don't know of a single pro using freebie software). With hardware calibration, it's measuring your actual monitor and building an accurate profile for the exact monitor you're using, and yes—it makes that big a difference.

Step One:
To find the free software that comes with Windows 10, in the Settings Panel click on System, then click on Display, then in the Advanced Display Settings, click on Color Calibration. In Mac OS X, in the System Preferences dialog, click on Displays, then click on the Color tab to find it. I use Datacolor's Spyder5ELITE hardware color calibrator (around $299 street price), because it's simple, affordable, and a lot of the pros I know have moved over to it. So, I'm going to use it as an example here, but it's not necessary to get this same one, because they all work fairly similarly. You start by installing the software that comes with the Spyder5ELITE. Then, plug the Spyder5ELITE sensor into your computer's USB port and launch the software, which brings up the main window (seen here). You follow the "wizard," which asks you a couple of simple questions, and then it does the rest.

Step Two:
Start by clicking the Next button in the bottom right, and the window you see here will appear. If you're new to calibrating your monitor, I recommend using the Step-by-Step Assistant (which is already selected by default), so at this point just click the Next button again.

(Continued)

Step Three:

The next screen asks you which type of calibration you want to do. Are you going to just update an older calibration you did previously with the Spyder5ELITE (then you would choose the ReCAL radio button), or do you just want to check to see how accurate your current calibration is (CheckCAL), or are you doing this for the first time (which you are, so you'd click the FullCAL radio button, as shown here)? Then, just click the Next button, because you're going to leave all the pop-up menus here at their default recommended settings.

Step Four:

The next screen asks you to put the Spyder unit on your monitor, which means you drape the sensor over your monitor so it sits flat against it and the cord hangs over the back. It shows you exactly where to place it (the two blue arrows you see beside its outline actually flash on/off, so you can't possibly miss where it goes). The sensor comes with a counterweight you can attach to the cord, so you can position the sensor approximately in the center of your screen without it slipping down. Once the sensor is in position over your screen, click the Next button, sit back, and relax. You'll see the software conduct a series of onscreen tests, using gray, white, and various color swatches, as shown here.

Step Five:

This testing only goes on for a few minutes (at least, that's all it took for my desktop), and then it's done. It asks you to name your profile (it puts a default name in place for you), so enter a name, and then click the Save button. Below that is a pop-up menu where you can choose when you want an automatic reminder to "Recalibrate your monitor" to pop up on your screen. The default choice is 2 Weeks (so please don't tell anyone that I actually set mine to 1 Month). Make your choice and then click the Next button.

Step Six:

Now you get to see the usually shocking before/after. Click on the Switch button at the bottom right and you can switch back and forth between your now fully calibrated monitor and your uncalibrated monitor. It's at that moment you say, "Ohhhhhh…that's why my prints never match my screen." Well, it's certainly one part of the puzzle, but without this one critical piece in place, you don't have a chance with the rest, so you did the right thing. Click Next one last time, and then click the Quit button in the Profile Overview screen.

Getting Pro-Quality Prints That Match Your Screen

When you buy a color inkjet printer and install the printer driver that comes with it, it basically lets Elements know what kind of printer is being used, and that's about it. But to get pro-quality results, you need a profile for your printer based on the exact type of paper you'll be printing on. Most inkjet paper manufacturers now create custom profiles for their papers, and you can usually download them free from their websites. Does this really make that big a difference? Ask any pro. Here's how to find and install your custom profiles:

Step One:

Your first step is to go to the website of the company that makes the paper you're going to be printing on and search for their downloadable color profiles for your printer. I use the term "search" because they're usually not in a really obvious place. I use a Canon PIXMA PRO-1 printer and I generally print on Canon paper. When I installed the PRO-1's printer driver, I was tickled to find that it also installed custom color profiles for all Canon papers, but some printers don't. So, if I needed to download them, the first stop would be Canon's website, where you'd click on the Drivers & Downloads link (as shown here). *Note:* Even if you're not a Canon user, still follow along (you'll see why).

Step Two:

Once you get to the Get Product Support page, enter your printer model name/number, then click the Get Drivers & Downloads button.

Step Three:
On the Drivers & Downloads page, click on the Software tab, then click on the Select button for PRO-1 series ICC Profile Ver. 1.0.0m for Art Paper Printing, then click on Download. After they download onto your computer, just Right-click on the profile(s) for the paper(s) you use, choose **Install Profile**, and they're added to your list of profiles in Elements (I'll show how to choose them in the Print dialog a little later). On a Mac, go to your hard disk, in your Library folder, and in your Color-Sync folder, to the Profiles folder. Just drag the file in there and you're set. You don't even have to restart Elements—it automatically updates. That's it—you download them, install them, and they'll be waiting for you in Elements' print dialog. Easy enough. But what if you're not using Canon paper? Or if you have a different printer, like an Epson or an HP?

Step Four:
We'll tackle the different paper issue first (because they're tied together). Say, I wanted to print from my PIXMA PRO-1 using a different brand of paper other than Canon. For example, say I wanted to use Red River Paper's Ultra-Pro Satin instead. So, even though I'm printing on a Canon printer, now I'd go to Red River Paper's site (www.redriverpaper.com) to find their color profiles for my PIXMA PRO-1. (Remember, profiles come from the company that makes the paper.) On the Red River Paper homepage, click on the Color Profiles link under Helpful Info on the left side of the page.

(Continued)

Step Five:

Under the section named Canon Pro Printers, there's a direct link to the ICC profiles for the PRO-1 (as seen here), but did you also notice that there are ICC Color profiles for Epson and HP printers? The process is the same for other printers, but although HP and Canon now both make pro-quality photo printers, Epson had the pro market to itself for a while, so while Epson profiles are created by most major paper manufacturers, you may not always find paper profiles for HP and Canon printers. At Red River, they widely support Epson, and have a bunch of Canon profiles, but there are only a few for HP. That doesn't mean this won't change, but as of the writing of this book, that's the reality.

Step Six:

Just like when you download Canon profiles, Red River (and many other paper manufacturers), provide the profile (shown here; some paper manufacturers provide an installer) and instructions, so you install it yourself. Again, on a PC, just Right-click on the profile and choose Install Profile. On a Mac, go to your hard disk, in your Library folder, and in your Color-Sync folder, to the Profiles folder. Just drag the file in there and you're set.

Step Seven:

You'll access your profile by choosing **Print** from Elements' File menu. In the Print dialog, click on the More Options button in the bottom left, then click on Color Management on the left of the dialog. Change the Color Handling pop-up menu to **Photoshop Elements Manages Color**, then click on the Printer Profile pop-up menu, and your new color profile(s) will appear. Here, I'm printing to a Canon PIXMA PRO-1 using Red River's UltraPro Satin paper, so that's what I'm choosing as my printer profile (it's named RR UPSatin 4.0 CanPro-1). That's it, but there's more on using these color profiles next in this chapter.

TIP: Custom Profiles for Your Printer

You can also pay an outside service to create a custom profile for your printer. You print a provided test sheet, overnight it to them, and they'll use an expensive colorimeter to measure your test print and create a custom profile, but it's only good for that printer, on that paper, with that ink. If anything changes, your profile is worthless. You could do your own personal printer profiling (using something like one of X-Rite's i1 Pro packages), so you can re-profile each time you change paper or inks. It's really just up to you.

Sharpening for Printing

When we apply sharpening, we apply it so it looks good on our computer screen, right? But when you actually make a print, a lot of that sharpening that looks fine on a 72- or 96-dpi computer screen gets lost on a high-resolution print at 240 ppi. Because the sharpening gets reduced when we make a print, we have to sharpen so our photo looks a bit too sharp onscreen, but then looks perfect when it prints. Here's how I apply sharpening for images I'm going to print:

Step One:
Start by doing a trick my buddy Shelly Katz shared with me: duplicate the Background layer (by pressing **Ctrl-J [Mac: Command-J]**) and do your print sharpening on this duplicate layer (that way, you don't mess with the already sharpened original image on the Background layer). Double-click on the new layer's name and rename it "Sharpened for Print," then go under the Enhance menu, and choose **Unsharp Mask**. For most 240 ppi images, I apply these settings: Amount 120; Radius 1; Threshold 3. Click OK.

Step Two:
Next, reapply the Unsharp Mask filter with the same settings by pressing **Ctrl-F (Mac: Command-F)**. Then, at the top of the Layers palette, change the layer blend mode to **Luminosity** (so the sharpening is only applied to the detail of the photo, and not the color), and use the Opacity slider to control how much sharpening is applied. Start at 50% and see if it looks a little bit over-sharpened. If it looks like a little bit too much, stop—you want it to look a little oversharpened. If you think it's way too much, lower the opacity to around 35% and re-evaluate. When it looks right (a little too sharp), make a test print. My guess is that you'll want to raise the opacity up a little higher, because it won't be as sharp as you thought.

Okay, you've hardware calibrated your monitor (or at the very least—you "eyed it") and you've set up Elements' Color Management to use Adobe RGB (1998). You've even downloaded a printer profile for the exact printer model and style of paper you're printing on. In short, you're there. Luckily, you only have to do all that stuff once—now we can just sit back and print. Well, pretty much.

Making the Print

Step One:
Once you have an image all ready to go, just go under the Editor's File menu and choose **Print** (as shown here), or just press **Ctrl-P (Mac: Command-P)**.

Step Two:
When the Print dialog appears, let's choose your printer and paper size first. At the top right of the dialog, choose the exact printer you want to print to from the Select Printer pop-up menu (I'm printing to a Canon PRO-1). Next, choose your paper size from the Select Paper Size pop-up menu (in this case, a 13x19" sheet), choose your page orientation beneath that menu, and then from the Select Print Size pop-up menu (on the bottom right), be sure that Actual Size is selected. In the middle of the Print dialog, you'll see a preview of how your photo will fit on the printed page, and at the bottom of the column on the right, there's an option for how many copies you want to print. If you want to print more than one photo, just click the Add button below the filmstrip on the left side of the dialog. This brings up the Add Photos dialog (similar to the one you get when using the Create Slide Show feature), where you can choose from your photos in the Organizer. Select the one(s) you want and click the Add Selected Photos button. To remove a photo from the filmstrip, click on it, then click the Remove button.

(Continued)

Step Three:

Click on the More Options button (at the bottom left) and then click on Custom Print Size on the left. Here you can choose how large the photo will appear on the page (if it's a photo that's too large to fit on the paper, just turn on the Scale to Fit Media checkbox, as I did here, and it will do the math for you, and scale the image down to fit).

Step Four:

Now click on Printing Choices at the top left of the More Options dialog. Here you can choose if you want to have your photo's filename appear on the page, or change the background color of the paper, or add a border, or have crop marks print, or other stuff like that—you have but only to turn the checkboxes on (you like that "you have but only to" phrase? I never use that in normal conversation, but somehow it sounded good here. Ya know, come to think of it—maybe not). Anyway, I don't use these Printing Choices at all, ever, but don't let that stop you—feel free to add distracting junk to your heart's content. Now, on to the meat of this process.

Step Five:

Click on Color Management on the left to get the all-important Color Management options. Here's the thing: by default, the Color Handling is set up to have your printer manage colors. You really only want to choose this if you weren't able to download the printer/paper profile for your printer. So, basically, this is your backup plan. It's not your first choice, but today's printers have gotten to the point that if you have to go with this, it still does a decent job. However, if you were able to download your printer/paper profile and you want pro-quality prints (and I imagine you do), then do this instead: choose **Photoshop Elements Manages Colors** from the Color Handling pop-up menu (as shown here), so you can make use of the color profile, which will give you the best possible color match.

Step Six:

Below Rendering Intent, you'll see a warning asking if you remembered to disable your printer's color management. You haven't, so let's do that now. Click the Printer Preferences button that appears right below the warning (as shown here). (Note: On a Mac, once you click the Print button in the Elements Print dialog, the Mac OS X Print dialog will appear, where you can go under Printer Color Management and set it to Off [No Color Adjustment].)

(Continued)

Step Seven:

In your printer's Properties dialog (which may be different depending on your printer), you will turn off your printer's color management, but you have other stuff to do here, as well (on a Mac, you will do this in the OS X Print dialog, as mentioned in the previous step). First, choose the type of paper you'll be printing to (I'm printing to Canon Photo Paper Pro Luster). Find the Print Quality setting, choose Custom, click the Set button, then in the resulting dialog, drag the Quality slider at the top to the quality setting you want and click OK. If you have the option, be sure to set your printer options to **Off (No Color Adjustment)**. Here, under Color/Intensity, I chose Manual, then clicked the Set button, and chose None. Click OK to save your changes and return to the More Options dialog.

Step Eight:

After you've turned off your printer's color management (and chosen photo quality paper), you'll need to choose your color profile. Again, I'm going to be printing to a Canon PRO-1 printer, using Canon's Photo Paper Pro Luster paper, so I'd choose that profile from the Printer Profile pop-up menu in the Color Management section. Doing this optimizes the color to give the best possible color print on that particular printer using that particular paper.

Step Nine:

Lastly, you'll need to choose the Rendering Intent. There are four choices here, but only two that I recommend—either Relative Colorimetric (which is the default setting) or Perceptual. Here's the thing: I've had printers where I got the best looking prints with my Rendering Intent set to Perceptual, but currently, on my Canon PRO-1, I get better results when it's set to Relative Colorimetric. So, which one gives the best results for your printer? I recommend printing a photo once using Perceptual, then printing the same photo using Relative Colorimetric, and when you compare the two, you'll know. Just remember to add some text below the photo that tells you which one is which or you'll get the two confused. I learned this the hard way.

Step 10:

Now click the OK button, then click the Print button at the bottom of the Print dialog (this is where, on a Mac, you'll choose the options we talked about in Step Six and Step Seven).

What to Do If the Print Still Doesn't Match Your Screen

Okay, what do you do if you followed all these steps—you've hardware calibrated your monitor, you've got the right paper profiles, and color profiles, and profiles of profiles, and so on, and you've carefully turned on every checkbox, chosen all the right color profiles, and you've done everything right—but the print still doesn't match what you see onscreen? You know what we do? We fix it in Elements. That's right—we make some simple tweaks that get the image looking right fast.

Your Print Is Too Dark

This is one of the most common problems, and it's mostly because today's monitors are so much brighter (either that, or you're literally viewing your images in a room that's too dark). Luckily, this is an easy fix and here's what I do: Press **Ctrl-J (Mac: Command-J)** to duplicate the Background layer, then at the top of the Layers palette, change the layer blend mode to **Screen** to make everything much brighter. Now, lower the Opacity of this layer to 25% and (this is key here) make a test print. Next, look at the print, and see if it's a perfect match, or if it's still too dark. If it's still too dark, set the Opacity to 35% and make another test print. It'll probably take a few test prints to nail it, but once you do, your problem is solved.

Your Print Is Too Light

This is less likely, but just as easy to fix. Duplicate the Background layer, then change the layer blend mode to **Multiply** to make everything darker. Now, lower the Opacity of this layer to 20% and make a test print. Again, you may have to make a few test prints to get the right amount, but once you've got it, you've got it.

Your Print Is Too Red (Blue, etc.)

This is one you might run into if your print has some sort of color cast. First, before you mess with the image, press the **Tab key** on your keyboard to hide the Toolbox, palettes, and Tool Options Bar, and put a solid gray background behind your photo. Then, just look to see if the image onscreen actually has too much red. If it does, then click on the Create New Adjustment Layer icon (the half-white/half-blue circle) at the top of the palette, and choose **Hue/Saturation**. In the Hue/Saturation adjustments palette, from the Channel pop-up menu, choose **Reds** (or **Blues**, etc.), then lower the Saturation amount to –20, and then (you knew this was coming, right?) make a test print. You'll then know if –20 was too much, too little, or just right. You may have to make a few test prints before you nail it.

Your Print Has Visible Banding

The more you've tweaked an image, the more likely you'll run into this (where the colors have visible bands, rather than just smoothly graduating from color to color. It's most often seen in blue skies). Here's how to deal with this: Go under the Filter menu, under Noise, and choose **Add Noise**. In the dialog, set the Amount to 4%, click on the Gaussian radio button, and turn on the Monochromatic checkbox. You'll see the noise onscreen, but it disappears when you print the image (and usually, the banding disappears right along with it).

My Elements 14 Photography Workflow

One of the questions I get asked the most is "What is your suggested digital workflow?" (Which actually means, "What order are you supposed to do all this in?" That's all "digital workflow" means.) I wrote this book in kind of a digital workflow order, starting with importing and organizing your photos, correcting them, sharpening them, and then at the end, printing. But I thought that seeing it all laid out in one place (well, in these six pages), might be really helpful, so here ya go.

Step One:

You start your workflow by importing your photos into the Organizer (we learned this in Chapter 1). While you're in the Photo Downloader (shown here), I recommend adding your metadata (your name and copyright info) during this import process. Also, while you're in the Photo Downloader, go ahead and rename your photos now, so if you ever have to search for them, you have a hope of finding them (searching for photos from your trip to Hawaii is pretty tough if you leave the files named the way your camera named them, which is something along the lines of "SK2_1751.JPG"). So give them a descriptive name while you import them. You'll thank me later.

Step Two:

Once your photos appear in the Organizer, first take a quick look through them and go ahead and delete any photos that are hopelessly out of focus, were taken accidentally (like shots taken with the lens cap still on), or you can see with a quick glance are so messed up they're beyond repair. Get rid of these now, because there's no sense wasting time (tagging, sorting, etc.) and disk space on photos that you're going to wind up deleting later anyway, so make your job easier—do it now.

Step Three:

Once you've deleted the obviously bad ones, here's what I would do next: go through the photos one more time and then create an album of just your best images (see Chapter 1 for how to create an album). That way, you're now just one click away from the best photos from your shoot.

Step Four:

There's another big advantage to separating out your best images into their own separate album: now you're only going to tag and worry about color correcting and editing these photos—the best of your shoot. You're not going to waste time and energy on photos no one's going to see. So, click on the album, then go ahead and assign your keyword tags now (if you forgot how to tag, it's back in Chapter 1). If you take a few minutes to tag the images in your album now, it will save you literally hours down the road. This is a very important step in your workflow (even though it's not a fun step), so don't skip it—tag those images now!

(Continued)

Step Five:

Now it's time to start editing those photos. My workflow begins in Camera Raw, which I honestly believe is the fastest and easiest way to get your images looking the way you want them (even if you didn't shoot in RAW format; see Chapter 2 for how to open JPEGs, TIFFs, and PSDs in Camera Raw). We're going to edit a portrait I shot. The first thing I do at this point is figure out what's wrong with the photo, and the question I ask myself is simple: "What do I wish were different?" Of course, if the white balance or exposure is off, I would fix it in Camera Raw before I did any retouching. You can see the adjustments I made here (again, see Chapter 2 for more on working in Camera Raw). Now, click Open Image to start working in the Editor.

Step Six:

We don't really have a whole lot of retouching to do with this image, so we'll just tweak a few things. (*Note:* You can learn a lot more about retouching in the Retouching Portraits bonus chapter I provided on the book's companion webpage, mentioned in the book's introduction.) Let's start with her eyes. The whites of her eyes are kind of grayish and her irises are kind of flat-looking, so click the Create New Adjustment Layer's icon at the top of the Layers palette and choose Levels. Set the blend mode to **Screen** and invert the layer mask by pressing **Ctrl-I (Mac: Command-I)**. Zoom in on one of the eyes, press **D** to set your Foreground color to white, then get the Brush tool **(B)**. Paint over the whites of her eyes and then bring the Opacity of the adjustment layer down to 50% so she doesn't look freakish (once you've painted them in, you can tweak the amount a bit).

Step Seven:
Now, let's add some contrast to her irises. Go to the Create New Adjustment Layer icon and choose Brightness/Contrast. In the Adjustments panel, push the Contrast up to +89 or so. Next, invert the layer mask, as in the previous step, and resize the Brush tool so it's a little bit smaller than the irises and click on them.

Step Eight:
If you zoom in closer, you'll get a much better look at her skin, and you'll see a few blemishes we should probably get rid of (it only takes a few seconds). Select the Background Layer, grab the Spot Healing Brush, make your brush size a little larger than the blemishes you want to remove, then move your cursor over each blemish and just click once to remove the blemish. (See Chapter 8 for more on the Spot Healing Brush.) Go ahead and take a minute to remove the larger ones. Remember, this is just a tweak, not an in-depth retouch, so don't spend too long on this step—a minute or two, tops.

(Continued)

Step Nine:

While we're still zoomed in tight, let's add some sparkle to her eyes. We can take advantage of a tool that lets us sharpen just one area and it does it using the most advanced sharpening algorithm in all of Elements—it's the Sharpen tool (Adobe updated the math for this tool by adding a Protect Detail checkbox, which is on by default, and it's fantastic for things like sharpening eyes. See Chapter 10 for more on the Sharpen tool). Get the Sharpen tool from the Toolbox (it's nested beneath the Blur tool), and make sure the Protect Detail checkbox is turned on in the Tool Options Bar. Now, paint in a circular motion around her irises a few times and, man, it really makes those eyes sparkle! You can also paint over her necklace to add some sparkle there, as well.

Step 10:

Let's create a final adjustment layer to add some highlights to her hair. So, click on the Create New Adjustment Layer's icon and choose **Hue/Saturation**. Set the Channel pop-up menu at the top to **Reds**, increase the Saturation amount to around +33, and then invert the layer mask. With your Foreground color set to white, get the Brush tool again, and just paint over the highlight areas in her hair.

Step 11:

The last thing I would do here is check over the image to see if you've missed any blemishes or stray hairs, and remove them with the Healing Brush tool (press Shift-J until you have it). Once all your retouching in Elements is done, you have two steps left: (1) Save the image by pressing **Ctrl-S (Mac: Command-S)** and make sure the Include in Elements Organizer checkbox is selected in the Save dialog. And, (2) close the image. That's it—do just those two things, and the edited image will appear in the Organizer right beside the original un-edited image. Below, I'm showing you the before and after images so you can see the differences between them. This isn't one of those hit-you-between-the-eyes type of retouches—it's all subtle stuff, and the end result is subtle too, but that's the idea.

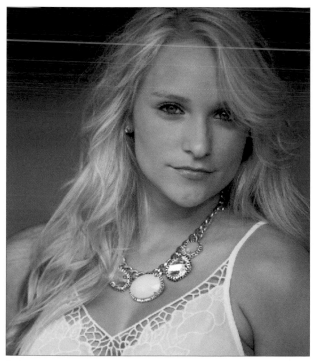

Before

After

Index

(Continued)

(Continued)

(Continued)

(Continued)

(Continued)

(Continued)

(Continued)

(Continued)

ADD MORE TO ALL THE MEMORIES.

You eat, sleep and breathe creativity. You don't take life for granted. You take it for more than that. With the photos on the fly and the designs that you draw. These are the bottles that you always leave open by your side, ready and waiting to catch lightning whenever it should choose to strike. Fuel your creativity.

kelbyone | *Easy training from the best in Photoshop, Lightroom, and Photography.* kelbyone.com

Only you can make

time stand still.

Shot with a Canon PowerShot G3X

Jennifer Wu is ready to capture the moment, no matter where her journey takes her. With relentless perseverance and the rugged, compact cameras in the PowerShot G Series, nothing stands between her and the image she wants—even heavy fog, dim lighting and a slippery mountain trail. It's that attitude that helps you take the art of travel photography to new heights. Stay focused. Be creative. Canon is with you every step of the way.

pro.usa.canon.com

Canon
SEE IMPOSSIBLE

TAKE IT. MAKE IT.

Make the change from Adobe Photoshop Elements to the Creative Cloud Photography plan and get the world's best image editing tools — Adobe Photoshop CC, Adobe Lightroom CC and integrated mobile apps — to do everything from total transformations to everyday edits on your desktop, iPhone, Android device or iPad.

Adobe Creative Cloud Photography plan

Learn more at: adobe.com/creativecloud/photography.html